Literary Art in Digital Performance

LITERARY ART IN DIGITAL PERFORMANCE

Case Studies in New Media Art and Criticism

Edited by Francisco J. Ricardo

continuum

NEW YORK • LONDON

2009

The Continuum International Publishing Group Inc
80 Maiden Lane, New York, NY 10038

The Continuum International Publishing Group Ltd
The Tower Building, 11 York Road, London SE1 7NX

www.continuumbooks.com

Library of Congress Cataloging-in-Publication Data
A catalog record for this book is available from the Library of Congress.

ISBN: 978-0-8264-3600-9 (HB)
ISBN: 978-0-8264-3680-1 (PB)

Typeset by Newgen Imaging Systems Pvt Ltd, Chennai, India
Printed in the United States of America

Contents

INTRODUCTION

Juncture and Form in New Media Criticism

Francisco J. Ricardo

In their respective histories and traditions, literature and art have come to enjoy the primordial status that few forms of human expression—among them, music and dance—have warranted. Venerable and variegated, these disciplines have offered creative pedestal to largely distinct pedigrees and varieties of articulation, tied to fundamental processes in presentation and reception. Literature operates with reliance on the act of textual reading; the visual arts have been framed around optical perception, and in the last one hundred years has emancipated itself from mimetic reproduction. These processes have naturally offered possibilities and posed constraints on the medium within which each expressive form operates. The mechanism of print has relied on modes of production as efficient and modular as movable type; something largely (except in the newer media of photography and film) without comparable possibility in the visual arts, which have correspondingly preserved the value of the original work that inscription possessed before print, that writing had before Gutenberg.

These correspondences have not been incidental to history, they—through the existence of the book, of sculpture, of painting, and of the poem—have constituted culture by memorializing it, together with the human sentiments that comprise its motivations. If it is possible, then, to concede a certain sovereign pride endemic to artistic and literary traditions, it is also possible to imagine the continued independence of lineage and practice that each would maintain into posterity; the book, poem, journal, letter would remain largely textual; painting, sculpture, photography and drawing, largely visual. This possibility implies an account not only of the expressive practices themselves, but also of the media within which they have developed, and to which they have been anchored.

It ought not be startling, therefore, to additionally imagine that when transformations are introduced *within* the constitutive media that these expressive traditions exploit, consequential changes in the categorical character of art and literature would result. And, acknowledging the ubiquitous trope of Convergence that accompanies technology's permeations, we might also expect that the extent to which these media changes materialize independently of context, genre, or discipline results in conditions proportionally able to undermine the expressive distinctness that separates art and literature.

While human expressive force remains vibrant, electronic media have made it possible to create work that spans traditional distinctions at key junctures, to include the aesthetic and the poetic; the entirely participatory and the entirely receptive; the act of narrative creation and that of real-time production. The many questions that this provokes are not philosophically trivial: what, in a work that is as visual as it is literary, does it mean to speak of art, or of literature? What critical methods correlate with the approach and appreciation of such integrated work? How does one speak of an "audience" in work that is driven and whose development is largely fashioned by those who would have heretofore experienced it purely as viewers or readers? After the development of mechanical reproduction, the originality and spirit of art have, by a line of collective argument from Walter Benjamin to Clement Greenberg, to Arthur Danto and Donald Kuspit, been, in a word, compromised. These accounts chronicle a status of art under assault by a turn of history, and changes of taste. But concern may also turn to the possibilities of expressive *creation* in several problematic forms. For interactivity has produced the consequence of work that often performs neither as literature nor as art, but beyond both; something neither entirely predetermined nor entirely random, but beyond both; and that dwells neither in a single place nor everywhere, but beyond both. Is it time, then, to extend Walter Benjamin by raising a new critique on the work of art in the age of *electronic production*? Should the materialistic term "production" be replaced by "realization"?

Complicating all this is the variegated nature of what comprises electronic art and literature; the cinematic element in computer games; poems in projective installations; dramatic reenactments played out in simulated online worlds; the audible immersive, explorable in open physical space. As its formal plurality, with so many new varieties of work, makes evident, this situation is best approached *interrogatively*, rather than through the formulation of one unifying theory or one particular critic. The authors who have contributed essays to this question have each treated a different kind of expressive work, and operate from distinct literary, visual, post-literary, or postart vectors, but they nonetheless approach the lack of singularity as critical openness amenable to several theoretical explorations with certain stable determinations. As I clarify later, there is relevance here not only to the contingent and new, but also to ontological concerns that energize much continental philosophy and to formal questions rooted in the analytic tradition.

Several patterns emerge in this book's treatments of expressive work in electronic media. One is an essentially postmodern but nonetheless paradoxical suspicion against categorical judgment. While the general thinking often leans toward maximally broadening any existing genus—of literature, most persistently—so as to accommodate new varieties of expressive work, there is also perceptible reluctance to think of literature as containing too many characteristics beyond its unvarying entailment with the written letter. But as deployed through electronic media, this kind of expressive work has ranged across a cluster of names: digital literature, electronic literature, new media art, digital art, cybertexts, game studies, all depending on the author and the type of work considered. All of these labels have the benefit of pointing directly to technology as the paradigm of change that led to the conditions of categorical rupture transcending "literature" or "art" alone. But this reference also risks descending into

problematic ahistoricity, ignoring the underlying bonds of philosophy merging the new with something much older. And more importantly, the presence and influence of visual engagement is minimized by names that emphasize "literature." If a name could convey the fusion of literature and art beyond media, it would connect to earlier traditions that harbored the same aesthetic and poetic aspirations. For what might still too imprecisely be called "Literary Art" in digital media follows significant forays into lettristic exploration that began with Mallarmé, Marinetti, Picabia, Chagall, and later returned with Broodthaers, Holzer, Kruger, Bochner, Kosuth, Nauman, Horn, and Weiner. This spectrum encompasses and has navigated through whole movements that swept within concrete poetry, Futurism, Dada, Fluxus, conceptual art, and even postart, to use Donald Kuspit's term.[1] The innovations of these directions are symbolically rediscovered in electronic poetry, literature, and particular kinds of interactive games, if by implicit reference and extension. Reflecting similar creative divagations, each essay in this book considers either a separate work (almost a separate genre)—as a case study—or a challenge with discipline or method—as a critical position—and is followed by a post-chapter dialogue in which its author and I engage in a profundization of conceptual themes exposed by the essay. I shall have more to say about the reasons for such dialogue shortly. With all of this we must also acknowledge that these dialogues are positions, if not desiderata, from the critic, historian, or theorist, speaking back to the openness of this emerging field.

As an example, it was during one of these dialogues that I realized how the problematic nature of certain electronic kinds of expressive work, to include the immersive drama of certain games, has been called "art," or "literature"—a designation that opens onto the series of problems that Kuspit has compellingly tackled. In particular, his oft-quoted (and oft-misquoted) eponymous critique on the end of art has been read only in relation to crises in contemporary art, or postart, without any extension of its relevance toward digital media works that challenge structural sensibilities and traditions of art in no less direct a manner. In fact, one might argue that critics and historians of electronic art and literature have more to learn from Kuspit's critical insights than do members of the contemporary art establishment, if for no other reason than that digital art and literature are on a kind of juggernaut of path of escalation, and have made their way into a breadth of venues, from galleries and museums that engage new media, such as Eyebeam, Bitforms, ZKM, and the Whitney Museum, out to the commercial shrink-wrap of the retail game, through the online world, and in event venues that date back to exhibitions like the 1968 "Cybernetic Serendipity" show at London's Institute of Contemporary Arts, and which came to include gatherings like Ars Electronica, SIGGRAPH, and the Boston CyberArts Festival curated biennially by George Fifield. Basically, everywhere.

This dynamic fissure of outgrowth, breaking as it does, through established conventional contexts, reiterates the argument that if a series of questions can be asked about what the presumption of art and literature in new media imply, it seems apposite to consider positions, challenges, and clarifications in contemporary art's own challenges as germane to electronic art. In fact, only in contemporary art can we speak not of one rupture but of several, overlapping, and not invariably cosynchronous. One of these is the decathexis of the image—as Kuspit and Arthur Danto[2] maintain, the end of the

long historical period during which art is defined in terms of attention to the visible object, how it is perceived and judged, and how the created object corresponds—or conforms—to established genres and traditions of practice. This happened along two simultaneous directions: the elevation to the status of art of *material* work that was not primarily retinal—a tributary that logically begins with Duchamp; and the emergence of *visual* work that was not considered art, namely film and Greenbergian kitsch, now upheld as aesthetic objects. Another rupture comes at the sensory point of what comprises the art object, a rupture that inaugurated every form of what Rosalind Krauss termed sculpture in the expanded field[3], including the work of Christo, Matta-Clark, Smithson, Heizer, Serra, Morris, Judd, Flavin, Hanson, Manzoni, Klein, and so many others. This direction, which promoted as art a spectrum of objects that had theretofore not been considered such, was simultaneously complemented by the entirely non-object work of the conceptual, in performances, unproduced possibilities, and more—to include the work of Kaprow, Piper, Calle, Acconci, Weiner, in the 1960's and after.[4]

Following this dual rupture, art could no longer be considered in terms that were exclusively retinal or material. And yet, as if to inaugurate an age of Schism, a third rupture surfaced, involving materiality. The choices for art's materials were traditionally tied to the skill required in shaping them. The mastery of the fresco mural is different from that of the digital projection—this is a qualitative distinction, albeit resistant to comparison. But when the hardness of marble is replaced by contemporary art's mundaneity through plastic and cardboard, we can no longer speak of the same skill of fabrication as a measure of artistic merit, new criteria emerge. For its part, cardboard's role, too, has been further degraded by the artwork of cigarette butts and supporting detritus, all of which connect back to the physical and conceptual nothingness that Lippard first profiled as dematerialization.[5]

Almost inescapably then, the terms of the digital/electronic/virtual in art and literature ought now to be interrogated in light of these ruptures of retinality, objecthood, and materiality, and in ways similar to how Stanley Cavell viewed the cinematic world four decades ago. For when Cavell makes clear that "a 'possibility' of a medium can be made known only by successful works that define its media"[6], his stance examines what was unique to film, what comprises it from within, without precluding the conditions that assert it as categorically one medium among several. His is a view of film informed by what lies *outside* of it. This perimeter-probing identifies the methodological approach of virtually every essay in this book.

If what lies *within* an electronic medium can be defined by what its mechanism makes available for use, the external denominators that make media study a relatively stable project, which is to say the ontology of certain genres and practices, like locative art, are more tenuously approached in these writings. The essays are treatments, close readings of signature works in diverse styles and forms. But to define the conditions that may unify one medium or style with others, more open-ended inquiry, beyond the scope and context of individual works, becomes necessary. This happens after every chapter in discussion with each author, through the aforementioned post-chapter dialogue. What is *in* the essay treats what is *in* the work. What is *outside* the essay— through dialogic inquiry—treats what is *outside* the work, though remaining necessary to the context of its medium as seen through the prism of each author.

And, as I indicated earlier, several patterns emerge in authors' views of the orbit of aesthetic media. One of these is a marked aversion to ontological thinking. So while the idea of literature and art, fully distended for novel practices, is held up, one also perceives a reaction against insinuations of universals as might underlie electronic works and media. Only qualia, distinct from characteristics that can be *in* works, are considered real or legitimate; of these the assumed ones are the *poetic*, the *aesthetic*, and the *literary*, and considerable effort is spent on clarifying them throughout. And where this is not evident with certain authors, analytic emphasis centers on the "apparatus effect" of those processes implemented electronically, processed physiologically, or experienced phenomenologically. Despite the choice of analytic emphasis, no author here denies that the presence of something *literary*, for example, pervades the works examined here. Why qualia, as non-instantiated properties, would be acceptable, even implicitly, while any notion of an ontology of new media art or literature is not, marks a paradoxical turn folding into a larger ontological uncertainty, because the existence of such qualia is premised on conditions in an object that are necessary and sufficient for it to *be* poetic, aesthetic, or literary in the first place. Sensorily, qualia—let us take the color blue as trivial example—cannot exist only in the abstract; eventually there must be *one* blue object in the known universe for the color to be seen, as there must be at least two blue objects for the quality to be understood as free of instantiated objecthood, as *blue*. And it is precisely because of their context-freedom that qualia confirm conditions which a work must satisfy for the possession of such attributes. The independence of object from qualia is implicit in the most basic questions that we can ask about it; to the extent that we can wonder, "What makes it blue?"; we can also ask "What makes it literary?", presuming that some, but not all, electronic works are literary, or poetic, or aesthetic. And likewise, we can ask about the work's central relationship with other qualia—what makes it *sculptural? interactive? performative?* Each of these characteristics can be instantiated. There is thus some implicit ontology about digital art and literature that simultaneously overcomes genre boundaries and expresses the conditions of artistic quality or character that modernist sensibility requires. Whether this potential ontology is closer to Heidegger's—contingent, *thrown* into circumstance—or to Danto's—essentialist, dependent on defining conditions—or to Ingarden's—looking not merely at what is, but what might potentially be—is not yet evident. For despite these essays' general aversion to affirming underlying conditions of art or literature[7], often remaining largely within situational description, there are nonetheless strong traces of thematic constitution of experience which, being theatrical, literary, poetic, or aesthetic, beg the question of what common conditions allow such experience to acquire this character. To suggest that this connection is one of dependence—perceptual experience depending on the characteristics that foster it—is to return to an essentialist position, and to tune closer to that frequency, here is Danto's own avowal of such relative dependence:

> As an essentialist in philosophy, I am committed to the view that art is eternally the same—that there are conditions necessary and sufficient for something to be an artwork, regardless of time and place. I do not see how one can do the philosophy of art—or philosophy *period*—without to this extent being an essentialist. But

as an historicist I am also committed to the view that what is a work of art at one time cannot be one at another, and in particular that there is a history, enacted through the history of art, in which the essence of art—the necessary and sufficient conditions—are painfully brought to consciousness.[8]

But since this question itself depends on the way one experiences creative works, a related problem now involves the comparative degree of critical treatment to which new media art and literature (which, through interactivity, randomness, and networked strategies, become rich with experiential uniqueness) have been subject. Orbiting this tacit question, two logics surface in these essays. One accentuates synthetic/formalistic analysis (e.g., Funkhouser, Hayles, Raley) while another favors a critical/historical approach (e.g., Simanowski, Gendolla, Cayley). That the former is largely represented by American voices, and the latter by European ones seems analogous to the geography of modern philosophy's two major and opposing branches: analytic philosophy—open to propositional logic, scientific method, and proportionally inimical to grand speculation—versus the continental tradition—greatly appreciative of major movements, of the relevance of history, and proportionally skeptical of scientism.

But, in this balance of authorial predisposition, toward which logic or tradition does the preponderance of media art theory appear to be leaning? In electronic art and literature, the answer depends upon whether one's critical gaze falls on the aesthetic *mechanism* of an electronic work, or on the aesthetic *experience* of what it generates. The case has often been made that nondigital art and literature, relying on static supports like the printed page, the sculptural object, the canvas, or the etching, exist over stable, unchanging media, and it is in the imaginal horizons of readerly or visual perception that literary or aesthetic action takes place. In electronic art and literature, however, such subjective processes are additionally informed by patterns of kineticized action in the programmatic aesthetic of the *ergodic* and its overarching blueprint, the *cybertext,* to use Espen Aarseth's terms for the tradition of works that employ recombination of elements, the introduction of chance, and other strategies of dynamic play.[9] Since these works both *present* and *respond,* we might view some of them as accommodating a dual phenomenology involving both reader response and author response, since this correspondence drives interactive experience through a "dance between accident and design," as Katherine Hayles affirms here.

So one might first point to the distinction between two moments that could be called the algorithmic experience and the moment of aesthetic enactment. While they need not be entirely unconnected, many digital works are selectively structured so as to emphasize one and reduce or dissimulate the other. Evident here is an important strategy; many works here bear this mark and thus alter our conventional means for literary or visual analysis. It is a distinction that illustrates the flowing ethereality articulated by the poem, the virtual or locative world, or the projective segment on one hand, and the underlying mechanics of functional affinity as exposed in the authors' analyses on the other.

And in many electronic works one is surprised to learn of the extent to which constituents and processes of a work were produced with extensive programmatic effort not apparent to the aesthetic experience of the work. In each of the case studies here,

the examined work's mechanism illustrates the uniqueness of its production across invocations, lending to it behavior that is both idiosyncratic (reinforcing its internal sense of difference), yet sufficiently cohesive to accentuate the voice and character of identity (reinforcing its internal sense of continuity). This contingent volatility clearly complicates any essentialist position. Ultimately, claims that any ontology of digital art or literature is impossible depend on whether by ontology we mean "possibly underlying principles" or "possibly rightful principles"—that is, whether questions about the shared abstractions that promote the idea of a definable electronic art or literature emerge from a descriptive stance, or a normative one, because presently both exist.

These concerns haven't yet assumed the conceptual center stage of digital art criticism. Before approaching allegorical or poetic dimensions, such appraisals must realize at least two dimensions, for, in new media, accounts of *sensory* activity take place over a framework of *algorithmic* execution—either or both of which can entail aleatory or chance processes. Each chapter embraces this characteristic shift from the descriptive to the functional, at times anchored in a distinctive phrase that reveals the mechanism of the work's autonomy as an aesthetic, poetic, or literary production. Such duality, among others unique to this medium, compels the question of what logic and structure might best inform any analytic or critical methodology for digital media art and literature. What we cannot ask about all digital artworks, we can ask of individual ones, but if the ultimate critical question is, "What might constitute a paradigmatic method for analyzing the intricacy of such work?", the answer, despite formal or critical alternatives, is necessarily pluralistic. Insufficiently, neither contemporary art nor literary theory provide an adequate vantage, or suitably strong points of reference from their own traditions to aesthetize *function*, which is the basis for the uncanny elegance and intricacy of electronic works. When the common word in the oft-used terms, "work of art" or "literary work" becomes a reference to a verb, rather than an object, its signified must be regarded as both.

As a specific example here, consider Katherine Hayles's chapter on the visual electronic poem *slippingglimpse*, through what seems at first to be an exclusively formal treatment. At first clarifying how distributed cognition contrasts with modernist grand narratives that stipulate singular causality, Hayles turns from a transcendental layering of elemental forces in the poem (for which a common analytic substrate is that of reading topological surfaces) to a literary reading of the work into the second half of her analysis. If we accept the implication that the insights of the *text* in this visual work cannot be more revealingly explored except through a *literary* mode of analysis, this questions the presumable indispensability of *nontextual* aspects of the work: if this regenerative poem ought best a literary reading, would its *nontextual* elements not assume secondary importance as something more ornamental than essential? One alternative is that a work of this kind, which is both textual, and simultaneously operating on the neo-textual plane of expression that its new media elements inhabit, can be read as two integrated expressions. As a poetic/textual work, it populates a literary world layered in the aesthetic tradition of Eliot. As a poetic/concrete body, its visual textuality is enveloped within sensory activity that expresses a second, distinct, and semi-autonomous octave of allusions reflecting the spirit rather than the letter of the work. These analytic chords, however, resonate to the question of *how* such a work may

be read, given that the analysis Hayles provides has argued for, and performed, readings from separate directions. A persistent, indispensable multiplicity fills the phenomenology of transmodal works like *slippingglimpse* and new media criticism must always assume a decisive stance on how to weigh, interpret, and synthesize the phenomena expressed within this breadth of expressive complexity. The interpellated reading that Hayles sustains, delving into relationships between poetic structure, algorithmic strategy, and scientific models, makes evident that the ontology of digital poem is as free of hermetic or traditional criteria for poetic form as Danto depicts for contemporary art (on grounds that it does not cogently enough operate as a language[10]), or Kuspit holds for the emancipatory dissimilarity of postart from what precedes it. Neither indexical, nor instrumental, nor of figuration, although assuming all of these directions, the digital work of art rather uses its anti-realist form as argument for metaphoricality, for a way of thinking about post-industrial being in relationship to persistent shifts and realignments, conceptually comparable to the way that contemporary art selects the signs implied by the materials and objects that it, too, exploits for that function. Given the elaborate course of this prelusive chain of considerations, sounding the depths of electronic creativity requires an increasingly complex and dynamic engagement with the conditions of art and literature, of production, and of response than initially seems apparent. And this task marks our point of departure into new critical space, some of which these essays attempt to bring to more familiar view.

Notes

1. Donald Kuspit, *The End of Art* (Cambridge: Cambridge University Press, 2004).
2. Danto's end refers not to the demise of objects of creative expression, but rather to "the end of a certain narrative which has unfolded in art history over the centuries, and which has reached its end in a certain freedom from conflicts of the kind inescapable in the Age of Manifestos." Arthur C. Danto, *After the End of Art: Contemporary Art and the Pale of History* (Princeton, NJ: Princeton University Press, 1998), 37.
3. In the transgression of sculpture is arguably the epitaph for electronic art and literature's preemption and redefinition of non-art objects, networks, media, and practices. One item of evidence for this is the sudden unsuitability of a name or label to describe its practice, a disparity that Krauss, too, finds in the term "sculpture" itself: "Sculpture is rather only one term on the periphery of a field in which there are other, differently structured, possibilities" (Rosalind Krauss, "Sculpture in the Expanded Field" in *The Originality of the Avant-Garde and Other Modernist Myths* [Cambridge, MA: MIT Press, 1985], 284).
4. The most cogent chronicle of art's conceptual transgressions remains Martha Buskirk, *The Contingent Object of Contemporary Art* (Cambridge, MA: MIT Press, 2003).
5. Lucy R. Lippard, *Six Years: The Dematerialization of the Art Object from 1966 to 1972* (Berkeley, CA: University of California Press, 1997).
6. Stanley Cavell, *The World Viewed* (Cambridge, MA: Harvard University Press, 1971), 146.

7. Peter Gendolla is the only author in this collection with an entirely essentialist commitment to literature. Similarly, Roberto Simanowski operates in normative relativity, refracting the literary or visual object through the space between Gumbrecht's endorsement of presence and Lyotard and Derrida's own relationship to the question of meaning versus presence. I find these positions useful as groundstakes in the evolution of digital criticism.

8. Danto, *After the End of Art: Contemporary Art and the Pale of History*, 95.

9. Espen Aarseth, *Cybertext: Perspectives on Ergodic Literature* (Baltimore, MD: Johns Hopkins University Press, 1997).

10. The art object has never been conflated with any other kind of production because it is both forceful and free, purposeful and questioning, structured and open—all of this to an extent not risked by other expressive forms, least of all that of language. This distinction is possible without contradiction because of the special character of the universal in art and how it differs from any particular instance of it, of genres of art and of semantics of art in general—being rule-bound, language does not possess two such separate identities, one at a categorical level, and another at the idiomatic. Thus contrasts like the following are specious:

> Imagine a sentence written down, and then a set of marks which looks just like the written sentence, but is *simply* a set of marks. The first set has a whole lot of properties the second set lacks: it is in a language, has a syntax and grammar, says something. And its causes will be quite distinct in kind from those which explain mere marks. The structure then of works of art will have to be different from the structure of objects which merely resemble them. Arthur C. Danto, "Art, Philosophy, and the Philosophy of Art," *Humanities* 4, no. 1 (1983): 1–2.

Bibliography

Aarseth, Espen. *Cybertext: Perspectives on Ergodic Literature.* Baltimore, MD: Johns Hopkins University Press, 1997.

Buskirk, Martha. *The Contingent Object of Contemporary Art.* Cambridge, MA: MIT Press, 2003.

Cavell, Stanley. *The World Viewed.* Cambridge, MA: Harvard University Press, 1971.

Danto, Arthur C. "Art, Philosophy, and the Philosophy of Art." *Humanities* 4, no. 1 (1983).

—. *After the End of Art: Contemporary Art and the Pale of History.* Princeton, NJ: Princeton University Press, 1998.

Krauss, Rosalind. "Sculpture in the Expanded Field," in *The Originality of the Avant-Garde and Other Modernist Myths.* Cambridge, MA: MIT Press, 1985.

Kuspit, Donald. *The End of Art.* Cambridge: Cambridge University Press, 2004.

Lippard, Lucy R. *Six Years: The Dematerialization of the Art Object from 1966 to 1972.* Berkeley, CA: University of California Press, 1997.

CHAPTER ONE

What is and Toward What End Do We Read Digital Literature?

Roberto Simanowski

The Exterminated Reader

Imagine a reader reading a story about an adulterous couple planning to kill the woman's husband. This reader is completely engrossed, reading about the planned murder from his comfortable chair by his fireplace gives him an almost perverse pleasure. Reading the description of the house the murderer enters, he thinks of his own house. Then he reads that the man enters the room in which the husband's character is sitting by the fire; it's too late for him to avoid the knife his wife's lover rams into his chest.

This reader exists. In a short story by Julio Cortázar: *La continuidad de los parques* (The Continuity of Parks) of 1964. Cortázar is not the only writer who tried to turn the reader into a character. Italo Calvino, in his novel *If On a Winter's Night a Traveler*, gives the reader the main role in the book, and narrates in the second person. In Gabriel García Márquez'*One Hundred Years of Solitude* the protagonist finds a book entitled *One Hundred Years of Solitude* and reads it until he comes to the page in which he is reading the very same book. There have been many such experiments in late modern or post-modern times. After the all-knowing author of the nineteenth century had long been dismissed, authors fantasized about regaining omnipotence by exercising direct impact on the reading situation.

Now, in the cases of Cortázar and Márquez the reader is himself part of the text which another, real reader is reading. And in Calvino's case, the *illusion relies* on the reader's willingness to be addressed. Unfortunately, or rather, fortunately, it is not possible to literally draw the reader into the story. The author has no way of directly killing the reader. Sure, one could poison the paper, as in Umberto Eco's *The Name of the Rose*. But the poison is not applied by the author and is not part of the text. Literature cannot bridge the gap between the world of the narrative and the world of the recipient. Conventional literature cannot. Digital literature can.

Real Clocks and Virtual Hand Grenades

In the first half of the nineteenth century, it was popular to integrate a tiny mechanical clock in paintings at the spot where there would be a painted clock. The clock in the

painted interior hence presented the real time and thus belonged to the world of the spectator. The world of the painting and the world of the recipient were bridged. But the bridge was broken when, for example, the painting was of a dinner scene but the museum closed at noon. Rather than being drawn in, the viewer was thus pushed away into a mode of meta-reflection reaffirming the gap between the painted world and the real world.

Digital media are more successful in connecting the viewer's time and the artwork's time. In the German collaborative online writing project *23:40*, for example, one can write a text recalling a particular moment and specify the time when this text will be presented on the website each day. The bridge between text time and reader time works pretty well because the writer knows what time the reader sees his text and can determine whether the description of a romance is available only at 2 a.m. or at noon.

John McDaid's 1992 hyperfiction *Uncle Boddy's Phantom Funhouse* contains a link to a level that the reader does not have permission to access. If the reader nonetheless clicks the link, a message appears declaring that the reader has to be killed for trespassing. Although it's the program that is then *terminated*, the reader is indeed killed *as* reader in so far as there is no reader without text.

The killing is easier the other way around. In Susanne Berkenheger's 1997 hyperfiction *Zeit für die Bombe*, the reader encounters a situation where the character, Iwan, opens a stolen suitcase that turns out to contain a time bomb with a button to arm it. The text reads:

> Don't we all always want to push, turn or click something to make something happen without any effort? This is the best. Isn't it? Iwan, come on, do it, *push the little button.*

It is up to the reader to push the bomb's button by clicking a link. This naturally upsets Iwan, who starts insulting the reader for sitting comfortably in her chair by the fireplace pretending compassion but really deriving excitement from watching him run through freezing Moscow carrying a time bomb. Iwan then threatens the reader: "Look," he warns, "what I have here in my hand. Do you see my little hand-grenade? Now you can have compassion for yourself." While the bomb finally explodes, tearing Iwan apart, the hand-grenade is never used, not even to shut down the program. Lucky reader. He benefits from the early days of digital literature when authors didn't know how far they could go when entering the readers' world. After all, they wanted their text to be read. And how many readers would try again after the programs shut down? Thus, the author leaves it at the allusion to Aristotle's concept of catharsis and does not program any fatal links or send any dangerous viruses.

Killing the Text

However, the killing is not over. Berkenheger's hyperfiction links to another kind of killing; this time the opponents are not author and reader but the different media involved.

After the reader arms the time bomb, we encounter the following text: "And the *bomb* ticked" with the word "bomb" blinking. This exemplifies what additional means

digital literature possesses in contrast to print literature: Time. The text becomes what Kate Hayles "eventilized."[1] The text is based on code and this code not only makes the word "bomb" appear on the screen but also interrupts this appearance.

This sentence also points to some core questions for digital literature. Why is "bomb" blinking? Shouldn't the verb blink since it's the one that signifies the action? But a blinking verb would only translate its message into another language. The version the author chose is correct from a logical point of view; *processing* the action signified requires the *agent* to blink. From an aesthetic point of view, however, its redundancy is problematic. The word "bomb" is blinking, so why do we also need the verb "ticked"? There are two languages here: the linguistic language that denominates an action and the language of performance that presents it. It is as if the stage directions of a play were acted out and also spoken.

The author could easily have had the two languages cooperate: "And the *bomb*." Since the signifier for "bomb" already presents the action of the signified, the verb is actually dispensable. Of course this is not the end of the alteration and adjustment of language in digital media. The next step could be to use the icon of a bomb, the step after that to make the signifier honest and have, rather than a blinking icon, a ticking sound.

To generalize, what we have here is the elimination of the text, its substitution by image, sound, and action. Such operation is a common feature in digital media. In many cases the operation looks like a mere supplementation of the text. But supplementing text with an image *does* actually mean eliminating the text, for what is shown as an image does not need to be described with words. The paradigm of expression changes from creating a world in the reader's *imagination* based on a specific combination of letters to *presenting* a world directly to the audience through extralingual means.

Actually, this substitution of text is the justification of digital literature. If an object only consists of static letters it does not really need digital media and hence should not be called digital literature even though it may be presented on the internet. By definition, digital literature must go beyond what could be done without digital media. By definition, digital literature must be more than just literature otherwise it is only literature in digital media. This would, no doubt, also be very interesting from a sociological perspective. Think of all the text presented on websites and blogs, bypassing any police of the discourse and any publisher's evaluation. However, that is another matter and another book. My concern here is not about who writes literature but about how the materiality of literature changes when the digital technology is used for aesthetic reasons and not just for distribution.

Two aspects of the change from literature to digital literature should be clear by now: In digital literature the reader of the story can kill the character in the story, and the bomb can blink, tick and—in the form of a virus or a shutdown—also "explode." There is a third aspect that should be stressed: Digital literature is only digital if it is not only digital. What do I mean by this?

Almost ten years ago, John Cayley's essay *The Code Is Not the Text (Unless It Is the Text)* described alphabetic language as a digital structure since it consists of a small set of symbols that can be endlessly combined and recombined. Instead of analog elements

as found in painting, we have distinct linguistic units that are either there or are *not*, with no option in between. In her essay *The Time of Digital Poetry* Hayles reminds us of Cayley's notion and concludes that the computer is not the first medium to use digitized language but rather "carries further a digitizing process already begun by the transcription of speech into alphabetic letters."[2]

I agree that literature was digital even before it extended into digital media. In digital media, literature is digital in a double sense: It uses a small set of distinct, endlessly combinable symbols, and those symbols are now produced by binary code. The first sense of digitality refers to the semiotic paradigm of the material (the distinct units), the second sense of digitality refers to the operational paradigm of the medium (the binary code as basis for all data in digital media). If we agree on the criterion that digital technology is used for aesthetics, not just for presentation, then being digital in this double sense is not enough to be considered "digital literature." Or actually, I should say: that's one "digital" too many, because using the old system of symbols in a new medium only creates literature *in* digital media, but not digital literature.

Obviously one doesn't need digital media to create text consisting only of recombinable linguistic units, but if the text blinks or disappears, if it is an *event* rather than an *object*, then it really needs the screen rather than the page. When text is "eventilized" it also stops being purely digital in the semiotic sense, since, in contrast to alphabetic language, the language of performance, sound and visual signs does *not* consist of discrete units. Non-linguistic signs are, as Roland Barthes phrased it in his essay *Rhetoric of the Image*, "not founded on a combinatory system of digital units as phonemes are." This notion insists on a more precise concept of text in the heyday of an extended concept of text 30 years ago. As Hayles argues in her essay on *slippingglimpse*, in digital literature the inscription of verbal symbols shrinks "to a subset of 'writing' in general." Hayles puts the word "writing" in quotation marks suggesting that this kind of writing produces a kind of text that also needs quotation marks: text that is not *really* text or not *only* text. What, however, is the text in digital literature?

Digital Hermeneutics

As I mentioned, John Cayley gave one of his essays the programmatic title *The Code Is Not the Text Unless It Is the Text*. For him, code is only text insofar as it *appears* as text. An example is *Perl Poetry*, a genre in which natural language is mixed with the syntax of Perl code in a kind of insider poetry for programmers. If, in contrast, the code runs to *generate* text, the code itself is not text. This is true with respect to the *linguistic* concept of text to which Barthes refers. If we use Hayles's broad concept of writing, the code is the text even if it is not the text; the effect of the code—making a word blink or tick, for instance—is part of the "text" and needs to be "read" alongside the blinking, ticking word itself.

Whether we use the broad, figurative concept of text—enclosed in quotation marks if necessary—or whether we insist on the *linguistic* quality of text, it should be clear that when it comes to digital literature we need to "read," or let's say, to interpret, not just the text but also what happens to the text. As a rule of thumb one may say: If

nothing happens to the text its not digital literature. As a result, when we read digital literature, we have to shift from a hermeneutics of linguistic signs to a hermeneutics of intermedial, interactive, and processing signs. It is not just the meaning of the words that is at stake, but also the meaning of the performance of the words which, let's not forget, includes the interaction of the user with the words. We should always explore these different elements and their possible connections—though there may not be a significant relationship between them.

One could argue that a hermeneutics of digital signs requires a completely new methodological approach. However, it is probable that the discussion of digital litera- ture ought best to be a combination of new and old criteria. As Fotis Jannidis argues, genre theory is still a valid analytical tool for the discussion of computer games. The analysis can benefit from concepts developed in the past such as "story," "plot," and "character" or theoretical frameworks such as reader-response theory, formalism, and inter-discourse theory. And as Jörgen Schäfer's analysis of the interactive drama *Façade* shows, knowing genre history helps realize that this cutting-edge piece refers to the oldest and most traditional theoretical drama model.

Façade is also a good illustration of the fact that authors often make decisions about characters and plot based on technological constraints, as opposed to just artis- tic intention. For instance: though it's amazing how, as the guest in the two charac- ters' home, you are able to "say" anything to them via your keyboard and influence the progression of their argument, sometimes the program can't handle your input, in which case the husband and wife seem to ignore you. This technical limitation is acceptable because the two are presented as self-absorbed, "difficult" people. Their personalities are not necessarily a choice of the authors; they are a requirement to keep the interaction plausible despite the technological challenge. A hermeneutic of digital signs has to take into account the possibility of such technological determinism.

So far I have evoked murder, adultery, time bombs, and hand-grenades. Let me talk now about . . . cannibalism. To begin, I'll borrow from Chris Funkhouser: his presen- tation at the Electronic Poetry Festival in Paris in May 2007 drew a connection between *creative cannibalism* and *digital poetry*, saying that digital poetry "devours other texts" by appropriating, transforming, and reconfiguring them. Funkhouser evoked rit- ual anthropophagy, the practice of killing and eating the other in order to inherit his qualities. A form of digital cannibalism can be seen in Camille Utterback's and Romy Achituv's interactive installation *Text Rain*, whose large screen shows letters rain down onto your projected shadow. As you collect them on your silhouette, the letters form words and sentences taken from a contemporary poem.[3] However, as I experienced it, and as I saw others experiencing it, one mostly does not engage in the reading process, but rather plays with the rain of letters. The text has been transformed into visual objects. As Francisco Ricardo argues, the transmodal work exists as a series of several phenomenological moments of which the last brings back some of its lexical, linguistic character and, to say so, undo the cannibalism.

A very subtle example of text cannibalism is the installation *Listening Post*, which Rita Raley explores in her essay. Since it features a curtain of screens quoting from live internet chats, one would think it is all about text. But, stepping back from the screens to take in the installation as a whole, one is not really reading anymore; instead one

perceives this plethora of text as part of a trance-like experience. A very gentle form of "eating the text," that lies, in the end, at the feet of the reader.

Digital Humanities

At one point, Stephanie Strickland's video-poetry-collage *slippingglimpse* provides the following words:

> I find myself kind of alone at the Academy
> they're into turning out people
> who can get jobs
> in the animation industry

In the context of the conference "Reading Digital Literature" I organized at Brown University in October 2007, an underlying theme revolved around the inevitability of an evolving canon. Francisco Ricardo summarized it this way:

> Now that the initial waves of enthusiasm, hype and counter-hype have given way to sustained creative production and critical inquiry, it is time to move away from highly generalized accounts into detailed and specific readings that account, in media-specific ways, for the practices, effects, and interpretations of important works.

How do close readings help develop *digital literacy*—to use one of the buzzwords of digital humanities?

They help insofar as digital literacy cannot be reduced to the competence in using digital technology but also entails an understanding of the language of digital media. Like cinematic literacy develops by understanding the meaning of techniques such as close ups, cuts, cross-fading, and extradiegetic music, digital literacy develops by exploring the semiotics of the technical effects in digital media. I think such "reading" competence in the realm of digital media can best be developed by talking about examples of digital *art*. Since art is by default always more or less concerned with its own materiality, it seems to be the best candidate for a hermeneutic exercise that aims to make us aware of the politics of meaning in digital media. However, we might consider that such close reading might not be limited to what is considered art but should also include pop culture, such as ego shooter games. After all, almost a century after Duchamp's first ready-made it has become more and more difficult to tell what is and what isn't art.

However, the difficulty in defining art is not the only challenge scholars of digital aesthetics confront. For one thing, most of the scholars in the field of digital aesthetics were born too early. During their formative years there was no curriculum that combined humanities and technology. We may wish we were able to create the sophisticated animations or interactivity we discuss. However, we are proud of what we bring to the table where the future scholars of digital humanities are educated: *reading* skills. It is for us something of a duty to ensure that the university turns out people who know not only how to generate impressive animation or program a specific grammar of

interaction but also—and perhaps more importantly—know how to read and understand such interaction.

Notes

1. N. Katherine Hayles, "The Time of Digital Poetry: From Object to Event," in *New Media Poetics. Contexts, Technotexts, and Theories*, ed. Adelaide Morris and Thomas Swiss (Cambridge, MA: MIT Press, 2006), 181–209.
2. Ibid., 189.
3. The poem, *Talk, You*, can be found in Evan Zimroth, *Dead, Dinner, or Naked* (Evanston, IL: Northwestern University Press, 1993).

Bibliography

Hayles, N. Katherine. "The Time of Digital Poetry: From Object to Event," in *New Media Poetics. Contexts, Technotexts, and Theories*, ed. Adelaide Morris and Thomas Swiss. Cambridge, MA: MIT Press, 2006.

Zimroth, Evan. *Dead, Dinner, or Naked*. Evanston, IL: Northwestern University Press, 1993.

Post-Chapter Dialogue, Simanowski and Ricardo

FJR: A crucial feature of digital work is the distance between design and use, or structure and performance. A digital poem is structured as program, as code, as a fixed sequence of algorithms, yet performs as a work of indeterminate direction in the sense of its variety across invocations. This incongruity calls into question the choice of a suitable method for analysis of such works. On one hand it seems appropriate to expose the anatomic logic and mechanism of a digital work as the ideal means of analysis. After all, this demonstrates most clearly how the piece works. But while not inappropriate, this approach seems insufficient to capture the expressive breadth of the digital work. No dissection of a literary or visual work's functionality will demonstrate what makes it distinct from any nonaesthetic object, such as the proverbial, utilitarian computer program. Since the creative function of an aesthetic work operates in a way that exceeds the components of its apparatus, we must accept that beyond functional analysis, it is necessary to interrogate what, as an aesthetic expression, makes the work transcend its own medium and mechanism. This naturally implies the connection of analysis to a theory of analysis, whether semiotic, hermeneutic, historical, critical, or formalist. Your approach specifically favors the close reading. Can you elaborate on the reasons for this?

RS: There are several reasons. The first purpose that a digital work serves is as an act of creative expression, not as an object of technology. A close reading, as the term implies, stays close to the expressive action, rather than the algorithmic organization. And because a digital work is fundamentally different from and more complex than a material or printed work, it for me deserves a broad, extratextual reading of its creative context, so it makes sense to effect a close reading as in the tradition of New Criticism and also so as to extend it beyond the text of work to include external elements. So, "extratextual" here includes even what the author says about the work.

Let me give an example. In an interview, David Rokeby addresses the fetishization of control that the computer brings with it and asserts that he intends to undermine this through "systems of inexact control." With this background information, he informs us that his *Very Nervous System*, in which we indeed cannot reach a point of satisfactory control, has to be read within a pedagogical and even political agenda, and that the lack of satisfactory control felt by the user is not the result of flawed programming but of an intentional reaction against this fetishism.

We are therefore required, in situating that effort in something broader than the work itself, to move beyond formalism up into a critical reading.

And in this analytical responsibility, I will develop a sense of context from the artist or even deduce it myself; the end point is a critical reading. Consider mapping art. In such a work, we in effect have data in the age after grand narratives. This data is linked either to works that present it as is, a mode that I call mimetic and naturalistic and

which exists without adding new information to the work's data map. One example of this is Legrady's *Making Visible the Invisible*, a work which acks any poetic metaphor and presents its data with statistical precision and informational value. This contrasts with Mark Napier's *Black and White*, which takes CNN data and translates it into dots on screen—a pattern translation that we can interpret as more than a mere translation of the data, it adds up to a new creation by the artist. Legrady echoes the data, while Napier presents it within a specific perspective and thereby substitutes its messages with his own.

The contrast between these two works is what I call mimetic-naturalistic versus the poetic-metaphorical. Again, we might ask what, after grand narratives, do we do with poetic expression? Nothing: we just show the data.

FJR: How does this kind of analysis acquire the characteristic of a critical reading?

RS: I connect the phenomenon of mapping to the culture of presence and meaning. While Napier's obfuscating transformation of the data calls for interpretation, Legrady's piece presents the data for their own sake. To put it another way: Legrady's work embraces the data in their pure existence or presence; Napier's gives them meaning through their presentation in a seemingly meaningless way. The former I read as fascination with information as such or respectively as the embodiment of the lack of a privileged artistic perspective after the postmodern end of grand narratives (the narrative is basically reduced to reality as is). The latter, however, can be read in terms of Alan Liu's *Laws of Cool*,[1] in his book on knowledge work and the culture of information. According to Liu cool is a way of looking at information in a nonutilitarian way, it is a way of living in the information age that resists and undermines the fetishism of information. If we agree with Liu that formalism is a necessary approach to information cool, it becomes clear that formalism (e.g., in mapping art) itself is a culture-critical statement (as it was a century ago with respect to classical avant-garde).

Another example: imagine yourself in an interactive installation. Its expressive power is led by your physical actions. If you just engage and do not interpret, this mode of activity directs your attention to the intensity of the moment and favors the materiality of the work. For Lyotard, Barnett Newman's *Who's Afraid of Red, Yellow and Blue* shows the importance *not* of what happens but *that* something happens. This connects directly to Gumbrecht's *Fairwell to Interpretation* in the book *Materialities of Communication*.[2] Gumbrecht argues against Derrida, welcoming at first his critique of phono- and logocentrism and his embrace of materiality but rejecting where Derrida takes this. Gumbrecht prefers that Derrida focuses completely on the material sign of the signifier in the same manner as Lyotard, in his analysis of Barnett Newman and the sublime, claims that we should focus on the material and the intensity of the event rather than assigning meaning to it. For his part, Lyotard favors this because for him, the essence of an artifact is about its presence, not what it represents.

FJR: Yet, how is it possible to focus on the material and intensity of the event distinct without assigning meaning to it? Is that possible without reverting to an empty conceptual distinction? What new media work would have us experience one without the other, and how would such a distinction even be enforced in a material or even conceptual way?

RS: In *Production of Presence*[3] Gumbrecht demands that we not look at any meaning at all, advocating for a culture of presence over a culture of meaning. Whereas the latter wants to know so as to change things, the culture of presence would embrace things as they are, to appreciate something without "taming" it, to use Sontag's term in *Against Intepretation,*[4] through interpretation and rationalization.

I argue for Derrida, and thus view how the interactive installation can seduce us into the paradigm of the culture of presence and how, while it allows us to do something with intensity and to experience ourselves as a body without thinking. As they promote this, the physical overrides the cognitive. Thus I enjoy an experience but do not ask for a deeper meaning. It is thus problematic how the interactive in this mode of embodiment places us within the mode of culture industry, a position that is marked not only by the question whether we are passive or active but whether we *think*. Interactive art like this would collude with the realm of culture industry.

Gumbrecht adopts the romanticism of an almost religious feeling, but we need to construct different signification, we should be *within* the experience of trying to make sense of something by accepting that we don't possess certainty, and thus use one meaning to undermine another meaning. This is in accordance with the notions that in the aesthetic experience the context of an utterance is not as settled as in the social context of normal discourse that acquires a regular automatism and predictability. Most transactions in the world are structured within conventional forms of interaction. But with art, the situation is different, as we realize there are so many ways to read a work in an attempt to make sense of it. This practice is exactly what we need, especially in a multicultural world. If we embrace presence unproblematically, we don't learn to deal with the conflict. Within this larger critical context, close reading is better than huge mega-theories of code; the work of interpretation of artwork is what I am interested in, over the formulation of any single universal model that in effect restricts interpretation.

FJR: Contemporary art criticism accepts installation art as one expressive genre among several. The idea that installations are themselves sites of interpretive tension, seen as belonging either to a culture of presence or a culture of meaning, strikes me as innovative. In new media art, the installation is distinct from its predecessor: it now induces interaction explicitly, a move that is at the heart of the incongruity you describe. Thus the *interactive* installation, unlike its nonresponsive genus in contemporary art, makes explicit and forces open the question of one's consciousness and participation in the dialogue with the work of art. How we decide when confronted by prompts for participation—whether for uncritical immersion or reflective distance—turns on your distinction between the culture of presence versus the culture of meaning.

RS: Yes, but in contrast to mapping art or other screen-based genres of digital art, the interactive installation still has something for us, even if we are not situated in a paradigm of meaning. Installation art induces the compelling feeling of physical engagement with the art. However, while it can occur in the culture of presence, and is in the moment, as in playing with the letters in *Text Rain* or producing a shadow in *Deep Walls*, this is only one moment. Only when you step out of the interaction and revert to the role of spectator can you ask yourself reflectively, what does the interaction the

artist wanted me to engage in mean? Now you have to interpret the applied symbolic and grammar of the interaction, such as in *Deep Walls*, the gradual erasure of the oldest image as a new one appears.

FJR: It bears mentioning that Kaprow's aim with the *happening* was social engagement through confrontation in circumstances of intersubjectivity.

RS: Finding meaning can also emerge in situation where you are required to do something that you don't do in everyday life—it is a kind of alienation or intimidation. Take *Deep Walls* which tells you to do something but doesn't say what that is. You can dance for *Deep Walls*, would you do it if people were around? Maybe people just walk left to right to test the system. It wants you to get out of the box of being rather than of thinking. Whatever you do, you will learn something about yourself, about your own limits. Here the art tells me something about me, independent of the level of meaning. A different example is *Exchange Fields* by Bill Seaman, where I put my limbs in specific places in furniture and video is triggered where the specific body part is featured. This grammar of interaction doesn't require you to do anything funny, to dance, or express yourself. It is interactive in a way that doesn't hurt or demand something from you and thus doesn't reveal your timidness in case you prefer walking left to right over dancing. To that extent, that piece does not work if you don't think, so there is no surplus outside of thinking. People think they've engaged in the work if they've done something with it. Some people think they can fool the system, "check it out," trick it, putting a foot in the place for the head. What has been achieved? Of course, nothing. But now, if you think about what you have to do, You have to immobilize your body in order to trigger a projected dance sequence. You basically trade your own outworn body for the idealized beautiful body on the screen. Isn't that what goes on in our culture, in your TV, in cinema, and the fashion magazine—a trade of your body with their ideal body, with the practical result of dissatisfaction and cosmetic surgery. Such insight is only possible if you think, if you look for the meaning of this grammar of interaction. If you only engage in presence, you will not get anything. In *Deep Walls*, you at least learn about your body's timidity or daring. Even more so with Rokeby's *Very Nervous System*, which is at the other end, for it indicates nothing of what you should do.

FJR: This mutual cancellation is not present in noninteractive installations. Your argument makes evident that interactivity is the central possibility around which the crucial decision of participating, of aligning within a culture of presence or one of meaning seems to revolve.

Notes

1. Alan Liu, *The Laws of Cool: Knowledge Work and the Culture of Information* (Chicago, IL: University of Chicago Press, 2004).
2. Hans Ulrich Gumbrecht and K. Ludwig Pfeiffer, eds, *The Materialities of Communication* (Stanford, CA: Stanford University Press, 1994).
3. Hans Ulrich Gumbrecht, *Production of Presence: What Meaning Cannot Convey* (Stanford, CA: Stanford University Press, 2004).

4. Susan Sontag, *Against Interpretation and Other Essays* (New York: Farrar, Strauss & Giroux, 1966).

Bibliography

Gumbrecht, Hans Ulrich. *Production of Presence: What Meaning Cannot Convey.* Stanford, CA: Stanford University Press, 2004.

Gumbrecht, Hans Ulrich, and K. Ludwig Pfeiffer, eds. *The Materialities of Communication.* Stanford, CA: Stanford University Press, 1994.

Liu, Alan. *The Laws of Cool: Knowledge Work and the Culture of Information.* Chicago, IL: University of Chicago Press, 2004.

Sontag, Susan. *Against Interpretation and Other Essays.* New York: Farrar, Strauss & Giroux, 1966.

CHAPTER TWO

List(en)ing Post

Rita Raley

"The crowd, suddenly there where there was nothing before, is a mysterious and universal phenomenon. A few people may have been standing together—five, ten or twelve, not more; nothing has been announced, nothing is expected."[1] These lines from Elias Canetti's *Crowds and Power* frame Jody Zellen's work of the same name (2002), an illustrative engagement with that magisterial sociological work, as well as a meditation on urban space and interface design.[2] Making heavy use of pop-up windows, a common aesthetic feature at the time, Zellen's work endeavors to produce the crowd through visual framing: as the user navigates the work the interface becomes crowded but notably never illegible, the tiled windows assuming the form of either mosaic or collage that preserves the integrity of both parts and whole.

Zellen has collected images of crowds from newspapers and other media sources, pictures from the archives that themselves constitute an archive. These pictures, along with the hyperlinked word "suddenly," open a series of split screen pictures of the crowd, suggesting an unplanned and unexpected appearance, both spatially and temporally emergent—"the crowd, suddenly there where there was nothing before." "As soon as it exists at all, it wants to consist of more people."[3] The pop-up windows close shortly after they open: "Just as suddenly as it originated, the crowd disintegrates."

We can see in the operation of the pop-up windows a gesture toward instability and emergence in the general sense. Five years on, a shift in computing technologies,

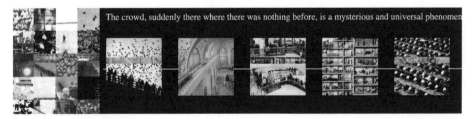

Figure 1. Jody Zellen,
Crowds and Power,
2002,
Website (screen capture).
© 2002, Jody Zellen

production environments, and aesthetics has made algorithmic text generation a more common means of achieving that sense of instability—and these algorithmic works also serve to remind us that there is both a human and machine processing the text. The dataset for these works tends to be fixed, however, and the difference I want to articulate has to do with the use of networked communication—specifically IRC but also SMS—as compositional material. In effect the crowd now provides the dataset that realizes the instability and mutability that might otherwise be simply projected. My essay focuses specifically on *Listening Post*, a multimedia installation that is both a sonification and a visualization of messages posted to more than 5,000 online forums (including chat settings and bulletin boards). Statistician Mark Hansen and sound artist Ben Rubin were issued a challenge from Bell Laboratories—give us a representation of the internet—so to answer the challenge they posed this research question for themselves: what would 100,000 people chatting on the internet sound and look like?[4]

In my analysis, I retain the word "crowd" to stand in for those 100,000 people. Since crowds are equated with modernity and imagined to have declined if not disappeared

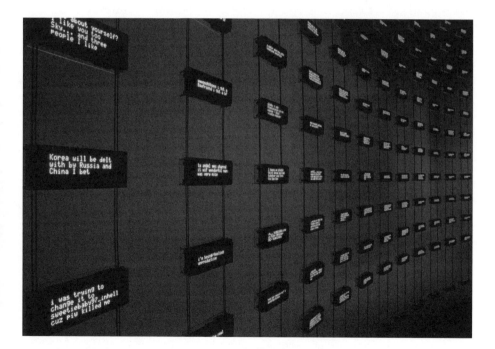

Figure 2. Mark Hansen and Ben Rubin,
Listening Post,
2003.
Electronic installation.
© 2003, Mark Hansen and Ben Rubin.
Photograph by David Allison.
Image courtesy of the artists.

in the post-industrial context, one might ask why I do not speak of virtual communities or electronic gatherings, both forms of a public. Publics share common traits and experiences, being in common. Crowds share physical space. The public is a discourse of intimacy while the crowd is a discourse of strangeness, strangeness rather than modernist estrangement. Moreover, the crowd, in the sense that I am employing it, is both singular and multiple, not based on self-same identity but instead heterogeneous. In order to think about the affects and effects of *Listening Post*, I need to retain one line from Canetti that is also featured in Zellen's new media work: "In the crowd the individual feels that he is transcending the limits of his own person." The barriers separating self and the crowd dissolve in a process not of assimilation but of transport.

Listening Post is at once a post (site) for "listening to the web," an installation comprised of 21 columnar posts (suspended chain-circuit displays), and an algorithmically manipulated series of chat posts (messages). It is postmodern, post-linear, post-print, and to some degree post-literate. It is not then a realist presentation of 100,000 people chatting; rather it utilizes natural-language processing algorithms to parse, filter, and re-present their chat messages. Software agents collect data in near real-time (there is a time delay of 1–2 hours) from the online forums so there is an immediacy to the conversations on display that is reflected in the topical quality of the phrases that emerge in the piece. *Listening Post* is both communicative and aesthetic: as the artists explain, they "have endeavored to create a result which communicates information clearly, yet at the same time sounds well composed and appealing."[5] The emphasis throughout is on intelligibility; it is not a matter simply of voicing each message in a given chat setting, which would be essentially unlistenable, "uproarious babble." The installation is divided into seven movements or scenes: seven sets of display algorithms structure the individual movements of the piece, filtering and organizing data so as to allow for the discovery and presentation of different patterns, signals rather than noise. While the dominant sensorial quality of the first six scenes alternates between the visual and the aural, the last culminates in an operatic synthesis of image and sound, textual script, and musical score. The durational cycle is approximately 20 minutes and throughout, *Listening Post* maintains a tension between viewing and reading, the singular message or voice on the one hand and multiplicity on the other, and this dialectic is never permanently resolved. As they explain, they were able simultaneously to convey "both scale (the impression of multiple voices talking at once) and content (by isolating a single voice, we can hear one person's contribution to the stream of thousands)."[6]

The project's significance is multifold. It is not that it merely satisfies our voyeuristic curiosity, nor does its significance derive solely from its virtuoso technique—lauded as it has been for its visual aesthetic, acoustic design, and statistic engine. Rather, *Listening Post* informs and delights—if you like we can say it has literary value—because it allows us to encounter a social totality in all of its complexity, because it offers up the fantasy of our temporarily situating ourselves as individuals in relation to a dynamic and mutable large-scale community, and because it allows us to become aware that we are performing "polyattentiveness," the dominant mode of data processing in the contemporary moment.[7] In this context, polyattentiveness ups the ante on "reception in a

state of distraction": it requires that we process musical content alongside of visual and spoken words, data streams that are not spatially fixed and that move well beyond the one-dimensional surface of the screen and even the projected three dimensionality of virtual environments such as the Cave.

The form of the installation is distinctive: 231 vacuum fluorescent display (VFD) screens mounted on circuit boards and hung from a curved scaffold. Each of the 231 screens is approximately 2″×6″, their form evoking cash register screens, their green neon echoing stock market tickers, watch faces, news tickers, transport boards—evoking older media, earlier display technologies. "The artists selected this technology because it has a timeless and undated quality that will keep the piece fresh many years hence."[8] En masse, the 231 individual screens produce a circuit board effect that can be linked to our cultural imaginations of the grid, William Gibson's cyberspace, Thomas Pynchon's circuit card, the circuitry at the edge of the fabricated world in the film *13th Floor.* Some of the hardware of the circuits is exposed, reminding us that a user's affective experience of a new media installations is not simply a product of conceptual machinery, but of actual machinery as well. The visual display is only part of the picture of course; it is after all a site for listening that includes spoken text and algorithmically generated piano accompaniment.

The first, third, and fifth movements are predominantly visual. At the outset of the piece, five waves of text wash in from right to left, announcing a fundamental violation of the conventions of the page for Roman alphabets. In the third movement, the pace varies but speed prevents complete comprehension of the 231 messages that scroll from right to left and fill out all of the displays. In both, the text is illegible, a-semantic, the signs purely visual and material. In movement five, four log-in names appear on a single screen, scrolling from bottom to top and from the edges to the center. In some of the movements the text is stabilized either on the vertical or the horizontal axis but on the whole *Listening Post* fundamentally violates the top-centric and left-centric orientations of print. When the text becomes positional—roughly analogous to the shifting of pieces on a game board—the familiar and stabilizing spatial coordinates of print-based reading have long been left behind.

In the second movement, for example, the visual display is initially concentrated in the center columns, then it moves from center to edges and edges to center. The effect is that of the slot machine and the text cannot be read from afar; one has to move in to isolate a single display to read. There are comparisons to be drawn here to visual artists such as Mark Lombardi and Chris Jordan, both of whom work with the interplay between organic whole and individual parts. With *Listening Post*, as with these other visual works, zooming in to read a particular part, a singular data element, means losing a grasp of the whole. They cannot be simultaneously comprehended in part and in whole. Jameson's reading of Nam June Paik's video installations as an illustrative example for the geometral optics of the postmodern aesthetic, practiced by viewers who try impossibly to "see all the screens at once, in their radical and random difference," would pertain in this instance.[9] But just as collage is deemed a "feeble name" to describe the assemblage of discontinuous parts into a whole, so, too, Paik might now be an outmoded example for the new geometral optics produced by split screens and multi-layered visuals that have a spatial, visual, semantic, temporal, and aural register.

Hansen and Rubin's commentary will allow us to pursue further the question of epistemological difference:

> While it is beyond our capabilities to grasp the millions of simultaneous transactions taking place on the Internet, it is of compelling human interest to make sense of such environments in the large, to grasp the rhythms of our combined activities, of our comings and goings. Our inability to orient ourselves or otherwise fully perceive a larger environment is not a phenomenon unique to the virtual world. As communication and transportation technologies accelerate our movements and interactions, the spaces we live in are receding from our ability to directly sense them.[10]

In both Paik and *Listening Post*, the principle of sensorial overload and cognitive disorientation remains the same. The effect of reception may not differ but the effect of production does: the data that feeds Paik's video installation—and installations like it—is pre-recorded and forms a closed circuit. The content streams for *Listening Post* are live, filtered but also random and unpredictable, and therein lies the epistemological difference.

And, indeed, this installation is not strictly about the visual field but part of a broader turn to the multi-sensorial. In the second scene we first encounter the synthesized TTS (text-to-speech) engine, which speaks out phrases such as "we have to be smarter than the terrorists"; "he could be my son"; and "I like to be descriptive in my words." The sound moves from discrete words to surround sound and total cacophony as the TTS streams overlap. The mesmerizing and hypnotic qualities of the synthetic voices become clearly manifest, the sound of the work occasionally taking on what I hear as the cadence of a Gregorian chant. The fourth scene also makes significant use of positional and multi-layered sound. The trajectory of this section is roughly from singular spoken words, to overlapping voice streams, to positional sound that produce echoes. (Each word is played through a different speaker; in the latest installation, nine speakers are used.) At this point in the durational cycle of the piece, the user can clearly discern the extent to which both motion and font size are used to articulate and project volume. What is removed from her is the origin both of the utterances—we never know who is speaking—and of the sounds themselves, the source, cause, or emitter of which is not visualized. These are acousmatic rather than visualized sounds, to use the terms of Michel Chion, "sounds one hears without seeing their originating cause."[11] The acoustic and visual fields of the installation are thus semi-autonomous: the acoustic field is not strictly dependent on what we see just as the visual field is not strictly dependent on what we hear.

The physical density that Canetti articulates as one of the primary features of the crowd is captured in the layered voices and use of positional sound: density is achieved via cacophony as the listener has the sense of being physically surrounded, of being absorbed into the structure of the work. The crowed here is created acoustically rather than physically. Chion's reading of the use of sound in the street scenes of *Blade Runner* is apposite here: "in some of its crowd scenes a typical shot will contain very few characters, while on the soundtrack one hears a veritable flood of humanity . . . The effect

of pullulation created in this manner is actually stronger and more convincing than it would be if people were massed in the frame to 'match' the numerous voices" (191).

Hansen and Rubin speak of the acoustic goals of their work:

> The advent of online communication has created a vast landscape of new spaces for public discourse: chat rooms, bulletin boards, and scores of other public on-line forums. While these spaces are public and social in their essence, the experience of "being in" such a space is silent and solitary. A participant in a chat room has limited sensory access to the collective "buzz" of that room or of others nearby—the murmur of human contact that we hear naturally in a park, a plaza, or a coffee shop is absent from the online experience. The goal of our project is to collect this buzz and render it at a human scale.[12]

What I have not yet directly acknowledged is that the buzz, the messages from bulletin boards and other chat settings, is unsolicited. This is private data made public—not precisely private in the sense that the IRC messages are culled from boards and other chat settings—but they are private to a particular community. But this interception of communicative signals for the production of art is an instance of surveillance turned back on itself, one analogy for which would be a guerrilla surveillance art practice such as video sniffing, that is, picking up signals from wireless CCTV networks with a cheap video receiver. *Listening Post* invites us to think about it in terms of both surveillance and voyeurism in the sense that we are looking at and listening in on private, local, often intimate messages that have been appropriated for a gallery installation. More precisely perhaps, the strata of public and private are collapsed in a work that filters according to constraints and strips away all sense of context and situatedness, whether regional or subjective. What remains is something like the Google Zeitgeist: a mass of subjective articulations that masquerades as collective consciousness. Listening to the crowd means confronting a cacophony created by overlapping voices; a density of acoustic layers; and the problem of extracting coherent meaning—either a single data stream or a single line on a bar graph.

In that Hansen wrote the set of instructions (algorithms) for the collection and sorting of data, *Listening Post* can be read in the context of the "aesthetics of administration" particular to the work of artists such as Sol LeWitt and Andy Warhol—except that in this instance, production tasks are delegated to computational machinery rather than to a team of workers, rendering the distinction between manual and intellectual labor as a distinction between machinic and human cognition. We thus need to consider *Listening Post* as a virtuosic statistical work. All of the movements are structured by constraints common to the field of data analysis: character length, frequently and least frequently used words. In the pivotal middle movement, for example, the algorithm pulls the least common words from a data set of approximately 100,000 real-time messages, producing a list that appears at once quite common and quite random—exceptions that tell us something interesting and important about the whole data set. The effect is synthesized spoken-word poetry: fate, squeeze, exists, multiply, oxymoron, matrix, costume, abs, vibration, institutes, expensive, scale, homemade. Scene six works with four-character groupings. Its aural quality stems not from TTS but from the ticking of the displays, evoking transport schedule displays and stock market tickers. The four-character

words scroll downward and then fade upward; they appear and then disappear. Here one encounters words and acronyms, occasionally misspelled, usually but not always in English: "skip only pity / feel wont trek / good evil milf / hace sata." In an algorithmically generated work that uses linguistic constraints one can clearly see the two historical tracks that inform literary uses of computational media: the history of programming on the one hand and experimental writing practices such as Dadaist cut-ups and the techniques of Oulipo on the other. *Listening Post* began as an acoustic and statistical work but in the process of developing it they discovered a poetic as well.

The idiom and the content make it clear that *Listening Post* does not represent a strictly local population. The predominant use of English might seem to point to a more narrow demographic than "the global community" but it must first be noted that the linguistic constraints of the project are those of natural language processing, which has since its inception taken English as its default. The more significant point is that the English on display is a kind of electronic English, which is not necessarily geographically situated, nor is it necessarily the idiolect of a certain class or institution (its features are Leet-speak, acronyms, and the alphanumeric codes of IRC communications). With *Listening Post*, then, we have not just one audience but many, not just one community but many.

What is the significance of a text—visual, verbal, or acoustic—that makes one wonder what the signboards are, that will not allow access, that renders itself illegible? Such texts are quite common in the field of electronic literature: they throw into perplexity our sense of how symbolic structures work, how they are organized. They require the reader, listener, or viewer to create her own hermeneutic architecture and in this sense make explicit the act of interpretation that goes into the analysis of any text. But they also speak to a certain doxa about the information society: information overwhelms the sensorium because we have been inaugurated into a different, implicitly more basic, mode of processing information. Thus do we see Talan Memmott's "Lexia to Perplexia" employ the trope of interference and Young-Hae Chang Heavy Industries test the limits of our visual perception in "Rain on the Sea."[13] In some sense this is the state of the field: writers and artists want to push eye, ear, and machine to their limits. But this is not to suggest a distinction between contemplative reflection (print) and distraction (new media). Rather, we read, view, and listen to new media works such as these in a state of distraction, whereby cognitive engagement is neither conscious nor apperceptive but based on an interplay between the two. *Listening Post* is paradigmatic in this sense: one pays due diligent attention but some of the semiotic structures are so manifest as to be interpreted without the reader/viewer ever becoming self-conscious about that interpretation. Moreover the speed of some of the textual movements, like the Young-Hae Chang, both command attention to reading and refuse over-attention: neither allows for the structured, controlled mode of reading that we have historically designated as literary.

Over a decade of thinking about the work of reading electronic literature and thinking about the work involved in that reading has led to many theories of reading practices that involve doing things. From Ted Nelson on hypertext as that which branches or performs on request to Espen Aarseth on the ergodic text as that which requires a nontrivial work from the reader, we have complimentary accounts of navigating gestures and theories of navigation as labor. But what labor, and what interactivity, is required in order to view, read, listen to *Listening Post*?[14] The installation almost always

includes chairs, highlighting the extent to which it encourages stillness; contemplative, reflective reading and listening; even meditative absorption. We might then compare the sedentary qualities of "reading" *Listening Post* to Bruno Nadeau and Jason Lewis's *Still Standing*, a work that takes a stand against motion.[15]

Nadeau and Lewis's installation features a series of poetic texts that require the viewer's immobilization in order to be read: specifically, the stillness of the viewer's body causes the projected text to assemble as if attracted to a magnet. "The participant can then enjoy a motionless moment and contemplate the textual content that becomes more and more legible." On the face of it, *Still Standing* seems to require cognitive rather than physical engagement, thus rendering stillness as an integral feature of reading. But there is an important paradox here: standing still asks for physical movement that we might even call rigorous; after all, it takes a certain strength and muscular control to remain motionless. Standing still, still reading, are still bodily—and an analysis of *Listening Post* must necessarily emerge from machinic production, textual content, and somatic response.

The seventh movement of *Listening Post*, its operatic climax, uses another primary dataset: from the last 100,000 messages surveyed, 85 beginning with I am/I like/I love (in alternating durational cycles) are selected and sorted by length. The syntactic constraints are such that one hears and reads the assertion of preferences (taste, habit, distinction), identity (situatedness), affect and emotionality. In this, the longest movement, rhythm and volume are variable; at moments it seems to wind down and come to a kind of conclusion; at others it intensifies, but it never becomes overly frenetic. The individual phrases are not always discernible aurally partly because of typos ('I like my breats perky') but a clear sense of the Other and of community emerges. A representative sample:

I am 16
I am stupid
I am a vegetarian
I am looking for love
I like to masturbate and torture small animals
I love French onion soup
I love Curt Donald Cobain!!!

Wonder and delight, disgust and repulsion: such is the range of the affective register produced by *Listening Post*. Here we can point to Teresa Brennan's study of the

Figure 3. Bruno Nadeau and Jason Lewis,
Still Standing,
2004,
Electronic installation.
© 2004, Bruno Nadeau and Jason Lewis.
Image courtesy of the artists.

transmission of affect as "a process that is social in origin but biological and physical in effect," the transmitted affects notably coming from interactions both from the environment—from the work itself—and from other people in the room.[16] The wave of positive almost euphoric feeling that washes over the listeners is, as is the data represented, mutable. It is impossible to stabilize the mood, the sentiment, the affect of this piece, just as it is impossible to stabilize the mood of the Web. The pleasure of the quotidian, the amusement of the odd—these can quickly be superseded by mistrust and distaste as viewers gasp, laugh, and recoil from the articulations of self and desire. The synthetic voice strips out tone, which is invisible in written language and requires a live voice to animate it and bring it to the surface. How, then, are we to interpret the phase "I like Palestine"? Is this ironic? Vehement? Even noncommital? How do we respond to such a sentiment of moderation, particularly when it is voiced without tone?

What Hansen and Rubin have given us in *Listening Post* is a startling and provocative visualization of a collective, of community, on the one hand, and individual affect on the other. It may intuitively seem to be the case that large-scale, multi-user SMS works evoke or produce the more powerful notion of community (given that they feature active collaboration and participation), but in fact it is the unsolicited messages in *Listening Post* that give us something larger—more hopeful and possibly more disturbing all at once. After all, one moment may be "I like peach pie" and the next "I like to masturbate and torture small animals." It simultaneously invites recognition and identification—"I am a vegetarian," too—and the refusal of identification—some of these desires are wholly other to me, illegible and incomprehensible. Part of the sensation is attributable to the liveness, the near-synchronicity of the data: even with the hour-long delay one still has the sense that somewhere, out there, the author whose words we read is at her terminal, "looking for love." On the one hand the individual listener is stationed before the work, but on the other, the sensorium is so bombarded that one becomes caught up in the work and in the crowd.

A sense of liveness, perpetual and perceptual presence, is also achieved through the syntactic and syntagmatic form of the list. Lists produce an insistent, even manipulative sequentiality, but they also establish an interplay between the individual and the cumulative whole, the dynamic relations between the singular item, unit, or object on the one hand and the archive or database on the other. Lists, too, offer an accelerated and compressed temporality: why else should Jameson's list of postmodern works come in the form of a manic citational list (Robert Venturi, Godard, Talking Heads, Gang of Four, Pynchon, John Ashbery, all at once, the postmodern situated in the perpetual present). A corollary here is Chris Mendoza's software piece, *Every Word I Saved* (2006), which, as its title suggests, displays every word the artist saved to his hard drives from 2000 to 2006.[17] The words are harvested from text documents, email messages, and IMs and then alphabetized; original capitalization is retained but otherwise content is stripped away, again rendering six years of work in a perpetual present. On the other hand, however, lists are about belatedness, which is to say that the effects of the lists are after effects. This is certainly the case for *Listening Post*, the words and phrases echoing in the mind for days and even months after viewing the work. It is as I have suggested difficult to identify a stable affect in the texts on display without context and a tonal register, but a kind of affect is produced both in the

on-site processing and in the belated processing, the encounter one has with strains of affect that have lingered and encrusted themselves in the memory.

There are at least two meanings or registers of the list: the first is that of collection and archiving, its province that of the personal and the cultural. The second is that of aggregation and complexity, each item not additive but transformative. *Listening Post* makes the relentless sequentiality of the list aesthetic, hypnotic, mesmerizing (here we must certainly think of John Cage). It also participates in a long-term tradition of literary lists and using lists to produce aesthetic effects, notably encompassing *Ulysses'* "Ithaca" chapter and Raymond Queneau's "Cent milles milliards de poémes" (1961), and in our current moment we might note Mark Z. Danielewski's *House of Leaves* and his recent *Only Revolutions*, with its user-generated lists of important events in the twentieth century. But *Listening Post* also works with the second register of the list in that each word, each phrase, is transformative of the whole. *Listening Post* brings disparate posts into some form of intersection and synthesis. In that intersection, something else is created that exceeds those discrete posts. The intersection of discrete posts forms a strange kind of community, one that is mobile, fluid, dynamic.

Hansen and Rubin speak specifically about community in their commentary on *Listening Post*. It is a representation of user activities online and there is a certain emphasis on the viewer/listener experience of the data, but more broadly, the project is an "attempt to characterize a global dialogue, integrating political debates, discussions of current events, and casual exchanges between members of virtual communities."[18] Further, they explain, "a byproduct of our Web traffic sonification is the creation of a kind of community from the informal gathering of thousands of visitors to a given Web site."[19] But what kind of community is this exactly? We have seen already that it provides an interplay between univocality and frenetic babble, the virtually unintelligible murmurs of the crowd. It is also a community without community, a community based not on self-same identity (blood or soil) or consensus but heterogeneity and dissensus: in this respect it is an ideal figure for new media theorists who endeavor to articulate "virtual community" in non-idealist terms.[20]

Many media artists have sought to break the closed-circuit networks of IRC and SMS communication by inviting visitors to contribute text, to make private speech public. Such performance spaces are exterior to the gallery, mobile and unframed. SMS projects in particular tend to be "designed for crowded public spaces"—bridges, street corners, public squares—their use of building facades as projection screens signaling a shift away from framed and static screens to practices of mobile and locative media. SMS projects are designed for crowd participation but *Listening Post is* the crowd, or least a representation of the crowd. The grid display in this respect functions as a visual metaphor for large-scale community and collectivity. Here we can think literally of the relay clicks, which make the searching of tens of thousands of messages materially audible; the use of positional sound; and the aural cacophony of many of the movements of the piece, all of which produce a sense of being physically and psychically crowded. CGI has situated the crowd as the predominant visual figure of our moment—the crowd is the figure by which one proves the mettle of the application and of the designer— and we can learn something from these representations. Think of *Ratatouille* or *300*: the computer-generated crowd is at once a singular entity and locally defined and

detailed. In other words, this crowd is not the same as the fascist crowd, which thinks in common and becomes a mob. A shared social context inevitably leads to patterns, thematic threads, topic clusters—celebrity, sex, food, war, politics—but the crowd of *Listening Post* does not act, perform or present as a unified whole. We might also be accustomed to thinking of the crowd as a violation of the sanctity of the individual and of individuation—such is the threat of the Matrix and of films such as *I, Robot*. But the crowd of *Listening Post* is marked not by its unity but by its internal differentiation and mutability. Its mutability and dynamism is partly a consequence of the use of real-time data but we might also venture further to say that what we see on display is unpredictability, non-programmed thinking.

To understand the community presented in and constituted by *Listening Post* we need to think in terms of the crowd in order to convey the sense of presentation, monitoring, surveillance. The crowd is that which one surveys, represents, assesses—yet it is also that which invites transport, the "transcending of the limits of one's own person." Our connections and affinities with it may be fleeting and temporary, but no less powerful and productive for being such. *Listening Post* makes significant contributions to the fields of sound and new media art but it does not offer us an abstract and abstracted aesthetic experience; instead it quite distinctly offers us an "ear to the ground," a window looking out on to the crowd through which we can see, hear, and encounter the foreign and the familiar. It is, finally, paradigmatic for how I understand the work of the digital humanities for its text analysis; its mobilization of live content; its emphasis on multi-sensorial engagement, of which semantic processing would be one component; and its gesture toward polyattentiveness, a mode of cognition that is and yet is not available to us.

Figure 4. Mark Hansen and Ben Rubin,
Listening Post,
2003,
Electronic installation.
© 2003, Mark Hansen and Ben Rubin.
Photograph by David Allison.
Image courtesy of the artists.

Notes

1. Elias Canetti, *Crowds and Power* (New York: Farrar, Straus and Giroux, 1984), 16.
2. Zellen's work was the portal for the Whitney Artport site in October 2002 and was also published in *The Iowa Review Web* (December 2002); it is currently available from http://www.ghostcity.com/crowdsandpower/. Zellen notes that *Crowds and Power* is part of a larger work on urban spaces, *Ghost City* (1997–2006).
3. Canetti, *Crowds and Power*, 20.
4. *Listening Post*. http://www.earstudio.com/projects/listeningpost.html
5. Mark Hansen and Ben Rubin, "Babble online: Applying statistics and design to sonify the Internet," International Conference on Auditory Display (2001), vol. 5, http://stat.bell-labs.com/who/cocteau/papers/pdf/rubin2.pdf.
6. Mark Hansen and Ben Rubin, "Listening Post: Giving Voice to Online Communication," International Conference on Auditory Display (2002), vol. 1.
7. Merce Cunningham: "The logic of one event coming as responsive to another seems inadequate now. We look at and listen to several at once." Quoted in Daniel Belgrad, *The Culture of Spontaneity: Improvisation and the Arts in Postwar America* (Chicago, IL: University of Chicago Press, 1998), 161.
8. http://www.nytco.com/pdf/Moveable_Type.pdf (accessed on February 2, 2009).
9. Fredric Jameson, *Postmodernism; or, the Cultural Logic of Late Capitalism* (London: Verso, 1996), 31.
10. *Ear to the Ground: Hearing Movement and Change in the World*, http://web.archive.org/web/20030901145300/cm.bell-labs.com/cm/ms/departments/sia/ear/index.html (accessed on February 2, 2009).
11. Michel Chion, *Audio-Vision*, trans. Claudia Gorbman (New York: Columbia University Press, 1994), 71.
12. Mark Hansen and Ben Rubin, "Listening Post: Giving Voice to Online Communication," 4.
13. See Talan Memmott, *Lexia to Perplexia*, http://collection.eliterature.org/1/works/memmott__lexia_to_perplexia.html and Young-Yae Chang Heavy Industries, "Rain on the Sea," http://www.yhchang.com/RAIN_ON_THE_SEA.html (accessed on February 2, 2009).
14. Erkki Huhtamo, "Trouble at the Interface, or the Identity Crisis of Interactive Art," www.MediaArtHistory.org (2004), http://193.171.60.44/dspace/bitstream/10002/299/1/Huhtamo.pdf (accessed on February 2, 2009)
15. http://www.keenk.com/papers/inter-inactivity.pdf (accessed on February 2, 2009).
16. Teresa Brennan, *The Transmission of Affect* (Ithaca, NY: Cornell University Press, 2004), 3.
17. Chris Mendoza, *Every Word I Saved* (2006), http://www.matadata.com/projects.php?id=1 (accessed on February 2, 2009).
18. Mark Hansen and Ben Rubin, "Babble online: Applying statistics and design to sonify the Internet," 3.
19. Ibid., 3.
20. See, for example, Geert Lovink and Ned Rossiter, "Dawn of the Organised Networks," *Nettime* (October 17, 2005).

Bibliography

Auslander, Philip. *Liveness: Performance in a Mediatized Culture.* New York: Routledge, 2008.

Belknap, Robert E. *The List: The Uses and Pleasures of Cataloguing.* New Haven, CT: Yale University Press, 2004.

Belgrad, Daniel. *The Culture of Spontaneity: Improvisation and the Arts in Postwar America.* Chicago, IL: University of Chicago Press, 1998.

Brennan, Teresa. *The Transmission of Affect.* Ithaca, NY: Cornell University Press, 2004.

Canetti, Elias. *Crowds and Power.* New York: Farrar, Straus and Giroux, 1984.

Chion, Michel. *Audio-Vision.* Trans. Claudia Gorbman. New York: Columbia University Press, 1994.

Crary, Jonathan. *Suspensions of Perception: Attention, Spectacle, and Modern Culture.* Cambridge, MA: MIT Press, 1999.

Crystal, David. *Language and the Internet.* Cambridge: Cambridge University Press, 2001.

Currell, Sue. "Streamlining the Eye: Speed Reading and the Revolution of Words, 1870–1940." *Residual Media.* Ed. Charles Acland. Minneapolis, MN: University of Minnesota Press, 2007, 344–360.

Danielewski, Mark Z. *House of Leaves.* New York: Random House, 2000.

Gibbons, Carey. "The Listening Post." *Museo* 6. http://www.columbia.edu/cu/museo/6/hansen_and_rubin/index.html (accessed on February 2, 2009).

Hansen, Mark and Ben Rubin. "Babble online: Applying statistics and design to sonify the Internet." International Conference on Auditory Display (2001). http://stat.bell-labs.com/who/cocteau/papers/pdf/rubin2.pdf (accessed on February 2, 2009).

—. "Listening Post: Giving Voice to Online Communication." International Conference on Auditory Display (2002). ftp://cm.bell-labs.com/cm/ms/who/cocteau.old/icad.pdf http://stat.bell-labs.com/who/cocteau/papers/pdf/rubin2.pdf (accessed on February 2, 2009).

Jameson, Fredric. *Postmodernism; or, the Cultural Logic of Late Capitalism.* London: Verso, 1996.

Lovejoy, Margaret. *Digital Currents: Art in the Electronic Age.* New York: Routledge, 2004.

Queneau, Raymond. "Cent milles milliards de poémes." Paris: Chapitre/Gallimard, 1961.

Vesna, Victoria, ed. *Database Aesthetics: Art in the Age of Information Overflow.* Minneapolis, MN: University of Minnesota Press, 2008.

Post-Chapter Dialogue, Raley and Ricardo

FJR: Polyattentiveness, as advanced in this essay, is a conceptual originality that fittingly describes one's being in the present historical moment; it connects to your photograph of society's incessant "reception in a state of distraction," requiring "that we process musical content alongside of visual and spoken words"—this harmonizes entirely with the notion of transmodality that I've found elsewhere, where the idea of "message" that is central to Roman Jakobson's model of language function, as a discrete entity passing through a single medium or container to a definite reception target, has been displaced by the separation of content out into an assumptive compound, a conglomerate of modalities that it penetrates in search of an optimal path of its expression but able to move through various such paths simultaneously. As an archetype, this notion seems generative: can we also imagine polyvisuality, polytextuality, polynarrativity, polytemporality, and polylocativity as dimensions of analysis of the new media art work, a phenomenon not exhausted by a definite route or region of representation?

RR: I borrow the term "polyattentiveness" from Merce Cunningham.[1] What I appreciate about the term is that it suggests a cultural and behavioral, rather than neurobiological, understanding of attention and distraction. At least in my own work, I feel on safe ground with a concept that speaks to subjective perception rather than empirical fact and to an implied rather than empirical audience. I realize that there are researchers in cognitive science who are thinking about, and working toward, an understanding of attention in neurobiological terms, but this does not obviate the need for cultural analysis. Polyattentiveness also suggests correlation rather than strict causality; in other words, it is not necessary that we adopt a determinist perspective in order to think about the way that the user receives a work such as *Listening Post*. Certainly it is too much to say that a particular work or even device causes us to behave, think, and read differently but we can say that a particular work is illustrative and symptomatic of changes that have already occurred *and* that it gestures toward changes that are still to come. In other words, we may not now have the mode of cognition adequate to a "full" processing of *Listening Post*—whatever that might entail—but who is to say that we may not in the near future, at least in that we are continually in the process of adapting to new interfaces and new sensorial experiences.

To speak directly to the question of polyvisuality, polytextuality et al as dimensions or components of analysis, I would point first of all to the very exciting work produced by *Vectors: Journal of Culture and Technology in a Dynamic Vernacular*, which has done much to foster a "born-digital" critical rhetoric.[2] If criticism without a linear style of argumentation is ever to become paradigmatic—the singular data stream implied by your question—then I think certainly it will have to be in a medium that allows for the layering of different data types. Notwithstanding the rich traditions of annotation, footnoting, and illustration, print does have obvious limits in this regard. At any

rate the topic before us is critical writing that is both analytical and multiple and here I would point to the difference between critical analysis and the art work. However much we might hope for a mode and platform for critical writing that would duplicate the experience of viewing an art work, I would not wish criticism to forego its discursive analytical function.

FJR: Three anomalies in *Listening Post* bear reflection. First, this work, which is not rhapsodic or narratival, and doesn't depend on any sort of temporally unfolding content, is nonetheless structured into seven movements. Secondly, the content of the work comprises, as you make evident, "private data made public"; it is text destined, but not intended, for mediation through an artwork installed within the hermetic conditions of a gallery. Lastly, the work's configuration as a two-dimensional grid of equally spaced displays challenges the destructured and asymmetrical spontaneity of its subject, which is the emergent polyphony of the internet. Transposing written text into sound displayed over a field of optical phenomena, as does *Listening Post*, is one of the practices alluding to what you indicate, namely, that works like this in electronic literature "throw into perplexity our sense of how symbolic structures work, how they are organized." Is this symptomatic of a larger spirit of intersection and synthesis, terms that you correctly pinpoint as important operations in this work?

RR: Your articulation of a tension between structured and unstructured data takes us to the heart of the practice of data visualization, which is precisely that: the filtering of masses of data into perceptible patterns, whether they be aural, visual, or lexical. But, from a different perspective, data visualization does not simply make patterns out of nothingness, or structure out of chaos, but it identifies or reveals the structure that already exists in a dataset. In other words, its project is pattern recognition, the discovery of hidden semantic structures. (*Many Eyes* provides a good overview of different visualization techniques.[3]) Data visualization also allows for multiple, simultaneous perspectives, a point that nicely connects with our exchange above.

I do think that the reading practices required by *Listening Post* are paradigmatic for digital literature, precisely in that the reader/viewer is often overwhelmed in her search for meaningful signifiers or at least is uncertain about how to construct a meaningful narratological, poetic, or even symphonic structure around it. Like *Lexia to Perplexia*, another work of digital literature that I cite and greatly appreciate, *Listening Post* takes away our certainty and surety in reading: they are partly legible and yet they withdraw any semiotic certainty. Again, it does not need to be this way; we could be inaugurated into different practices of reading, viewing, and listening, such that the polytextual, polyvisual, polyphonic aspects of the work might seem quite ordinary. In other words, its perplexity is only such in relation to conventional symbolic structures.

Notes

1. Quoted in Daniel Belgrad, *The Culture of Spontaneity: Improvisation and the Arts in Postwar America* (Chicago, IL: University of Chicago Press, 1998), 161.

2. http://www.vectorsjournal.org/
3. http://manyeyes.alphaworks.ibm.com/manyeyes/

Bibliography

Belgrad, Daniel. *The Culture of Spontaneity: Improvisation and the Arts in Postwar America.* Chicago, IL: University of Chicago Press, 1998.

CHAPTER THREE

Strickland and Lawson Jaramillo's *slippingglimpse*: Distributed Cognition at/in Work[1]

N. Katherine Hayles

From where, then, does our feeling of beauty come? From the idea that the work of art is not arbitrary, and from the fact that, although unpredictable, it appears to us to have been directed by some organizing center of large codimension, far from the normal structures of ordinary thought, but still in resonance with the main emotional or genetic structures underlying our conscious thought.

René Thom, Structural Stability and Morphogenesis

A significant body of work in the late twentieth and twenty-first centuries has focused on the distributed nature of cognition. Neurophysiologists, for example, Antonio Damasio, have emphasized that cognition includes emotions and feelings, extending beyond the neocortex and indeed beyond the central nervous system to the viscera and other areas of the body. Anthropologist Edwin Hutchins and neuro-philosopher Andy Clark have pointed to the ways in which cognition is enhanced and extended beyond body boundaries by everyday artifacts, from pencils to computers, that interact with bodily capacities to create extended cognitive systems. In analyzing how these extended cognitive systems work, researchers frequently draw on the cybernetic paradigm of recursive feedback loops uniting components into a dynamic and enactive system that includes both human and nonhuman components.

Applied to literary works, this approach encounters two troubling problems. First is the traditional association of feedback loops with a disembodied and decontextualized idea of information, a legacy from the early days of cybernetics when Claude Shannon declared that information has nothing to do with meaning. Second is a long tradition of associating literature with the decoding of words, as if it were solely a linguistic artifact without connections to the body beyond conscious thought. Neither of these tendencies, of course, is absolute. Donald MacKay and Edwin Fredkin, among others, have argued for an embodied and contextualized theory of information, and many literary critics have emphasized reading as a whole-body activity that involves breathing rhythms, kinesthesia, proprioception, and other unconscious or nonconscious cognitive activities. Still, the tendency persists to regard literature as an imaginative enterprise that begins with the conscious association of sound with mark (although certainly it does not end there).

The transition from print to electronic literature has rendered these problems acute, for electronic literature, with its diverse multimodal interfaces, challenges traditional ways of understanding how, where, and with what capacities we read. In digital media, reading partakes irreducibly of synesthesia, as sound, vision, haptic responses, kinesthesia, and proprioception work together to create complex sensory/cognitive experiences. Moreover, these experiences occur through the mediation of intelligent machines, resulting in the further in-mixing of human and nonhuman cognitions. We are only beginning to devise theories adequate to cope with these complexities. Fortunately, those of us interested in crafting theoretical frameworks for electronic literature have an increasingly deep and varied corpus of works to guide and instruct us.

My tutor text to engage the ways in which distributed cognition is being imagined and instantiated in contemporary electronic literature is *slippingglimpse*, a digital kinetic verbal-visual collaboration between Stephanie Strickland, a prize-winning poet, programmer Cynthia Lawson Jaramillo, and videographer Paul Ryan. *slippingglimpse* unfolds through ten sections, each consisting of one of Paul Ryan's videos of moving water, which are incorporated using Flash video format within the work's Flash files. The videos are dynamically associated with a poem text in each of three possible views: high resolution, full screen, and scroll text view. In the first two views, the words and phrases from the poem text appear in the image. In the scroll text view, the poem text, in addition to appearing in the image, also appears in its entirety below the image, where the reader can choose to scroll or stop it. *slippingglimpse* exemplifies how a work of electronic literature may respond to the two problems noted above. It is located within philosophical, technical, and aesthetic contexts that create a richer sense of information than the disembodied version that emerged from early cybernetics. Moreover, it both requires and meditates upon multimodal reading as a whole body activity. To see how the work explores what reading might mean in digital media, we can approach it along three major axes of interpretation: structure, dynamics, and modes of interaction.

The basic structure *slippingglimpse* enacts is a three-fold recursive cycle between human and nonhuman cognizers. We can begin our analysis with the moving images of water, filmed by Paul Ryan off the coast of Maine. Ryan's inspiration for his video images comes in part from René Thom's analysis of chaotic systems in *Structural Stability and Morphogenesis*. Whenever turbulent flow occurs—in crashing waves, bubbling streams, waterfalls, white water rivers—certain patterns are likely to appear amidst the continuing changes. This kind of chaotic behavior can be modeled as a trajectory in phase space that is unpredictable but nevertheless is contained within a constrained area, popularly known as a strange attractor. To describe these recurring patterns, Thom uses the term "chreod," a word his friend and associate, C. H. Waddington, coined from Greek roots meaning "necessary path." In his videography, Ryan sought out chreods and enhanced them through a variety of techniques, including timing, reverse direction, repetition, and the negative art of inverting color and brightness. The videos incorporated in *slippingglimpse* show the chreods in dynamic interaction with unpredictable flows, giving an impression of constant change that nevertheless is not merely random. Rather, the interactions manifest a complex order that can be grasped intuitively if one watches the moving images long enough.

As the user quickly becomes aware, she is not the only cognizer reading the water. Also at work is an algorithm that looks for color changes within the moving images; when the color change extends over a number of pixels, that location is tagged and randomly matched with a word or phrase drawn from the accompanying poem text situated below the image. The chosen phrase is then transcribed onto the image, where it grows or shrinks and also rotates along the plane of the screen, further enhancing the impression of ordered but unpredictable changes. The poem texts themselves are in part found language, selected and fashioned from interviews of photographers and/or programmers about their work. The concatenation of the poem text, video images, and algorithmically generated words in the images comprise a recursive system of three interacting feedback cycles. In Strickland's notes on the piece,[2] she comments that "the water reads the poem text, the poem text reads image/capture technologies, and, completing the loop, image capture videography reads the water—in particular, reading for chreods."

That there are three major components in these feedback cycles is not accidental. Ryan, inspired by ideas articulated by cyberneticist Gregory Bateson and the semiotics of C. S. Peirce, has done extensive research into what he calls "threeing." The basic idea is that whenever three people get together, there is a strong tendency for two of them to form a dyad and exclude the third person. Bateson believed that this exclusionary tendency was a formidable obstacle to expanding creative collaboration beyond the

Figure 1. Full Screen with High Resolution.

dyad. Ryan accordingly devised a system for training people to interact productively in groups of three or more; the core technique is to have them rotate between the three positions of initiator, respondent, and mediator (terms that have much in common with Peirce's "firstness," "secondness," and "thirdness") so that the dyadic symmetry is broken and all three positions are validated. In one version, he shows how a single person can occupy in turn each of the three roles through a video feedback system. The three components of *slippingglimpse* instantiate a similar system through recursive feedback loops between the algorithm-selecting words to be displayed in the moving images of the water, the text which can also move when in scrolling mode, and the image-capture technology of Ryan's videography showing water in motion.

That these recursive feedback loops are interpreted as "reading" raises significant questions about the act of reading, including what cognitions may count as reading and what relationships obtain between reading and language. Here structure and dynamics interact, for part of Thom's methodology in *Structural Stability and Morphogenesis* involves mapping chaotic motion onto a topology representing a two-dimensional slice through the phase space of the strange attractor. Motions through space are thus transformed into spatial surfaces. Thom further suggests that this topological method can be used to study language. Syntax in this view represents the speaker's motion through a linear stream of language; syntactical relationships can then be represented as topological surfaces. Through this approach, Thom suggests, one can compare verbal language with other forms of communication, for example, gesture, because both can be translated into the common denominator of topological form. Verbal discourse represents one possible dimension of language, but many other dimensions are possible as well.

The great advantage of topology over, say, traditional grammar as an analytical method is that it can be used to represent even high-dimensional forms, or what Thom called multidimensional languages. Reading in this view extends beyond decoding written symbols to any theoretical method capable of generating topological surfaces. In this context, it is not merely a metaphor to say that the videography "reads" the water, for the videography, including the initial image capture as well as the techniques Ryan used to enhance the visual perception of chreods, amounts to an analysis of complex surfaces by representing them as video images. Similarly, when the algorithm analyzes color changes within the image, that too amounts to a form of topological "reading," which is then correlated with the selection and positioning of words from the poem text in the image, where they become available for a form of reading by the user. Since the words are in motion, however, this recuperation back into verbal language can never be simply a decoding of written symbols, for the user necessarily perceives the motion of the words as they rotate, grow, and shrink, tracing through their movements another topology overlaid onto the topologies created by the images of moving water surfaces.

Having seen how the feedback loops between structure and dynamics operate, we can now turn to consider the modes of interaction that the work offers to the user, as well as the kinds of interactions that occur between human cognitions and the non-human cognitions of intelligent machines (leaving aside for the moment the question whether intelligent machines can cognize). Here we can engage in something that approaches traditional literary criticism, for surely an important part of the user's response to the work will derive from her understanding of the poem texts.

Figure 2. Full Screen with High Resolution.

Complicating the linearity of syntax and poetic line is a bold vertical stroke running down the middle of the text (indicated here as double vertical lines ||). Although sometimes sense requires that the stroke be treated as a divider, often syntax requires reading across it as well. The language has been shaped (by selection, lineation, and spacing) so that suggestive juxtapositions occur within and across the poem texts. One strand weaving through the poems is that of the image maker riding what we might call the cusp of control, pushing equipment to and beyond its limits, making use of accidents, searching for the aleatory juxtaposed with firm artistic control. In one text, for example, we read on one side of the stroke "huge failure rate," and on the other

> physical presence luminosity
> wanting to touch
> *please don't touch* almost any
> photographic paper will fingerprint if you touch[3]

In the same poem text, scrolling down reveals this thought: "I can work/with some accident/but I still have a great many disasters/usually through pushing something/too far." In another poem text, the voice refers to "the heaviest-duty black industrial/enamel I could find/toxic colloidal gunk/," "sludge from the bottom of the brush jar/" || "created this very lyrical and delicate/image landscape on the surface."[4] "Is it self-organizing?" the voice asks, answering ambiguously "totally/well" where "well" can be understood either as a completion of the previous thought or as an indicator of a reflective pause drawing back from conclusive certainty. After a long space (denoting an equally long pause by the speaker), the speaker says "are eighty-five percent," presumably aiming for a more exact qualification than the "totally/well" implied. Like the chreods appearing amidst turbulent flow, here patterns are revealed through all that the artist does not control and yet seeks out (or at least accepts) for their contributions to the overall effect.

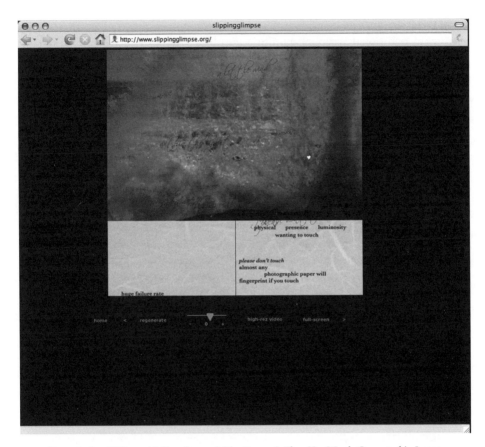

Figure 3. Scroll View with Text Stopped. The Dynamic Flow Has Words Generated in Image.

Related to this dance between accident and design is the collision/conjunction of human and nonhuman cognition. "I learn my form my (subtractive) form/from computed information/like learning a piece of/music by heart or a choreographic/sequence."[5] The analogies point to action below the level of conscious thought, as when a dancer or musician knows the moves in her body better than in her mind. Moreover, the language suggests that these nonconscious parts of cognition can form a creative coupling with the nonconscious performance of the intelligent machine, with the implication that what is "subtracted" is not only unnecessary superfluity but also the intervention of conscious thought. In another text, the voice invokes the capacity of artificial evolution for creative invention: "Genetic brushes/an evolutionary model where you could/breed two brushes together/they would make a whole new brush," and on the stroke's other side, "||brush over the entire image algorithmically/no human/intervention other than setting/the basic parameters."[6]

The theme of the nonconscious agent forming a creative coupling with human consciousness reaches its most intense expression in the passion of the flax, a folk motif that compares the beating of flax plants to release the silvery fibers so they can be spun into threads and woven into linen with Christ's suffering. This centuries-old story

extends the conjunction of human and nonhuman cognizers into the distant past, suggesting the traditional nature of appropriating objects into extended cognitive systems (an idea developed by Merlin Donald, for example, in his discussion of cave paintings as external memory storage devices).

> buried blue-eyed flowering plucked root
> & branch retted soaked to partial rotting
> scorched over the fire bound battered dressed
> rippled with hackle combs and thorns
> drawn fiber spun thread woven *linen*
> bleached on grass pierced needles sewn
> shirt worn to rag rent drowned calendered
> dried to paper written on[7]

The flax plants, themselves innocent, give themselves over to be tortured, as if they had agreed (as agents capable of choice) to their fashioning into fabric and clothes. Finally they are torn into rags and recycled into paper that may, among other purposes, perchance be used to record their suffering.

In the remediation of the ancient story in this digital work, the recursive cycles widen beyond flax, linen, and paper to turbulent flow, intelligent machines, and algorithmic reading. The questions set into motion by the passion of the flax expand accordingly: if we are bound to nonhuman cognizers through chaotic dynamics and multiple feedback loops, where does our responsibility to these nonhuman agents begin or end? The poem text entertains the question in the final passage of the section recounting the passion of the flax. Alluding to a harvest ritual called the Denial ceremony in which the harvesters' denied their guilt for torturing the plants by disguising themselves in animal skins,[8] the voice ritualistically disclaims her responsibility for atrocities visited on the vegetable kingdom:

> I have not tortured
> the plants
> nor have I shoveled them into the oven
> It is another who did this
> And brought them to me
> I ate innocently
> spoken to the loaf[9]

The logic of the work, however, argues against such pleading, for the feedback loops connecting us to the nonhuman world surely imply that we share responsibility for the interconnected fates of the animal and vegetable kingdoms, and indeed for the complex ecologies that constitute the world as a whole.

The positive side to this involvement is expressed in Paul Ryan's belief that "digital streams of aesthetic intelligence about our planet" can contribute to our survival by making us freshly aware of the environment's immense importance (p. 202). Following Gregory Bateson's argument that the unit of survival ought not to be seen

as the reproductive individual or group but rather the species plus environment, Ryan further concurs with Bateson's view that a "mind" is not only something that inheres in an individual but rather is "any system with the circuit structure necessary for self-correction," including organisms in their environments (p. 202).

With this claim the full scope of *slippingglimpse* as a work of digital art comes into focus. By establishing a "circuit structure" of threeing, Strickland and Lawson Jaramillo create (or better, re-create) an environment of complex interactions in which the user can occupy various positions, all bound together by recursive feedback loops. At every level—computer algorithm, image technology, turbulent flow, human being—possibilities exist for "mind" to emerge. At the widest scope, the kind of "self-correction" the work implicitly gestures toward is re-connecting us to the environment by opening us to the realization that we cannot survive if we destroy it; we live or die together with our environments, which we can affect but never completely control or predict. In this context, the passion of the flax bespeaks not so much the sacrifice of plants as our responsibility toward the environment, which we are obliged to take seriously if only because our very survival depends upon it.

In conclusion, I want to return to the trope that Strickland and Lawson Jaramillo insist upon in their notes for *slippingglimpse*: that the relational circuits critical to our survival emerge and develop under the sign of reading. As we have seen, the claim that the water (via the computer algorithm) can read the poem text, or that image technologies can read the water, invests reading with a significance that goes far beyond the decoding of words. By the same token, however, the claim also foregrounds the work's connection with the print tradition by insisting on retaining "reading" (as distinct from, say, "using," "playing," or "performing"). The result is a kind of balancing act in which the importance of inscribing and decoding verbal symbols is both glorified and delimited, disrupted and continued into the digital realm. Asked "what language do you write in," for example, a voice in one of the poem texts answers "C++," a response that expands writing to include programming and, at the same time, delimits the inscription of verbal symbols so it shrinks to a subset of "writing" in general.[10]

The ambiguity inherent in how reading is positioned echoes through the poem texts in views that at once invest perceptions of the environment with redemptive potential and simultaneously insist on the limitations of normative perceptions. One of the voices proclaims that "I finally learned to see/beyond the retinal/experience,"[11] while another suggests that "seeing is forgetting the name/of what you see."[12] Language inhibits and enables; seeing is essential and inadequate. The key to understanding how these ambiguities work within *slippingglimpse* is suggested by the title, which points toward the importance of connection in the way it conjoins two words without admitting a space between.

As long as seeing is understood as an individual experience limited by the boundaries of the skin, it is inadequate for grasping relational interconnectedness; as long as language is understood as verbal facility, it cannot open the doors of perception. Nothing works well when the focus narrows to the solitary individual considered in isolation; everything works when things are situated in relation to one another. Seeing is a concatenation of glimpses, no sooner experienced than slipping away to something else. At the same time, relationality cannot emerge except through a succession of glimpses, each inadequate in itself but fully realized when considered as part of an

connected whole. Mind is not up to the urgent task of embracing the realm of slipping glimpses, but "mind"—human and nonhuman, cerebral and visceral, individual and collective, focused and extensive—can engage in the multimodal, full-bodied and recursive reading that is both required and performed by *slippingglimpse*.

Notes

1. This essay was originally published in *Frame* 21.1 (2008): 15–29. I am grateful to the editors for permission to reprint. I also thank Stephanie Strickland, Cynthia Lawson Jaramillo, and Paul Ryanfor their generous reading of this essay and the corrections they offered. Any errors that may remain are, of course, solely my responsibility.
2. Personal Communication, Stephanie Strickland, Email, 29 April 2007. Personal Communication, Stephanie Strickland, Email, 22 July 2007.
3. Stephanie Strickland and Cynthia Lawson Jaramillo, *Slippingglimpse* (2007). http://slippingglimpse.org/ pages/scroll_6_lettuce.html
4. Ibid. http://www.slippingglimpse.org/ pages/scroll_3_green.html
5. Ibid.
6. Ibid. http://slippingglimpse.org/pages/scroll_10_leaf.html
7. Ibid. http://slippingglimpse.org./pages/scroll_7_sideways.html
8. The article on "The Passion of the Flax" was written by Robert Eisler, who died in 1949 before revisions could be completed that would make it suitable for publication in the journal *Folklore*. These revisions were completed by W. L. Hildburgh, and the article appeared posthumously in 1950.
9. Strickland and Jaramillo, *Slippingglimpse*. http://slippingglimpse.org/pages/scroll_7_sideways.html
10. Ibid. http://slippinglgimpse.org/pages/scroll_9_aquaGalaxy.html
11. Ibid. http://slippingglimpse.org/pages/scroll_3_green.html
12. Ibid. http://slippingglimpse.org/pages/scroll_2_blueFeather

Bibliography

Bateson, Gregory. *Steps to an Ecology of Mind: Collected Essays in Anthropology, Psychiatry, Evolution, and Epistemology*. Chicago, IL: University of Chicago Press, 2000.

Bateson, Gregory, and Mary Catherine Bateson. *Angels Fear: Towards an Epistemology of the Sacred*. New York: Macmillan, 1987.

Clark, Andy. *Being There: Putting Brain, Body, and World Together Again*. Cambridge, MA: MIT Press, 1998.

—. *Natural-Born Cyborgs: Minds, Technologies, and the Future of Human Intelligence*. New York: Oxford University Press, 2004.

Damasio, Antonio. *Descartes's Error*. New York: Vintage, 2006.

—. *The Feeling of What Happens: Body and Emotion in the Making of Consciousness*. New York: Harvest Books, 2000.

Donald, Merlin. *Origins of the Modern Mind: Three Stages in the Evolution of Culture and Cognition*. Cambridge, MA: Harvard University Press, 2005.

Eisler, Robert, and W. L. Hildburgh. "The Passion of the Flax." *Folklore* 61.3 (1950): 114–133.

Fredkin, Edward. "Digital Mechanics: An Information Process Based on Reversible Cellular Automata." *Physica* D 45 (1990): 245–270.

Strickland, Stephanie. Personal Communication, 29 April 2007, 17 May, 22 July, 10, 13, and 14, September 2007.

Strickland, Stephanie, Cynthia Lawson Jaramillo, and Paul Ryan. *slippingglimpse*, translated, 2007. Available from *http://slippingglimpse.org/*.

Thom, Rene. *Structural Stability and Morphogenesis: An Outline of a General Theory of Models*, trans. D. H. Fowler. Reading, MA: Benjamin, 1975.

Post-Chapter Dialogue, Hayles and Ricardo

FJR: When a medium of writing changes, its mode of reading will also be transformed. As an electronic work, *slippingglimpse* instantiates three different presentation modes so closely tied to each other that they constitute feedback loops engaged in "reading" each other within the work. For us, one purpose of reading is ascertaining intention. Since *slippingglimpse* cannot be read separately from how the work reads itself (for it is through its meta-reading that it creates what we see), we experience what are distinct moments of the work at different times. And here is John Dewey, asserting in 1934 what bears, it seems to me, prescient relevance to *slippingglimpse* and what your analysis shows us of works like it:

> It is absurd to ask what an artist "really" meant by his product: he himself would find different meanings in it at different days and hours and in different stages of his own development. If he could be articulate, he would say "I meant just *that*, and *that* means whatever you or any one can honestly, that is in virtue of your own vital experience, get out of it."[1]

Dewey's argument could be called a refutation of the stability of intention. What, for him, motivates creative work emerges from a constellation of impulses and reactions, not all of which might be comprehensively itemized or entirely present to straightforward summary. Instead, their infinite associativity leads to an open dialogue with the conditions and character of the work.

The line connecting Dewey's logic to that of your analysis relates the prospect of distributed cognition to this negation of singular intention—each of these characteristic dimensions is open, each refers to something deferred, something contingent less on presumptions of universal, objective, constants that on what emerges at the moment of experience of and inquiry into the work. Distributed cognition here appears as a higher mirror form of the indeterminate intention that Dewey maintains: the work becomes different in the sense he means—perceptually altering. In new media, however, this unfolding difference is much greater: no longer simply constrained to an interpretive possibility against the backdrop of a static work, it additionally manifests that aesthetic or poetic evolution of the work at structural levels within the mechanics and presentation of the work, as does *slippingglimpse*. Whereas historically only the *impression* of the work was open to change within the reader or viewer art and literature of traditional media, in new media, the *mechanism* of the work now evolves as much as do impressions derived from its use. I wonder if you can comment on how this a dual experience informs your theorization and reception of such works.

NKH: The notion of distributed cognition is key in my approach to New Media art and theory. In *My Mother Was a Computer*,[7] I argued for an approach I called

intermediation that recognizes nonhuman as well as human possibilities for meaning-making. Gregory Bateson, whom I quote in my essay, had a similar notion about meaning on a global scale, in which the entire eco-system participates in creating meaning. Meaning has traditionally been intimately associated with "aboutness," a recognition by a system that situates actions with contexts that allow for reflection and connection. We have no difficulty seeing that human consciousness, with its awesome capacity for self-reflection, has plenty of "aboutness." We can expand the idea of "aboutness" if we recognize that cognition happens in many contexts, and each of these has its own ways of linking incoming information to its context so as to interpret the information and give it a specific local meaning. A cell, for example, has a context in which incoming information in terms of chemical gradients and flows into and out of the cell are meaningful in its context. I think it is legitimate, then, to talk about the cell as a cognizer (or perhaps a sub-cognizer), a view that Daniel Dennett espouses in *Kinds of Minds*.[2] From such low-level cognitions, higher-level cognitions emerge, through different kinds of organizations such as organs, endocrine systems, etc., on up to human consciousness. In this sense, intentionality is always multiple and complex and almost never unitary in its operations. Freud said as much, of course, but here the idea of distributed cognition goes much deeper and broader. What we gain from such a perspective is a richer sense of our connections to the living (human and nonhuman) world and a way to account for the emergence of thought without confining this process solely to human consciousness, which after all is only a small part of the enormous complexity of the global ecosystem.

FJR: One of your critical interests has been to examine how the outward similarity of phenomena created by two means, virtual and analog, conceals deep constructionist differences between both processes, but that this difference of production does not imply independence of one from the other. Recently, you observed that "different technologies of text production suggest different models of signification; changes in signification are linked with shifts in consumption; shifting patterns of consumption initiate new experiences of embodiment; and embodied experience interacts with codes of representation to generate new kinds of textual worlds. In fact, each category—production, signification, consumption, bodily experience, and representation—is in constant feedback and feedforward loops with the others."[3] Your broader analyses of science and technology seem to me to be thoroughly amalgamated with your work in literary and visual studies in a way that the approach of many other scholars is not. One can emphasize the internal mechanism of a work, thus providing some of the formalist analysis that Noah Wardrip-Fruin favors, or one can scrutinize the reach of technology into broader arenas of life, as Friedrich Kittler does. What might comprise, in your view, optimal methodological practices for the analysis of new media art and literature, given that your own view of electronic literature embraces but also transcends literary concerns alone? And, beyond textuality and technology, it is also important to consider how a straightforward lexico-poetic reading of *slippingglimpse* additionally points to ethical dimensions going to the heart of the matter of our shared responsibility for "the interconnected fates of the animal and vegetable kingdoms, and indeed for the complex ecologies that constitute the world as a whole," to which the third part of your essay turns.

NKH: Since I am trained both as a chemist and a literary critic, I naturally tend to look for connections between the human and nonhuman world—in other words, between the human sense of self and all the nonconscious components that go into creating that self, from protein molecules to cells to organs, etc. We might even say that human being contains within itself the nonhuman, in the sense that carbon atoms, for example, are only bound within our bodies for a period of time, being released again at our deaths to reform other compounds and perhaps to be recycled in other bodies. I am firmly committed to a materialist approach; all that happens, in my view, must have a basis in the material world. Thus explaining consciousness (echoes here of Dennett's book) must include consideration of how consciousness can emerge from lower processes. Given this orientation, I tend to focus on the processes that together make many different kinds of components into complex systems and on the recursive feedback loops that link lower to higher, higher to lower. My approach, then, is neither functionalist nor formal (although it takes account of both form and function in various ways) but rather processual and dynamic. Applied to New Media art objects, this implies focusing on the processes within the computer (where the recursive loops between lower and higher levels of code create the complexities of the screen display), the processes within human users that connect the kinetics of hand and finger motions, eye scanning, and other muscular activities with higher-level cognitions, and of course, on the loops that connect the computer to other computers and to human users. This orientation is why I was especially interested in chaos and complexity theory (the dynamics of which is explored in *Chaos Bound*[4] and *Chaos and Order*[5]); why I saw cybernetics as a crucial intellectual development, with its joining of information with the ancient idea of feedback loops (a history interrogated in *How We Became Posthuman*[6]), and why I proposed the concept of intermediation in *My Mother Was a Computer*. The world is not only in motion; from this perspective, the world is motion, from sub-atomic particles on up to human thought and action. Without motion, the world and all that is in it would instantly cease to exist. Applied to literary texts, this perspective tends not to think about the book as a stable object one reads or puts away but rather as a continuous flux of interconnections, networks, and processes, from the activities of writing to the processes of publication to the thoughtful engagements of a reader.

Notes

1. Cf. John Dewey, *Art as Experience* (New York: Penguin, 1934/2005), 113.
2. Cf. Daniel C. Dennett, *Kinds of Minds: Toward an Understanding of Consciousness* (New York: Basic Books, 1996).
3. Cf. N. Katherine Hayles, *Virtual Bodies and Flickering Signifiers.*
4. Cf. N. Katherine Hayles, *Chaos Bound: Orderly Disorder in Contemporary Literature and Science* (Ithaca, NY: Cornell University Press, 1990).
5. Cf. N. Katherine Hayle, ed., *Chaos and Order: Complex Dynamics in Literature and Science* (Chicago, IL: University of Chicago Press, 1991).
6. Cf. N. Katherine Hayles, *How We Became Posthuman: Virtual Bodies in Cybernetics, Literature, and Informatics* (Chicago, IL: University of Chicago Press, 1999).

Bibliography

Dennett, Daniel C. *Kinds of Minds: Toward an Understanding of Consciousness.* New York: Basic Books, 1996.

Dewey, John. *Art as Experience.* New York: Penguin, 1934/2005.

Hayles, N. Katherine. *Virtual Bodies and Flickering Signifiers,* translated [cited 26 January 2009]. Available from http://www.english.ucla.edu/faculty/hayles/Flick.html.

—. *Chaos Bound: Orderly Disorder in Contemporary Literature and Science.* Ithaca, NY: Cornell University Press, 1990.

—. *How We Became Posthuman: Virtual Bodies in Cybernetics, Literature, and Informatics.* Chicago, IL: University of Chicago Press, 1999.

—. *My Mother Was a Computer: Digital Subjects and Literary Texts.* Chicago, IL: University of Chicago Press, 2005.

Hayles, N. Katherine, ed. *Chaos and Order: Complex Dynamics in Literature and Science.* Chicago, IL: University of Chicago Press, 1991.

CHAPTER FOUR

Reading the Discursive Spaces of *Text Rain*, Transmodally

Francisco J. Ricardo

I begin with a basic claim—all literature has some relationship to imagery, and that the inverse is not true. Even the most extreme experiments of abstract poetry, or concrete poetry, even the most phonologically focused constructions cannot evade the perceptual intimation of sounds as aural imagery, or hypnotic trance, with which such sounds are instinctively associated. For despite the roil of new media and literary machines, of novel forms of expression and authoriality, the program of literature still remains to elicit resonances that emerge out of, but soon transcend, the literalized tokens of a text. And if this transcendence can be felt as a membrane that isolates two worlds—the literal world of phrasal reading from the interpretive world of the imaginal—the world between them, that is, the world of lexical tokens of phrasing from the much more extensive of fictive associations produced in the reader, then it is helpful, in the space of that intersection, to think of literature as a genre of text wrapped in mantle of imagery.

Without denying the importance of this aesthetic partnership, literary critics have harbored implicit views about the manner in which this relationship, this rapport between written and imagined, ought to stand. The text is to exist in physical form—written, inscribed, imprinted—while the image is left to occupy the confines of readerly imagination. What is preserved in this specific arrangement is the necessary stability and identity of the work with the equally indispensable need for individual, personal, purely idiosyncratic reconstruction of facets of the narrative. The critical bias for this specific partition of written from visual is evident in consistently held judgments of what is understood as "pure literature," a term uttered in 1912 by Thomas Hardy on receipt of the gold medal of the Royal Society of Literature. He had little patience for anything outside the untainted use of well-formed textual expression over any other variant. In the Hardyian province of pure literature, even poetry kneels to the hegemonic strictures of decorous prose:

> For my own part I think—though all writers may not agree with me—that the shortest way to good prose is by the route of good verse. The apparent paradox—I cannot remember who first expressed it—that the best poetry is the best prose ceases on examination to be a paradox and becomes a truism. Anybody may test it for himself

by taking any fine lines in verse and, casting off the fetters of metre and rhyme that seem to bind the poet, trying to express the same ideas more freely accurately in prose. He will find that it cannot be done; the words of the verse—fettered as he thought them—are the only words that will convey the ideas that were intended to be conveyed.[12]

One can scarcely suppose what he would have felt about images and text, blended together, being classified as anything like "literature." Hardy's is an emblematic judgment over what is considered "pure literature" that stands in opposition, for example, to the graphic novel or the spoken text of recorded books—these are presumably *renditions* of literature and not literature itself. It seems that the mantle of imagery surrounding the literary reading is as mentally essential as it is physically undesirable.

I don't want to underestimate the word "essential" here, for texts without connection to such imagery, texts that include the journalistic article or the scientific monograph, might be appreciated as being erudite, inspiring, and even "literary," but never understood *as* literature. One explanation for this is of course because these are nonfiction genres whereas literature dwells in the imagined and the imaginary. But again, we return to the link between literature and the image—imaginary here implies the dimension of vitally visual signs of the fictive and the quasi-real: visions, dreams, trances, reveries, epiphanies, contemplations, revelations, depictions, portraits, impressions, panoramas, and so on.

Consider the constellation of intersecting forms shown in Dick Higgins's 1965 touchstone diagram; these were conceived at historically similar rupture points, not surprisingly at the height of Higgins's Fluxus years and during study with John Cage. Higgins's observation that "much of the best work being produced today seems to fall between media,"[1] underscores the futility of unique or pure forms in which performing, literary, and visual arts are entirely separate for an age of growing fusion of forms.

Indeed, the graphic novel, the comic strip, and the illustrated story demonstrate that the banishment of the visual from textual literature is unrelated to the history of production technology and, conversely, to technical constraints on the medium of print. The verdict of literature as "pure," as primarily textual, is rendered under attitudes that are doctrinal, not technological. Arguments for purity in literature on one hand and specific media for print and image production on the other evolved along entirely different historical tracks. This division will become central to works of digital art and literature whose media afford the processing and presentation of the textual and the visual with equal dynamic range and geometrical possibility. And it is precisely—and perhaps *exclusively*—because of those extratextual affordances that digital literature presents complex extensions over and against this conventional and problematic bias entailed in "pure literature." For distinctions of purity can rightly be made in instances where media are simultaneously physically and virtually intermixed—filmic narrative, for instance, projected on a screen before which actors on stage are performing is quite opposed to "pure cinema" as defined by nonnarrative techniques such as the visual juxtaposition and montage of the Kuleshov effect. But to constrain literature to what is produced by the physical mechanism of the printing press would preclude prison notebooks, napkin-inscribed poetry, graffiti, textual decollage, and much more; this

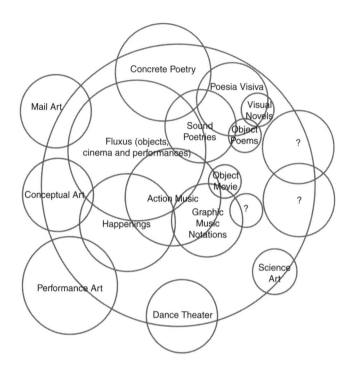

Figure 1. Dick Higgins,
Intermedia Chart,
1966,
Originally published in Something Else Newsletter 1, No. 1 (Something Else Press, 1966).
© 2009 Estate of Dick Higgins.
Permission courtesy of Hannah Higgins.

view is as narrow as limiting "literature" to what is hand-written. From these ambiguities of causality we know that literature's central preoccupation with text does not, in contrast with electronic literature, satisfactorily extend to questions exploring *how* such literary text was created.

Reflecting the greater theoretical distance underlying my discussion are the distinctions involving essence, form and instance—three events of the ontology of literature. However one feels about ontological contentions, it is nonetheless true that essence, form, and instance are three indispensable attributes of *all* literary and aesthetic objects. This doesn't imply that acknowledgment of *an* essence is equivalent to some *particular type* of essence, be it one claimed by Hardy, or anybody else. Existing without empirical proof, implicit, almost quasi-Platonic notions of the "essence" of literature have long been mentioned in aesthetic discussions deriving from strong Romantic and modernist roots. Its logic has been quietly imported from the literary tradition onto the visual arts; we might recall the art critics with professional beginnings in the literary world, including Clement Greenberg as literary critic for *The Nation*, and Peter Schjeldahl as poet and reporter.

Hardy, articulating literature's historical continuity, isn't entirely wide of the mark. The atemporal aura of literary essence, sustained as it is through writing's chain of epochs, accompanies and even nourishes, but does not totally fashion, expressive patterns understood as literary forms or genres—those are historically determined. And so, when we contemplate a work of electronic literature, we are tempted to look at its proximity to the logic that informs some kind of essence, form, or instance of what has come before, admissibly under the term *literature*, for why else evoke that classification if what is being cataloged within it is so new in medium, content, and form that no viable link with literature's history, which is to say, something of its established essence, can be made?

I have already discussed one problem involving that logic, captured in the conservatism of what implies "pure literature," which is to say, fictive text devoid of the contaminating co-occurrence of graphic accompaniment. That this is but a bias can be determined from our questioning whether such criterion of purity dwells in all conceivable universes of literary essence, or more narrowly, from the world of genres and conventions, that is, from literary *form*. Characterizing form offers an opportunity for any critic to advocate with consistency and clarity—the historical critic is the qualified expert on form in literature—but for essence, the logic becomes less patent, less compelling. For, who speaks for the essence of literature? Not form-specific, it rather approximates something analogous to what we imagine uttering the phrase "the power of literature," the source of which derives (necessarily) both from the textuality of any literary work and from the mantle of conceptual imagery that envelops it, given by the form of a work and the resultant reading. To estrange one constituent from the other is to attempt an obliteration, a de-synthesis of the literary phenomenon, one available in its own way to other visual forms and media—sculpture or more generally, film—or auditory ones—radio or more generally, music, for example. In the act of reading is born this unique literary imagination. Indistinguishable from what is presumably essential to any literary experience, this last word, *imagination*, implicates image-making directly.

I hope that this preamble has recalled the continual tension relating word to image within the literary experience, and how reconciliation of both is part of a necessary aesthetic cathexis challenging literature in a way not forced upon its visual partners, the photograph, the illustration, the image, which for their own part have no need to incorporate textuality. So it is that this synthesis, in the form of one particular work, the interactive projective installation *Text Rain*, extends an unequivocal reach into the imaginal whole of a particular literary instance, a poem, and simultaneously into the terrain of a literary essence of the new, as the nucleus of combined aesthetic experience. If it is worth remembering that a work by any other interpretation is just as literary, or visual, or performative, we might also bear in mind that interpretation is ancillary, rather than crucial, to the enjoyment and essence of any expressive form, something that by its all-ranging name, "expressive form," prefigures the instantiated: audience, setting, or message. Reaching for an apprehension of the larger sentiment, we might connect Susan Sontag's familiar claim that "the function of criticism should be to show *how it is what it is*, even *that it is what it is*, rather than to show what it means."[2] This "how it is what it is" marks the implicit line between *interpretation*, which can be conceived by any degree of familiarity with a work (including uninformed positions), and *close reading*, possible only through the scrutiny of rigorous analysis. But the avoidance

of interpretation also points us to non-interpretive, which is to say, principled, essential, *a priori* aspects of any work. This is the paradox then, whereby, uncovering underlying patterns, a close reading is synonymous with phenomenological investigation and is thus implicitly ontological, whereas an interpretation is not.

Having set out thoughts here from the basic assertion that literature embraces imagery, up through challenges against the idea of pure literature as an anachronistic formalism, I could now be blamed for having taken a sudden and seemingly incongruous turn, in the literal sense, against interpretation. What then of the multimodality of imagery and text that new expressive forms and media have attained, all the re/mediation to use another phrase,[3] all the convergence? Why all of this if not to take the receiving audience to new landscapes of imagination, and therefore interpretation? Ought we reasonably disallow the greater contemporary need for new interpretive positions in light of media, products, and works that bring novel sensory impetus and user participation? These questions which cannot be answered separately, derive from

Figure 2. *Text Rain*,
Camille Utterback and Romy Achituv
Text Rain,
1999.
Interactive installation,
custom software, video camera, projector, computer
Image courtesy of the artist.

a common source, a reference to epochal change in the way that art has integrated with technology at all stages and moments of its being, which is to say, not merely the end presentation of art but the actual creation itself. Less tritely put, the change to consider revolves around how the voice of artistic effort emerging from the author, painter, poet, filmmaker, orator, or sculptor is to accommodate within the presence of expressive mechanisms that produce projective imagery, sensory activation, and selective immersion of their own as instrument of creation that complement, or perhaps compete with, received notions of artistic expression. The production, therefore, of imagery as extension to or evolution after the staunchest formalism, to include arguments for pure literature, can not be distanced either from the *literary*—as abstraction, as ontological characteristic however defined—because that quality cannot be defined as either image-free or imagery-free. And in similarity with previous intents like the Dada collage, the reading of the image and the visualization of the word apparent in digital art and literature render the traditional separation between the literary and the aesthetic newly immaterial. Sontag's caveats on the question of interpretation refute anything in literature other than the fullness experienced in the reception of a work, rather than something to be seen as having an *a priori* moral, or an allegorical subtext, or perhaps even as something valuably pluralistic to multiple readings because of its inherent intertextuality. These are all forms of interpretation that prove problematic not because they appear to make a text render a larger story, but because their logic repositions the text toward the opposite direction, given the subtle reductionism that any interpretation imposes. Here I refer to the linguistic turn itself, of seeing less something of the whole than an array of itemizable constituents whose sense is uncovered by means of quasi-grammatical rules of transformation and exchange (read, simplification) so that, if, in Sontag's words, "the task of interpretation is virtually one of translation," the danger of such reduction is perhaps doubly true for digital works whose components can be that much more clearly isolated, dissected, and destructured from their integrative Gestalt. Nor need one concur with anything like Clive Bell's formalism via his signature assertion that "to appreciate a work of art we need bring with us nothing from life, no knowledge of its ideas and affairs, no familiarity with its emotions,"[4] a claim that proves the folly of overlooking the shared horizon of understanding, the "range of vision that includes everything that can be seen from a particular vantage point"[5] that Gadamer spent six decades educing. In closing this line of reasoning, I hope to have made clear that I am speaking of a structural ontology, resembling neither Greenberg's normative characterizations nor Husserl's transcendental ruminations. In considering ontological clarifications as important for the work of the new media critic, theorist and historian, which includes imagining what is common to all or much electronic work, I am addressing challenges to *framing*, not to value. Such work has no place for presumably objectivist/exclusivist systems of qualitative valuation: given the dynamic nature of experiences in new media art and literature, judgments are likewise contingent, ultimately possible only to each mutuality of artist, user, and instance.

What one is to make of this literary-aesthetic synthesis will remain one of the vexations of electronic criticism. From the outset, the constitution of a work as a primarily textual object constrains and dictates the direction of approach for its readerly construal.

Presenting itself independently of one's reading, whether motivated by interpretation, critique, or formal comparison, one's engagement with the text emerges from nothingness through the anatomy of the word. In the matrix of the textual page, it asserts all hegemony for meaning and the basic method for that experience, beginning as a lexical reading, almost invariably conforms to motion from an identifiable starting point to at least one destination any number of lines, verses, or pages away. By contrast, that "reading" an image is entirely distinct from this textual approach has been widely established; what bears repeating is the visual command of the image, as it eclipses the word when both cohabitate the same perceptual plane. There is no word worth a thousand pictures, except perhaps love, but how can it be experienced prior to the image of its affection?

Instinctual primacy moreover prioritizes our sensations, in the startling flash of any surprise; we hear before reading, and look before unraveling what is heard. That seeing presignifies reading or hearing has been evident to art history, which records and embraces more of the literary than has been commonly accepted. Any work or event of visual composition, regardless the extent of its literariness, is of interest to the art historian, critic, or philosopher. And the auditory, sensorily subsequent to the visual, also participates in the chronicles of art. Thus Rosalind Krauss, opening a discussion of the readymade with a theatrical performance of a literary work, recounts openly what the histories of literature and of theater have scarcely documented:

> One evening in 1911, four members of the Parisian avant-garde attended a bizarre theatrical presentation: Marcel Duchamp, Guillaume Apollinaire, Francis Picabia and Gabrielle Buffet-Picabia went to see *Impressions of Africa*, a performance based on a novel by Raymond Roussel. "It was tremendous," Duchamp was later to say of that night. "On the stage there was a model and a snake—it was absolutely the madness of the unexpected. I don't remember much of the text. One didn't really listen."[6]

Experiencing this similar sensory selectivity, Duchamp's relative inattention to the text is symptomatic to the sensory montage of multiple modalities, and to the dominance of action in the visual field, despite the fact that it is orchestrated from textual origins. It is for this phenomenological reason that we must now consider the electronic, projective, interactive, poetic reality of *Text Rain* as a both a completely visual work and a completely sovereign text; it contains a textual work in itself that orchestrates its visual possibilities, and because of its insistently combined textuality and visuality, the work as a whole (not merely as a text) is amenable to the kind of close reading that a literary text can sustain, but not in an exclusively textual manner—something that offers challenge and potential for critical reception. The work, in fact, presents several discursive spaces or moments of being, revealing themselves in gradual fashion. Patterns emerge from these discursive spaces, by which I mean aspects of the work that interact with the user's evolving response through a dialogic circle between user and work. And we can interrogate the patterns to expose aesthetic functions of the work as more than a phenomenal reality. *Text Rain* is motivated by a reach for connection, not merely by what emanates in the optic flow of its movements, but also by the text it fragmentarily presents. And that connection need not be reduced to a mapped or literal interpretation in order to be ascribed meaning. In all of this, we may take as our point of departure the work's

character as neither entirely visual not textual, enveloped neither in an arrangement of lexical tokens nor in a visual stream. Of particular note, however, is the tenuous manner in which the poem is presented. Gone is the implicit anchor of text, the baseline. As the guide for setting the horizontal axis of reading, the baseline is as invisible as it is indispensable. It may be angled or skewed, as exploited in Futurist and Dada texts that seem to be performing their own media-archaic renditions of text rain.

Manifestly evident in such works where text is more than textual is how directly the readerly function is challenged. When the baseline wanes, text appears visually, not lexically. As something beyond an expedient design strategy, de-anchored text wants to refute the rational assumptions that frame reading, supplying in their place a means for keeping attention vigilant: does a word mean what it normally means when it appears upside down? But in its dual existence as textual and visual sign, this type of work conveys a multimodality that is unsettling and refuses reduction

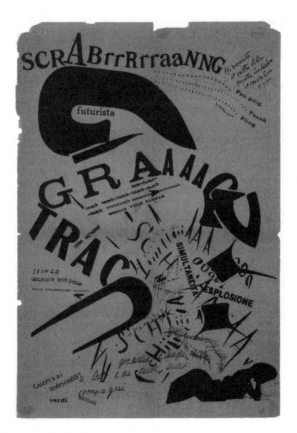

Figure 3. Filippo Tommaso Marinetti,
In the Evening, Lying on Her Bed, She Reread the Letter from Her Artilleryman at the Front,
1919,
© 2009 Artists Rights Society (ARS), New York / SIAE, Rome
The Museum of Modern Art, New York.
Photo credit: The Museum of Modern Art/Licensed by SCALA / Art Resource

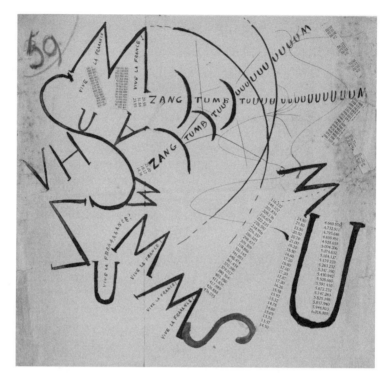

Figure 4. Filippo Tommaso Marinetti,
Vive la France, (late 1914 – February 1915),
1914,
Ink, crayon, and cut-and-pasted printed paper on paper, 12 1/8 x 12 3/4".
The Museum of Modern Art, New York
© 2009 Artists Rights Society (ARS), New York / SIAE, Rome
Photo Credit : Digital Image © The Museum of Modern Art/Licensed by SCALA / Art Resource.

to singular classifications. And if with such multiplicity of modal encodings comes a set of moments of encounter, one after another, then *Text Rain* as a work with additional motion and interactivity, is experienced as a more pluralistic multimodal, or rather, *transmodal*, identity. The elemental strategy of *Text Rain*, rather than depend on an archival inventory of objects to be displayed, is based on the kind of recombinant encoding that I have elsewhere associated with the language of cyberculture.[7] For the work's visual dimension is not comprised of anything manufactured and stored within it; its visuality is purely the projective derivation of images literally "captured" in the area facing the work's mural flatness. Neither is the text so prominent; the poem underlying the work is revealed in vertical motion, almost letter by letter. As I will explore next, the effect is transmodal, a recursive amalgam of filmic, literary, performative, and near-sculptural conditions within which the image of the body rests on the wall, the baseline of text rests upon and is defined by the contours of the body image, and the text is a poem alluding to bodily motion and human connection.

Figure 5. Francis Picabia,
Dada Movement,
1919,
Pen and ink on paper, 20 1/8 x 14 1/4".
The Museum of Modern Art, New York
© 2009 Artists Rights Society (ARS), New York / ADAGP, Paris.
Photo Credit : Digital Image © The Museum of Modern Art/Licensed by SCALA / Art Resource.

That *Text Rain* is thoroughly transmodal is additionally evidenced by considering it ontologically, as it exists, or perceptually passes, through a series of more or less distinct phenomenological stages, lives, or moments. In the initial observational encounter with *Text Rain* the work presents itself as a letter-based cascade. In this motion, interpretation is challenged: the work carves up a primary division between the audience that perceives the work as a text versus that which does not; there is no perceptual consensus on the letterfall at the outset. For, to a first approximation, *Text Rain* is exactly and no more than that—a torrential letter flux that, grasped in this preliminary phase, impedes experience of it as literature; none of the projective motion is evident as part of any narrative. But this first moment of its being comes to its close when the work, redefined on the subsequent discovery that it is interactive in a personally engaging way, yields another phenomenon. One could rightly deduce that participants are at first as much absorbed by the peculiarity of their own reflection on a wall, as they are attentive to a peculiar descent of letters. And, as true as it is with a lively toddler who first learns by doing, the synchrony of this particular work makes play precede

Figure 6. The transmodal evanescence of *Text Rain*.
Camille Utterback and Romy Achituv
Text Rain,
1999.
Interactive installation,
custom software, video camera, projector, computer.
© 1999 Camille Utterback and Romy Achituv.
Image courtesy of the artists.

reading. In the next moment of its being, as it were, the work will reveal the poem that alludes directly to this very interplay. But at first, during play, the collusion and collision between elements in the work and reflected human image on the wall instigate questions of entailment, specifically, whether the work's cascading elements are projected onto a real, physical world, or, symmetrically, whether the real, physical person belongs in the work of art.

From this kinetic adjunctness of worlds emerges a new life or phase in the possibility of reading a poem out of *Text Rain*. Since participants' motions are unrestrained, this discovery remains as potential experience, not inevitable outcome of the work. For to locate a poem in the visual kineticism *Text Rain* requires one to behave, move, travel, in a wholly different way, directed toward piecing together a selection of the lines and yearnings in the Evan Zimroth poem, *Talk, You.*[8] In the fifth, concluding stage or ontological mode, then, *Text Rain* unfolds at the moment the viewer reflects on how his or her motions have in fact been a relational dance more or less predicted by its poetic

stanzas. These are three—each comprising five short lines—outlining the motivated symmetry of two bodies in desirous connection to each other:

> I like talking with you,
> simply that: *conversing,*
> a turning-with or –around,
> as in your turning around
> to face me suddenly . . .
>
> At your turning, each part
> of my body turns to verb.
> We are the opposite
> of *tongue-tied*, if there
> were such an antonym;
>
> We are synonyms
> for limbs' loosening
> of syntax,
> and yet turn to nothing:
> It's just talk.

In this physical sense, it is worth noting that the first application of *Text Rain* was as a support to dance performance. Conceptually born in a series of theatre and dance collaborative workshops produced in New York City beginning in 1997, the work's original idea was not to inject a poem into the work but instead to superimpose an early art historical treatise on visual perspective on and around the stage performers in motion. So from the earliest, the sense of a projective text was there, but its dialogue was with the notion of space, not with the dancers themselves. With dance being the most transmodal of the arts, and borrowing from theater as much as poetry, the resulting work reflects a variegated, multimodal lineage quite distinct from that of any enacted deployments of literature. Perhaps sculptural poetry might be the apter term here, and it is in a poetic frame that we ought to consider the final moment of this work's genesis.

It is in the second-person's direct form of address that the poem establishes an I–Thou connection aligned with the thought of Martin Buber, particularly his *Ich und Du*,[9] the "I and Thou" call for a post-dialectical intimacy, a relation of directness that transcends the prevailing objectification of one's alienated state with things—a problematic relation he termed "I-It." *I-Thou* is deeply personal, yet more than personal; for Buber, as a theologian, *Thou* addresses not only the immediate you, but other forms of *you*: the unconditioned you that lives without boundary, the *all-of-you-here* collective second person, the transhistorical *every-you* that has always been and will potentially be, and the ultimate *You*, entailed in dialogue with the highest self, with God. *Thou*, translated from the German familiar second person *du*, depicts both this otherness and, simultaneously, the *familiarity-with* that evinces the connective intention. The poem's explicit yearning for engagement, the "I like talking with you" that is its opening line, underscores how *Text Rain* operates in this subject-to-subject manner: beginning with dialogue or "simply that: *conversing.*"

I opened this talk alluding to the problematic relation between work and image in text, an unresolved cadence in the corpus of literature. From the numerous ways to escape being rendered entirely in one or another modality, works of literature call on text to evoke imagery, a translation that is evident in *Text Rain*; observe how the literally dialogic of *conversing* immediately recodes into the visual act of *turning—with or—around*, ironically unfeasible in the two-dimensional context of this projection.

Without retreading already covered ground, one new point worth making relates to loss of baseline. Starting with the Dada and surrealist examples cited earlier, the visual break with typographic conventions pursued two forms, angularization and skewing of textual baselines, irregularizing distortions in letter shape. *Text Rain* effects the first of these transformations—variations in textual anchor—but not the second—variations in textual shape. This selective change ostensibly renders it a more legible work than its avant-garde antecedents. But no, printed matter can exploit visual deformations without loss of readability because, of course, the content is fixed, static. Once the content moves, as it does continually in *Text Rain*, the poem is fundamentally illegible as a whole. The rearrangement that subverts the attempt at a complete reading is twofold. Vertically, the letters are in motion, but horizontally, they never provide a clear simultaneously visible line; as soon as letters come to rest on the captured silhouette of an external person or object, they evaporate, and since this dissolve is timed to every letter's individual moment of collision rather than to the appearance of a whole stanza or a complete line, the constituents of multiple lines appear and vanish together, so that at any moment,

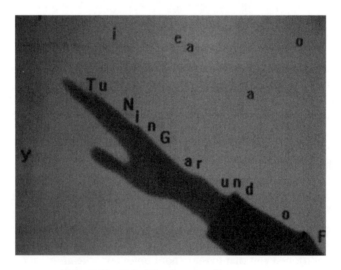

Figure 7. Text Rain, "Turning around"
Camille Utterback and Romy Achituv
Text Rain,
1999.
Interactive installation,
custom software, video camera, projector, computer
© 1999 Camille Utterback and Romy Achituv.
Image courtesy of the artists.

one's reading encounters only a selective sample of various lines. An empirical analogy of this is of multiple orators reciting a single poem together, each from a different point, each uttering and self-silencing at random points, like the traditional nursery rhyme, *Frère Jacques*, of which we can see four distinct ontological moments below:

> Frère Jacques,
> Frère Jacques,
> Dormez-vous?
> Dormez-vous?
> Sonnez les matines!
> Sonnez les matines!
> Din, dan, don.
> Din, dan, don.

<div align="center">The Frère Jacques poem, monologically.</div>

The staggered exposure of a nursery rhyme, performed in a round of three singers, produces an aural experience that is simultaneously disconcerting and engaging, as it

Figure 8. *Frère Jacques*, Musically

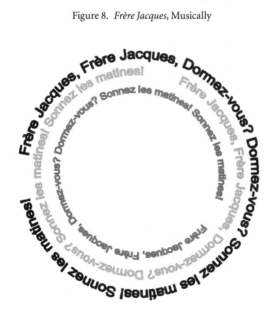

Figure 9. *Frère Jacques*, in Round of three

Figure 10. *Frère Jacques*, a performative point in the round

Figure 11. Ian Hamilton Finlay,
Acrobats,
1966,
Screenprint on paper. 388 x 279 mm.
Tate Gallery, London, Great Britain
Photo credit : Tate, London / Art Resource, NY
© Copyright 2009 Estate of Ian Hamilton Finlay.

would be to discern a poem under conditions of layered visuality. In *Text Rain*, litera-ture's complicated rapport with the image is not outside the interpretive conventions of much concrete poetry, including historically recent work, such as that of Ian Hamilton Finlay.[10]

The famous musical round becomes familiar to singers once they have sung it through, realizing that there in fact is a perceptually abstract "center" as there is to a circle, but not to the plane as we assume the ground of text to be. In these cases, it is no longer correct to speak of images and text together, as implied in the relationship with which I opened my discussion. *Text Rain* instead belongs to that tradition where the text *is* the image and vice versa, so that neither is fully itself autonomously, separately, individually. Here, against the modernist notion of the categorically pure, materializing neither specifically out of literature nor of visual art, but rather as something performative, expressive, and differentiated in multi-ple vantages and distinct moments of being, is the radiating expressiveness of the transmodal work of art.

Notes

1. Dick Higgins and Hannah Higgins, "Intermedia: Synesthesia and Intersenses," *Leonardo* 34, no. 1 (2001 [1965]), 49.
2. Susan Sontag, *Against Interpretation and Other Essays* (New York: Farrar, Strauss & Giroux, 1966).
3. Jay David Bolter and Richard Grusin, *Remediation: Understanding New Media* (Cambridge, MA: MIT Press, 1999).
4. Clive Bell, *Art* (London: Chatto and Windus, 1913).
5. Hans Georg Gadamer, *Truth and Method* (New York: Continuum Publishing Co., 1996/1960).
6. Pierre Cabanne, *Dialogues with Marcel Duchamp* (London: Thames and Hudson, 1971), 71. Quoted in Rosalind E. Krauss, *Passages in Modern Sculpture* (Cambridge, MA: MIT Press, 1977), 69. The event, and a photograph of it, appear in RoseLee Goldberg, *Performance Art: From Futurism to the Present* (London: Thames and Hudson, 2006 [1979]), 76.
7. Francisco J. Ricardo, "Until Something Else: A Theoretical Introduction," in *Cyberculture and New Media*, ed. Francisco J. Ricardo (Amsterdam/New York, NY: Rodopi, 2009).
8. For *Text Rain*, Utterback and Achituv edited, abridged, and reworked a subset of the poem. For reasons semantic and lexical, lines in stanza structure would need to be distended to the dimensions of a projection screen. Personal Communication, Camille Utterback, email, February 11, 2009.
9. Martin Buber, *I and Thou* (New York: Charles Scribner's Sons, 1970 [1923]).
10. Ian Hamilton Finlay's *Acrobats* (or similar works, like *Star*) circles toward the same question as Rosalind Krauss examined of the grid: where is the center of gravity in such works? Cf. Rosalind Krauss, "Grids," *October*, no. 9 (1979).

Bibliography

Bell, Clive. *Art*. London: Chatto and Windus, 1913.

Bolter, Jay David, and Richard Grusin. *Remediation: Understanding New Media*. Cambridge, MA: MIT Press, 1999.

Buber, Martin. *I and Thou*. New York: Charles Scribner's Sons, 1970 [1923].

Cabanne, Pierre. *Dialogues with Marcel Duchamp*. London: Thames and Hudson, 1971.

Gadamer, Hans Georg. *Truth and Method*. New York: Continuum Publishing Co., 1996/1960.

Goldberg, RoseLee. *Performance Art: From Futurism to the Present*. London: Thames and Hudson, 2006 [1979].

Higgins, Dick, and Hannah Higgins. "Intermedia: Synesthesia and Intersenses." *Leonardo* 34, no. 1 (2001 [1965]): 49–54.

Krauss, Rosalind. "Grids." *October*, no. 9 (1979).

Krauss, Rosalind E. *Passages in Modern Sculpture*. Cambridge, MA: MIT Press, 1977.

Ricardo, Francisco J. "Until Something Else: A Theoretical Introduction." In *Cyberculture and New Media*, edited by Francisco J. Ricardo, 1–22. Amsterdam/New York, NY: Rodopi, 2009.

Sontag, Susan. *Against Interpretation and Other Essays*. New York: Farrar, Strauss & Giroux, 1966.

"Thomas Hardy: His Plea for Pure English and His Theory About Poetry." *New York Times*, June 16, 1912.

Utterback, Camille. Personal Communication, February 11, 2009.

CHAPTER FIVE

Kissing the Steak:
The Poetry of Text Generators

Christopher T. Funkhouser

Syntext is a "Generator of texts" (*Gerador de textes*) originally produced between 1992 and 1995 by Abílio Cavalheiro and Pedro Barbosa, who now directs The Center for Computer-produced Texts and Cyberliterature Studies, an important research center at University Fernando Pessoa. Barbosa and Cavalheiro gathered (or re-presented) 15 programs which generated texts with both randomized and calculated variables.[1] Initially, this conglomeration of programs circulated in the French hypermedia journal *Alire*[2]; it was later circulated with the authors' book *Teoria do Homem Sentado*.[3] Some of the materials have been re-versioned for the World Wide Web (WWW) given the title *Syntext-W*.[4] This essay explores the content and formal considerations of three types of work that appear in the collection.

Permutation

Strict permutation with added elements is found in Barbosa's "Porto" (written in 1977), in which every activation of the program produced 25 lines of text that present permutations of a text built from four subjects: "GRANITO" (granite), "HISTORIA" (history), "PEDRA" (stone), and "SAUDADE" (longing/nostalgia). The additional inclusion of prepositions (e.g., "NA/NO," "A," "DA/DO," "O" in Portuguese) assigns alternative content to the nouns, enabling grammatical variation into the output. Porto, a city built on steep granite cliffs on the coast of Portugal, is the inspiration for the language presented and rearranged by the author for poetic effect. The output appears as a block of text of capitalized letters, and as such has a strong visual quality. Barbosa's program, while certainly cyclical, performs an expansion of the smaller permutations previously created by artists such as Brion Gysin. Mathematically, four words in themselves can only be ordered 24 different ways; Barbosa's program here enables 40,320 permutations. Since a limited amount of text is recycled, repetition of phrases would otherwise begin to occur quickly. The addition of prepositions adds three times as many configurations and prevents the poem from reflecting a slot apparatus. In this ten-line passage from "Porto" taken from Barbosa's *Literatura Cibernética 1—autopoemas gerados por computador*, the order in which lines appear is not repetitive, although their

construction is formulaic:

> in the nostalgia of the stone the granite of history
> in the nostalgia of the stone the history of the granite
> in the nostalgia of the granite the stone of history
> in the stone the nostalgia of the history of granite
> in the stone of the granite the history of nostalgia
> in the stone the history of the nostalgia of granite
> the nostalgia of the granite the history of the stone
> in the granite of the stone the nostalgia of history
> in the granite of the stone the history of nostalgia
> in the stone of nostalgia the granite of history.[5]

"Porto" contains basic permutation accentuated by precise prepositional content. Repetition—a strong indicator of some sort of permutation—is as blatant a characteristic of the output text here as it is in many early works of computer poetry. Even though some lines are nearly identical, where only a shifting of pairs of words occurs, the overall effect that is achieved by Barbosa's program is that endless different phrases are built that transmit different dimensions of the same sentiment. In each of these lines a sense of the passage of time, as absorbed by and reflected in the rock formation that supports the city (Porto), is apparent. By extension, other cultural aspects of the city and its people may be read into the lines, like how the people of Porto possess a strong sense of their past, or even how a longing for the past ("the stone of nostalgia") is engrained in the populous (perhaps negatively so). Barbosa counteracts this possibility through the use of contemporary, experimental forms of expression. The reader confronts impossible circumstances ("the nostalgia of the stone") made possible only through creative reflex, some of which are challenging to interpret or envision ("in the stone the history of the nostalgia of granite").[6] Yet out of such nonsense we are able to detect poetic logic. Deeper meaning can be evoked even when odd statements encountered, especially when the litany is absorbed as a whole and not just as individual lines.

Combinatorics

Permutation procedures vary greatly and since the first decade of their digital invention programs have incorporated a range of source materials (including texts by other authors). Multiple sources (inputs) lead to more diversified combinations, which led to more complexities (for both author and viewer), as well as more outcomes. Angel Carmona's "V2 Poems" is based on the text of an obscure book Barbosa found in Spain. When activated, the program rapidly generates a series of lines on the screen. The output appears as grammatical sentences, combining mainly traditional language with some neologisms so that the phrases resist bearing finite meaning. A sample of nine lines recently generated by the program sustains coherent narrative expression. This sequence contains unusual associations and discursive overtones, punctuated with

exclamatory and interrogative statements:

> Oh, how I do remember the quiet gardens forever feared!
> The sparks weep . . . in silence the rocks wake up again and burst slowly with a lot of space crying in smells never imagined.
> Why do I remember the silent moment of reflection?
> World of the night do not kill the flight . . .
> How much do I long for the quiet deserts, from now on with me!
> Will speak dark and absorbed my arms because the day of no fear would have begun.
>
> The cliffs explode again . . . for ever the valleys overflow and burst again slowly with a lot of space until they are in spontaneous spaces.
> Hit magic and dark my screams fondling in impossible steps of all the Advises because it would have sound the night of no shutting up.
> The rocks crack . . . with a scream the suns return and hide slowly with a lot of space until engaging in spontaneous sounds.[7] (n. pag.)

Although the passage is certainly a fragment, the opening line's "quiet gardens forever feared," draws the reader into a speculative internal dialogue that is sustained by characteristics of the programming in the lines that follow. The effects of the poem are heightened by sophisticated, surprising images ("crying in smells never imagined") and by fusing words to create new words, as with "despaciadamente," in the second and later sections, from which the phrase "slowly with a lot of space" is derived (i.e., "despaciadamente," is not a word but its roots are: despacio = slowly; espaciadamente = with a lot of space). The lines continue to approximate a reflective narrative of torment and realization with poetic lilt (e.g., "world of the night do not kill the flight") and dramatic sense, as in the juxtaposition presented in the fifth and sixth sections, "How much do I long the quiet deserts, from now on with me!/Will speak dark and absorbed my arms because the day of no fear would have begun." Reading the combination of lines in this example requires work, as it does in sophisticated conventional poetry, and any cumulative meaning or understanding is established by the reader, who is challenged to create the circumstance given the framework and loosely directed verbal scheme. At the end of the passage above, the invented language (such as "despaciadamente") leaves room for speculation. This poem literally displays a momentary reflective pause in a litany of text created by Carmona's program, which does not apparently conform to pre-configured structures and thus appears as a more versatile variety of randomized work.

The imposition of dramatic and mysterious elements is enticing. A second ten-line sample created by the program embodies similar themes of darkness, loss and sound/soundlessness. This example also sustains itself by mixing questions, assertions, and ponderous statements; poetic invention and foible (as above) is also present: the phrase "desde ahora" (from now) is used to vitalize the expression and force of the poem, putting the construction of the idea into the present moment. The fact that the phrase did not appear again in numerous other poems generated by the program speaks to the program's flexibility, an attribute that will keep viewers engaged. One can find similar rhetorical techniques between the two examples, though the syntactical construction is not

at all repetitive. Viewers are led into the poem in much the same way, with speculation and a natural setting: "How many wish the dark silences in my dead madness . . . /Secret night you do not open the moon . . ." As before, sentences vary in length and sophistication, and usually contain active imagery that revolves around the established themes, as in the line: "Dark and misplaced will sound your kisses kissing the thoughts apotheosis of all the blows because it would have sounded the minute of not fearing." In subsequent activations of the piece, poetic techniques such as isolated repetition of line structure are used to propel the work (e.g., "Secret night you do not kiss the laughter . . . /Secret laughter you do not open the night . . .").[8] The composition captures a troubled voice, one of a lonely person who imaginatively embraces the span of his or her existence and the end of life. Dramatic sensibility, surprising imagery, and tormented narrative startle the reader due in part because of their machine-modulated condition. The articulations of the program, written by a person but projected by a computer, may not be taken as seriously as the madness in the lines of Edgar Allan Poe or other poets who included such dramatic features, but they are convincing evidence that emotionally driven content can be projected by the apparatus. Various degrees of humor and irony are also supported in these effectively randomized, unique cyborgian texts.

Digital authors clearly have the ability to permute a poem into an endless series of new poems. The programming serves to reassemble a given text, or what Barbosa and others have referred to as the "text-matrix" (e.g., on *Syntext*, Barbosa *Cityman Story*,[9] Robin Shirley "Cosmic Poems"). In this process, one poem becomes the foundation of, as Jean-Pierre Balpe describes as an "infinite, not eternal" chain of subsequently produced works.[10] Barbosa's "Cityman Story"[11] is an example of this style. Described as a "synthesizer of narratives" on its title page, the program is written to recycle the language of a "text-matrix," which is an unspectacular 14-line poem that lists occurrences of a mundane life in confessional form:

> Here is a 35 year old man
> Every morning he takes a bus
> Gets in the office
> catalogues index cards
> lunches in the city
> recatalogues index cards
> drinks two beers
> Returns home
> kisses his wife
> says hello to the children
> eats a steak with the television in the background
> lies down
> fornicates
> falls asleep.[12]

Barbosa explains he was listening to the radio when he heard an unidentified text that he felt would be good to use in testing narrative structures in automatic variations. He retained the text by memory, and subsequently deconstructed the original

by inaccurately adapting the text-pattern structure as a model for this unlimited variational story.[13] In essence, the resulting, "cut-up" work adapts the language of the original to produce a series of texts that portray surrealistic (absurd) and humorous characteristics, in which "there are progressive degrees of freedom".[14] Many distinctive "stories" are told, all using the same language to portray wild deviations from the mundane occurrences found in the source text, driven by Barbosa's determination to subvert the status quo of his subject. Each version of output is formed with the same phrase (i.e., "Here is a . . ."), but the "voice" of the poem also takes on alternative identities, such as the city or the bus, as seen in these fragments of generated text excerpted from the beginning of two different activations:

> Here is a bus of 35 index cards
> Every morning he takes a man
> Gets in the office
> classifies two wives
>
> . . .
>
> Here is a city of 35 wives
> Every morning takes a bus
> Says hello to the television
> Gets in the background.[15]

The program does not necessarily elevate the status of the initial poem but does, in its transformation of the base text, retain a type of narrative while transforming the language into something different, projecting a narrative by something or someone who is seeing the world from an alternative point of view. In another example, the man in the poem is "of 35 beers"[16]; a type of drunken rambling ensues—and is projected by the program in general—as if the man is confused and disoriented by this state of being, and life has led to delusion:

> Here is a 35 beer man
> Every morning he takes a bus
> Gets in the index cards
> classifies the years
> lunches the office
> reclassifies the years
> drinks two wives
> Gets back home
> kisses a steak
> says hello to the television
> eats the children with his wife in the background
> Lies down
> Doesn't fornicate
> Doesn't fall asleep.[17]

The first two lines in each of the poems begin with the same patterns but the subsequent verbal structures are not uniform. Completely alternative perspectives and

meanings, divergent from the original poem, emerge through the randomness of the subsequent lines' order and shape. The positions of the poem's phrases and the meaning they produce change in each example. Though the shape of each passage is relatively similar, Barbosa's programming design generates a variety of narratives from words originally composed for other purposes. Discursive capabilities of the program well suit the task of making fragments cohere while enlivening the initial humdrum character of the poem (whose existence is portrayed as typical and narrow in scope). In contrast to the "text-matrix," subsequent iterations are lively and peripatetic—the program serves to unite content and form in an imaginative way. Brief phrases that comprise "Cityman Story," collected from another source and originally used to form a poem, are able to intricately reconfigure a previously-written text and generate hybridized, contemplative, and humorous expression.

In these combinatoric works we see programs that deliver a range of varied output, making it worth the viewer's effort to produce and consume poems. This is not the type of reading material that one may want to turn to regularly. However, anyone looking for a range of unique derivations of texts can enjoy these programs, and could use the output as a starting point for their own expressive articulations.

Slots

A creative programmer can impose outside (artificial) order and formal structure in computer poems by designing a framework where only certain components are randomly filled by grammatically appropriate words. Assembling texts using different varieties of a slotted framework was initially pervasive in computer poems—the author created slots and the program randomly chooses words from a database (or "pool" or "deck," etc.). The slotted structure makes it easier for grammatical meaning to remain intact, as long as the correct types of word forms are inserted into the pool from which output text is selected. Literary forms are well served by such formations, as the program has only to fill in the blanks of a line in order to meet the needs of the form. Thus, for instance, meter is easier to control; words in the poem's verbal database simply need to conform to the required standard. Sonnets, haiku, and other metrical poems can be generated as long as words containing the correct syllabic formation are used to fill the slots. The only archetypal form that is found on *Syntext* is Tim Hartnell's haiku program, which uses varying combinatory techniques in order to minimize redundancy. Two authors did, however, create programs that produce aphorisms. A brief look at these works provides an opportunity to further analyze the possibilities for poetic proficiency in the automatic generation of text.

Aphorisms, like haiku, portray brief statements that result from a combination of observation and wit, although they are defined by tone rather than predetermined verse structure. Both forms are convenient for computerized re-formulation because they seek to dispatch a lot of information in a short amount of time and space. "Aphorismes," a slotted piece by Marcel Bénabou (a member of the Oulipo) is included on *Syntext*.[18] This generator, written with the program APL, produces 25 aphorisms at a time.[19] A sample activation of the program, from which the following examples are drawn, indicates that a number of different equations or slotted configurations are used to formulate statements that often reflect profound human insight. The author

has chosen structures such as "X is in Y, not Z," "A delivers B but C will deliver us from D," "Q is the continuation of R by other means," and other slotted patterns to communicate messages. Here are three pairs of statements culled from the same sample.

(1)
Beauty is the continuation of patience by other means. Ugliness is the continuation of the form by other means.
(2)
Science delivers evil, but what will deliver us from the present? Nature delivers beauty, but who will deliver us from ignorance?
(3)
Happiness is in horror, not in hatred.
Happiness is in negation, not in the universe.

In the first, and perhaps least interesting of the three juxtapositions, a simple antonymic permutation occurs in the first slot ("Beauty is the continuation . . ."/"Ugliness is the continuation . . ."); the shift in the second slot is more compelling in its divergent scope "continuation of patience by other means"/ "continuation of the form by other means." The first statement is philosophically insightful in its promotion of patience; the second is more ambiguous and possibly self-reflexive, making the reader think along multiple lines. Is "the form" the generated aphorism refers to the aphorism itself? Or, because it is computer generated could it be read as some sort of critical commentary on generated forms? In the second pair we can see another example of a basic binaristic switch in the second slot ("delivers evil"/ "delivers beauty") but otherwise all of these aphorisms rely on the sheer fact of randomness of the program to fill the slots with compelling juxtapositions and sentiments. The author/programmer studies the form, determines an effective linguistic framework, and prepares the database accordingly in order to generate meaningful poetic statements (both in themselves and when juxtaposed with other examples). In the third example the importance of including a variety of possibilities and sensibilities are underscored. Among the questions the author must have asked himself include, what, and what are not, potential sources of happiness? The opportunity to provide obvious answers to these questions, as well as to resist ordinary responses, are clearly options, and in the interplay of these possibilities—the chance juxtaposition of elements or answers—emerges the wisdom found in each expression. The accumulation of messages, made with the same and differing slotted structures, adds value and becomes its own type of humorous, unconventional, variable list poem.

 Barbosa's program "Aforismos-1" is similar to Bénabou's program, but is less complicated. When activated, the program produces a litany of 25 aphorisms, two-part sentences (each part containing its own slot) that pose or suggest questions and intimate randomized answers structured around four phrases, as in these examples (taken from the same sample of output):

> I make direct questions, you give upright questions.
> Who makes loaded questions, receives forgetful answers.
> For convex questions, obscene responses.
> She makes ceasing questions, he ruminates responses on water.[20]

What makes this work less interesting than Benabou's piece is that a relatively ordinary adjectival shift transpires. Randomized juxtapositions appear but do not effectively portray different contexts and possibilities for the language involved except when poetic phrasings appears. This happens only occasionally in "Aforismos-1," as in the fourth example above, where "ceasing questions" is a curious phrase and ruminating "responses on water," while slightly clichéd, requires more imaginative engagement on the part of the reader, particularly when compared to another excerpt from the same sample, "She makes offending questions, he ruminates forgetful responses." "Aforismos-1" simply randomizes language that fills the slots and the order of the lines. The aphorisms are readable, and the happenstance merging of elements has the ability to create unusual and paradoxical concurrences.

Seemingly simple slot formations are able to generate meaning on multiple registers even when strict parameters are imposed on a work due to the versatility of the vocabulary included in the database. This work demands that the author/programmer select words that effectively fuse with others and cohere with each aspect of the verbal equation. To this end, Barbosa and Bénabou efficiently explore of mechanics of language. In their constructions, a finite amount of programming code is used to write endless aphorisms. Beyond formulating the equations, the author selects imaginative materials to fill the slots. Closely connected variables call for setting up a range of language that will juxtapose effectively, which becomes more complicated in equations with more variables. Here phrases are made with clear, grammatically correct poetic language. Precise formulation of the sentences and permutations and use of constraint are reminiscent of works presented by the Oulipo group, whose members also wrote useful programmatic works and their efforts were also generally compelling.

Almost as an aside, I wanted to mention briefly two other aspects of the program. *Syntext-W,* an online version of program, is much reduced from the original, but in sum fairly represents Barbosa's approaches to composition. Convenient features absent from the original, such as allowing the viewer to adjust the speed of, and loop, the output, are added here. Thus, while incomplete in terms of content, characteristics of the original are preserved and *Syntext-W* is easier to access and to use, even if it is only minimally interactive and does not enable the viewer to input text. Lastly, dialog created by the program has been used by Barbosa in the construction of the dramaturgy for his electronic opera "Alletsator" since 2001. I have also heard that engineers who are building the 3-D version of "Alletsator" are planning to incorporate live generation of text into the avatar's voices, which could be very interesting. I mention, and take the time to introduce these recent developments not only as information or as basic scholarly follow-up, but also to promote the activity of radical re-versioning (or doing significant renovation on, or re-applications to older works), and putting different programs into play with one another.

Comments

All works of text-generation, or archetypal computer poetry, can be seen as performing some type of permutation in that they transform or re-order one set of base texts or language (i.e., word lists, syllables, or pre-existing texts) into another form.[21] Works

from *Syntext* not only demonstrate the flexibility of computer poems, but also clearly establish that the careful arrangement of elements and negotiations between random factors become the forces that determine the quality of this form of digital poetry. In these examples, motivations beyond reifying basic Dada impulse are present in most works. Generally speaking, the "syn-" prefix affixed to "text" in the title can be taken literally. Works (texts) produced by the programs contained in this title are synthesized and synthetic poems or prose poems that do not spring from a natural, singular source.

What is perhaps most utterly intriguing is that the texts generated using *Syntext*, which come in to existence somewhere between chaos and order, deconstruct human language to find new meanings. Literary and cultural routines are subverted by the computer, the programming of which manages to preserve the poetry in a readable and interpretable state. *Syntext* is a valuable experiment because of its technically proficient use of cleverly devised language and capable syntax. Seeing these productions is an informative experience, which not only shows that computers can capably co-create poetry but that entire—potentially infinite—readable anthologies of such work have been produced. Using these programs that create readable texts is stimulating in several ways. They can quickly transform its audience's mindset, as poetry and literature have done since its condition as an oral form, with the push of a button instead of turning a page or sitting in the audience. Someone who is interested in reading something that will perhaps jar his or her senses will especially appreciate these programs.

Notes

1. Nearly half of the contents are programs that stem from Barbosa's own works produced in the 1970s, 80s, and 90s. Works by Marcel Bénabou, Herberto Helder, Angel Carmona, Robin Shirley, Nanni Balestrini, E. M. Melo e Castro, Aldemar Costa, and Tim Hartnell are also presented. In the original versions, Syntext engages with DOS language on the user's computer and appears in ascii (i.e., plain) text.
2. Philippe Bootz, *Alire: Le Salon De Lecture Électronique* (MOTS-VOIR, 1995).
3. Pedro Barbosa and Abílio Cavalheiro, *Teoria Do Homem Sentado* (Porto: Edições Afrontamento, 1996).
4. The WWW edition uses Java to produce output, see http://cetic.ufp.pt/sintext.htm (accessed January 16, 2006). Pedro Barbosa, Jose Torres, and Abílio Cavalheiro, *Syntext-W* (2007); available from http://cetic.ufp.pt/sintext.htm.
5. Pedro Barbosa, "Porto," in *A Literatura Cibernética 1* (Porto: Edições Árvore, 1996), 101.
6. Another of Barbosa's *Syntext* programs, "Aveiro" (1977), also addresses a town in Portugal and is presented and performs in much the same way as "Porto," though it adds the verbal configurations "with" and "without" as a way to diversify and vary the way statements are formed around the river ("ria") and its water ("água").
7. Angel Carmona, *V2 Poems* (Syntext) (Edições Afrontamento, 1996).
8. Ibid.
9. Pedro Barbosa, *Cityman Story* [Diskette] (Edições Afrontamento, 1996).

10. Jean-Pierre Balpe, "E-Poetry: Time and Language Changes" (paper presented at the E-POETRY 2003, University of West Virginia, Morgantown, WV, April 23, 2003), 7.
11. Pedro Barbosa, "Cityman Story," in *A Literatura Cibernética 2: Um Sintetizador De Narrativas* (Porto: Edições Árvore, 1980).
12. Ibid., 69.
13. Personal communication, Pedro Barbosa, 2007.
14. *Syntext*, Edições Afrontamento, Porto.
15. Ibid., March 23, 2005.
16. Ibid., July 12, 2004.
17. Ibid., March 23, 2005.
18. Marcel Bénabou, "Aphorismes," in *Syntext* (Porto: Edições Afrontamento, 1996).
19. APL ("A Programming Language"), used to produce several works discussed in my study, was developed in the 1960s and refined over two decades. APL, as explained in an essay "Why APL?," posted on the Association for Computing Machinery website, was commonly used to direct a computer to process numeric or alphabetic data, "designed to overcome the inherent ambiguities and points of confusion found when dealing with standard mathematical notation" (n. pag.). APL was capable of the following: addition, subtraction, multiplication and division, calculating logarithms and exponentials, converting number bases, performing trigonometric functions, generating random numbers, rearranging arrays of numbers into different size and shape arrays, that is, vectors, matrices, and multi-dimensional "cubes," and many other mathematical tasks (n. pag.).
20. Pedro Barbosa, "Aforismos-1," in *Syntext* (Porto: Edições Afrontamento, 1996). July 12, 2004.
21. Each program in *Syntext* makes use of chance elements and permutation, yet upon close mechanical and critical analysis, three distinct types of work are present. In my study *Prehistoric Digital Poetry: An Archaeology of Forms, 1959–1995* I identify the permutation procedures of algorithmically-generated poems, and the works made by every generator in *Syntext* can be classified into at least one of the following types: works are either (1) permutational (recombining elements into new words or variations); (2) combinatoric (using limited, pre-set word lists in controlled or random combinations); or (3), slotted into syntactic templates (also combinatoric but within grammatical frames to create an image of "sense").

Bibliography

Balpe, Jean-Pierre. "E-Poetry: Time and Language Changes." Paper presented at the E-POETRY 2003, University of West Virginia, Morgantown, WV, April 23, 2003.
Barbosa, Pedro. "Cityman Story." In *A Literatura Cibernética 2: Um Sintetizador De Narrativas*. Porto: Edições Árvore, 1980.
—. "Aforismos-1." In *Syntext*. Porto: Edições Afrontamento, 1996.
—. *Cityman Story* [Diskette]. Edições Afrontamento, translated by Pedro Barbosa, Christopher Funkhouser, 1996.
—. "Porto." In *A Literatura Cibernética 1*. Porto: Edições Árvore, 1996.
—. Personal Communication, 2007.

Barbosa, Pedro, and Abílio Cavalheiro. *Teoria Do Homem Sentado*. Porto: Edições Afrontamento, 1996.

Barbosa, Pedro, Jose Torres, and Abílio Cavalheiro. *Syntext-W*, translated, 2007. Available from http://cetic.ufp.pt/sintext.htm (accessed on August 14, 2007). *Syntext*. Edições Afrontamento, Porto.

Bénabou, Marcel. "Aphorismes." In *Syntext*. Porto: Edições Afrontamento, 1996.

Bootz, Philippe. *Alire: Le Salon De Lecture Électronique* MOTS-VOIR, translated, 1995.

Carmona, Angel. *V2 Poems* (Syntext) Edições Afrontamento, translated by Christopher Funkhouser, Jorge Roa, 1996 [cited May 21, 2004].

Post-Chapter Dialogue, Funkhouser and Ricardo

FJR: One striking aspect of the works you survey is the care with which the authors balance both literal structure with regular repetition of a basic motif, as enzymatic glue to suggest a more explicit or specific frame of sense in very vague terms like happiness, horror, hatred, negation, universe, etc. Thus in variants like "Happiness is in horror, not in hatred / Happiness is in negation, not in the universe" the terminology paints a verbal pendulum of cosmic inference on both poles of a line maintained in equilibrium by the swing of the readerly eye from one end to the next. This seems to suggest a particular aesthetic for automatic digital poetry, namely one in which rhythm equates to the suggestion of meaning in a collective "meme montage." Is this strategy one whose heyday in the 1990s has been expanded upon today? It seems not, or at least not prevalently.

CTF: The binary circumstance for poetry turns out to be quite expansive if an author's ideas are crafted well. When the number of either/or statements is large, many different points of entry into a minimal number of words are enabled, in spite of constraints imposed by the author or its programmatic origin. When the craft of the poet (word choice, placement, delivery) is strong, and the idea of a composition is clever, as in the example of Marcel Bénabou's work you refer to (or Pedro Barbosa's "Cityman Story," also discussed in my essay), the results can be stimulating, if enigmatic or absurd.

A growing number of ways in which authors can attempt to make the "enzymatic glue" hold together are available now. Since more options for presentation are accessible today, modes of expression have unquestionably diversified. Whereas in the past the ways lines and symbols appeared were limited by confines imposed by ascii text, as in *Syntext* or *Alire*, today any kind of text, from any source, can appear or disappear in countless ways. Variation and media expansion within works have shifted artistic focus into new areas. Since more is possible in the field, authors are conceptually and textually expanding the dimensions of digital poetry, and automatically generated poetry is now only a small part of the picture.

Many generators on the Web are extremely basic; some fairly sophisticated examples[1] are also available. Everything—written or programmed—has its limits, but when authors had less to work with, it seems they sought to find ways to conceive and generate poems in which much could be derived from a minimal amount of information and, comparatively minimal technical capabilities. One reason I respect the historical work is because the compositional scenario was much more challenging, plus a global community had not formed and fewer models were available. Permutation has become less of a driving force in digital poetry, but it still exists, even in non-generated works such as Jim Andrews's "Stir Fry Texts",[2] in my text-movies,[3] and elsewhere.

I like the phrase "meme montage." A montage of memes still occurs in the best works, where language and image, through media and sensory information, connect through different types of authorial rhythms (also dissonance). Since establishment

of absolute, explicit meaning is not required of the digital poem, new forms of artistic communication are becoming possible.

FJR: This structural figuration is very reminiscent of more fastidious Dada verbal craft; one imagines Kurt Schwitters's *Great Moments in Modern Art from October 1922*, which reads in part

- Black on green, black type on green paper
 Caslon Bodoni Baskerville
 edge wedge edge
 a wedge of paper strip of paper
 blue china chip playing card
 a feather
 enamel on ivory

CTF: Exquisite passage! Whether or not Schwitters was a purist with his randomness (he probably was, but also probably "generated" many examples to choose from), I sense here a type of artistic magic—free juxtaposition of verbal elements. Unexpected things—images—make me envision any number of imaginary scenarios and each object becomes multifaceted. This is a far cry from Williams's "The Red Wheelbarrow"; I can understand why not everyone might appreciate this type of poetry, yet the variability and versatility are pleasing to me. At one moment the accumulation of words/poetic images conjures for me an adulterated piano, the next as a collage of discrepant objects suggests a literal still life. The fact that two (or possibly many more) different dimensions emerge is among the attributes that qualifies much of Schwitters's work as poetry.

FJR: A comparison with the output of other kinds of poetry generators seems to suggest that the bounds of ambiguity which fuel poetic imagination are not infinite, that there are something like rules or limits to the extent of linguistic permutation, and that what qualifies as "interesting" is more elusive than first seems to be the case with programmed poetry. Since my experiments with the online Dada Poetry Generator[4] have produced something with very little of the color or discursive dimension in the programmatic works you have written about, the ineluctable question emerges about non-interestingness in this genre. The works cited in your book[5] exhibit a distinctive character and cohesiveness that reads well; they even do something that good (human) poems do, which is to impel speculation on the emotional horizons of the poet as part of the interpretive and reflective experience of taking in the work. Of course, we cannot think of an algorithm as something similarly capable of being "inspired," so the reflective moment goes doubly far back, to the poet/programmer. I like to feel the rustle of the poet's anxiety in the work, and to compare (perhaps none too formally) the world of the poem with that of the poet as I understand it at the time the work was created. Does the absence of an immediate biographical substance as "creator" of the work shape your relationship to the work, or does your reading method approach all poems in the same way, regardless of whether they were created by human or a system?

CTF: I'm not sure that the reception of the poet's anxiety drives my interests. Just seeing a fluid presentation of a resourceful objective can be enough to stimulate me

greatly. Beyond that, I like being steadily surprised by a digital poem most of all. Surprise, coupled with beauty of "lyric" (concept expanded to include other expressive possibilities beyond words), is poetic, and is foremost among the elements that have attracted people to art and literature throughout the ages. In the multimedia age, one can still expect as much from poets. Irrationality conveyed by automated digital programming or design may be part of what sparks the attraction.

Clearly some generators are more versatile and interesting than others. Works like the Dada Poetry Generator serve a purpose well in the context of making a Dada poem, but the results naturally become redundant and tedious fairly quickly. Extended formulaic pointlessness, accumulated, will eventually displease anyone but diehards and compulsive Dadaists. Patience, willingness to wait for an interesting work to emerge from a generator (like a pioneer sifting a river for gold nuggets) is helpful, as is some luck. Even the best poetry generators tend to become tiresome, either because the language is too repetitive, or because too much nonsense emerges. I cannot tell exactly how many days I spent generating and then selecting materials to write about in my book, but the process (which often included translation) took many months. In the end, generated poetry, despite its compelling attributes, typically propels too much noise and not enough signal. I suppose, however, that that depends on what the individual reader/participant seeks to accomplish or achieve. Along the way, the reader/participant's experience working the poem, and texts derived from the machine, can be significant, or at least be a creative springboard and lead to a composition or readerly event that would not have occurred otherwise.

Absence of biological substance is not something that has particularly bothered me thus far, probably since I am aware that all works have an author lurking somewhere in the background. While it is bound to happen, we have not yet reached the point of an artificially intelligent poetry—a program that can program itself to make a poem. When we do, and the results are less than impressive in terms of originality, I may have a different perspective on the matter.

FJR: It is necessary to ask about the extradiegetic dimension of the digital poem. It appears that narrative, in its creation of a reflective world, depends on some sequence of descriptive moments that make sense together. But in digital poetry each line is largely disconnected from depiction in previous lines. There are technical reasons for this, a model of narratival continuity and referential integrity is nontrivial to implement; we have the fine line between preservation of sense and creative monotony. What sense of a fictive world is evoked in digital poetry when the mechanism revolves around the generation of the vivid, perhaps eloquent, but often abbreviated cut?

CTF: For me, as someone steeped in classical traditions but who became a connoisseur of, and practitioner in, open and experimental forms, discursive approaches had already conquered narrative even before I became involved with computers. I can think of some programs in which lines in the output are semantically connected, but for the most part your observation is on-the-mark. A sometimes radical discursiveness is apparent in many examples of generated (and hypermedia) works. In your scenario, digital poetry really might be the perfect form in an A-D-D culture such as ours, but so far it has not proven itself as such on a mass scale. Digital poets have

the liberty to build a context for meaning rather than explicitly tell a tale, and the poetry produced, while sometimes rooted in modernist (i.e., coherent) techniques, is largely, expressively, postmodern. The type of reading the viewer/user is challenging, and most are not yet ready to embrace its demands, difficulties, and (sometimes) disappointments.

Some of the new settings for poetry also seem relevant here. In the 3-D "world" of Barbosa's "Alletsator" mentioned in my essay, or a place like Second Life—which digital writers such as Alan Sondheim and Sandy Baldwin have begun to explore— the fragmentation *and* vividness extends beyond language, yet also includes language along with imagery, characters (avatars), sound, and so on. These other stimuli are capable of transmitting lyrical (or contemplative) information. The complex multimedia context, which will ultimately grow to include automatically generated materials and dialog, requires us to approach reading in a new way, but such developments are exciting, and after a period in which technological refinements are made will be seen as progressive, or at least keeping in tune with the cultural possibilities for expression and human exchange.

Notes

1. Jim Carpenter's *ERIKA* and "The Electronic Muse" (ELO Collection Vol. 1) come to mind.
2. Cf. ELO Collection Vol. 1.
3. Cf. http://web.njit.edu/~funkhous.
4. http://www.poemofquotes.com/tools/dada.php?c=1
5. C. T. Funkhouser, *Prehistoric Digital Poetry: An Archaeology of Forms, 1959–1995* (Tuscaloosa, AL: University of Alabama Press, 2007).

Bibliography

Funkhouser, C. T. *Prehistoric Digital Poetry: An Archaeology of Forms, 1959–1995.* Tuscaloosa, AL: University of Alabama Press, 2007.

CHAPTER SIX

Geopoetics: Aesthetic Experience in the Works of Stefan Schemat and Teri Rueb

Katja Kwastek

Stefan Schemat: Wasser

The project entitled *Wasser* (Water) by Stefan Schemat is made for a specific location: a coastal area of the little town Cuxhaven, where the river Elbe opens out into the north sea.[1] The visitor to the work is provided with a daypack (which contains a Notebook computer, an attached GPS-device and headphones) and invited to walk along the beach and around the adjacent areas, an abandoned harbor, the boardwalk.

Figure 1. Stefan Schemat,
Wasser,
2004,
Locative media installation, Cuxhaven, Germany,
Site view
© 2004, Stefan Schemat
Image courtesy of the artist and Kunstverein Cuxhaven

The GPS-device transmits its current position to the computer, which activates sound files according to the visitor's position. Depending on the directions, movements and endurance of the visitor, the voices of different narrators build up a story, though not a linear one. Instead it comprises a network of situations, memories and actions regarding a woman that disappeared. The visitor becomes involved, addressed as a blind detective, and is asked to seek her. Sometimes the voices accost him or her directly, like *"Come on, move"* or *"As a blind detective, you should have brought a photo of her."* Sometimes, they seem to revert toward personal memories (*"But why did you run away?"*). At other places, they present scientific or philosophical statements about the weather or underwater phenomena. Often they then pass into thoughts about transformations or metamorphoses like *"As a shell, I am blind and deaf."*

The voices may represent distanced observers, protagonists of the scene, or may even compete with each other (*"Don't trust them!"*). The story oscillates between fact and fiction, dream and reality, present and future. At the same time, the voices are closely tied to the landscape, describe the surrounding sand and the shells, and the seaside weather. They also relate events that have happened—or are happening—at the visitor's location. The site thus becomes the setting of the plot, providing the imagery for the text. The visitor's impression is of walking in a film, being actor and audience at the same time.

It is the action of the visitor that shapes the spatial and temporal composition of the piece, determining the order and speed in which text and landscape interweave to become the work. The visitor becomes the physical, conceptual and executive center of the work, even if its fictional center, the missing woman, remains hidden.

Schemat's work is a hybrid between literature, fine arts, time-based and performative arts. Each of these disciplines can offer pertinent perspectives on the work, although each reaches disciplinary limits in interpreting it. One possible reason is that the foundation of aesthetic experience on the bodily activity of the recipient is in contrast with a basic condition of aesthetic experience itself, which is argued to be aesthetic distance. Hans Robert Jauss, pioneer of reader-response criticism, maintains that "aesthetic pleasure differs from simple sensuous pleasure by means of the differentiation of the ego and the object, or the aesthetic distance."[2] The aesthetic object constitutes itself only through the contemplative act of the recipient, itself enabled by detaching the reception situation from everyday behavior. As soon as the visitor is not only expected to visually perceive a representational piece, but to also actively realize an interactive artwork, the question of aesthetic distance becomes critical. The embodied action of the participant is mandatory for the realization of the piece and the artistic concept. By means of its realization the piece wants to be simultaneously explored and reflected upon.

My contention is that an analysis of the aesthetic experience at stake in the reception of interactive art can benefit from examining theories that concentrate on comparable configurations of experience, even outside the realm of the humanities. I hold that a fruitful approach may consider theories of game and play,[3] which also strive for contemplation within action. Ultimately, however, the complexity of the experience of interactive art forms exceeds that of game and play: in contrast to most games, the artistic configuration of the reception situation of interactive art both claims and reflects on the aesthetic distance deemed necessary for the experience of art. Interactive

art thereby introduces a level of reflectivity into the activity itself that distinguishes its experience from that of game and play.

I do not position Schemat's work within the opposing fields of ludology and narratology, asking whether it would be better to analyze the work either from the perspective of theories of drama and narration or from the perspective of game studies.[4] Nor will I pit art history against performance studies. Instead, I want to scrutinize the specific mode of aesthetic experience at stake in the work, evaluating criteria, that—due to the work's hybridity—have to stem from different disciplines that are not restricted to theories of art in the narrow sense. Although important insights may also be gained from traditional text analysis or an analysis of staging, I focus on those aspects of the work that go beyond the scope of the traditional disciplines and thereby constitute its hybrid character.

Geopoetics[5] as Hybrid between Literature, Film, Visual and Performing Arts

Within literary studies, Schemat's work can be addressed as a dramatic production. In terms of content, it is a crime story told by alternating narrators. Due to its use of acoustic media, it is cognate to a radio drama, whereas its non-linear structure equates it with a hypertext.

The story has a fixed starting point, to which the visitor is sent after borrowing the devices. The way to this point follows the boardwalk, which is confined by a wind-shelter on the one side, and by the embankment on the other. Straying from the path is thus practically impossible.

Figure 2. Stefan Schemat,
Wasser,
2004,
location of starting sequence, Cuxhaven, Germany
© 2004, Stefan Schemat.
Image courtersy of the artist and Roman Mensing, artdoc.de

This ensures that every visitor reaches the first text segment. It immediately emphasizes the interrelation of the temporal and spatial start of the work: *"Every story has a beginning. This is exactly the place, where you are standing."* This statement is followed by a short introduction to the story. The visitor is induced to assume the role of a blind detective commissioned via telephone by a man looking for his daughter. Prior to being sent off, the visitor is advised—a matter of course for a detective—not to believe everything heard: *"Don't ask how to solve the case—just start [. . .] Come on, hit the road."*

Proceeding in one of several directions, the visitor frequently encounters further utterances, spoken by a woman or a man. The "detective" may be addressed directly, encountering first person monologs or third person narratives. Sometimes, the voices refer to concrete events or memories, sometimes they discuss the situation of the blind detective. But many of the texts operate on a meta-level, dealing with weather phenomena or generally discussing liminal situations, especially the experience of drowning (*"A drowning man has no time to wonder about the underwater worlds"*).

It is mostly the male voice that addresses the visitor directly and expresses alerts (*"They want to draw you into the ocean!"*). The female voice talks mainly about past events, her own memories of visiting the beach as a child. She also utters most of the scientific statements. Nevertheless a clear distinction of roles is not possible, each of the speakers also assumes the others' registers. Furthermore, the boundaries between recipient, narrator, speaker, and protagonist are sometimes blurred. If, for example, the female speaker says: *"at this moment, I need your help,"* it is unclear whether she is addressing the visitor or a fictive person within the story. The same is true for the male speaker shouting *"Go back!"*. Furthermore, the male voice, which starts out as a neutral narrator, becomes more emotionally charged elsewhere: *"Why do the voices always try to lure me into the ocean?"*. This example also shows that the voices are themselves addressed as active protagonists of the action. The same is true when the visitor is warned *"beware of being diverted [by the voices], keep your eyes open!"*.

Accordingly, there is no direct correlation between individual texts in terms of sequences or causalities in a coherent narration. Rather, the texts assemble a rhizome of potential connections with manifold layers overlapping but also contrasting each other. In addition to the actual overlapping of voices, active at some locations of the work, there are layers of different narrative perspectives as stated above, and layers of time patterns, and even single texts portraying distinct pasts: *"There was a moment on the first day, when I stood in this place, and I had the impression that I had never been here before."*

Also technically, unlike a hypertext, the work does not implement links originating from specific terms or sentences (which could indicate the content of related lexia). There is no branching structure in the strict sense. The visitor may stop to listen to a text until the end or continue walking, thereby risking to leave the respective zone before the text ends. No two texts are directly linked, but the artist can augment the possibility of a consecutive interplay of the texts through spatial proximity. The visitor selects the texts based on consideration of locations that seem interesting in relation to personal reception strategies and the respective construction of the work or the story

itself. Therefore the selection of texts is by no means entirely random but based on the spatial setting motivating the visitor's movement.

As a mediated drama based on visual, kinetic perception of the environment and passers-by, the work suggests a comparison with film. There are, however, no individual visual elements or sections comparable to film frames to be processed or structured by the artist. His only possibility to influence the *mise-en-scene* was the initial selection of the environment that locates the story and the association of every text to its location. But the visitor's movement is beyond artistic control, as is the appearance of the location at the moment of reception. Nor can the artist predetermine the direction of gaze and the distance between subject and object of the latter, as he can do within film editing by means of frame selection. Moreover, timing of the perception (and accordingly of the story) is determined by the visitor, who decides when to stop or walk on, or when to change perspective, whereas in film this is predetermined by means of cuts. The visitor decides, which visual phenomena to address, toward which direction to head, and at which speed. Personal movement replaces the movement of the camera, human eyes replace its lens. The visitor explores instead of passively watching. In this respect, Schemat's work actually literalizes Dziga Vertov's theory of the kino-eye, equating the filmmaker—respectively the lens of the camera—with the human eye. Whereas Vertov in practice nevertheless adheres to the pre-recorded and edited film, Schemat's work is based on the perceptive selections of the participant.[6] Furthermore, visual impressions of the audience are not mediated, as is the case in film—Schemat's are not pictures in the narrow sense, but environment, matter put on stage by the artist.

The fact that the artist founds aesthetic experience on physical matter in turn suggests a view to the work in relation to fine arts. Works subsumed under this category are traditionally expected to have a material form, a spatial extension.[7] In Schemat's case, the work can be described as (immaterial) software, *filled* with sound files, related to GPS-data. But there is also materiality, a spatial dimension to the work. Its operating range is subject to compositional arrangements, as is the space of painting or sculpture. The texts are composed spatially, the distances—or overlaps—between them are predetermined, and are positioned in directions defined in relation to one another. There are centers featuring an agglomeration and superposition of texts; contrasts like short, irritating statements, and calmer zones with less information provided. There are positions where the text refers directly to the site, and others where it associates more freely.

Unlike most works of visual art, however, the composition is not located in a neutral space. The coordinates link the data to specific locations, which thereby become part of the work in a material sense. Insofar as the work is located within the landscape and *stages* it at the same time, Schemat's *Wasser* can be compared to land art. This parallel applies not so much to earthworks like those of Robert Smithson, actually transforming matter, but to works that explore landscape by means of temporary actions, like Richard Long's early *Walking a Straight 10 Mile Line Forward and Back Shooting Every Half Mile.* (Dartmoor England, January 1969).[8] In this 1980 project, Long walked through a landscape following strict conceptual specifications. At every half mile he shot a photograph, documenting each respective view. Stefan Schemat

also stages movement within landscape. He emphasizes specific zones, but—in contrast to common concepts of land art, he also intertwines them with new narrative contexts. And the landscape tells its own story; as part of and stage for the work it is in itself very heterogeneous. On the one hand, the river mouth of the Elbe and the tidal flats are the venue of primordial natural forces. There are few places on earth where tide cycles are so impressive. The resulting natural phenomena are one of the subjects the texts dwell upon, but they are not merely described in terms of a translation of visual impressions into text. Instead the texts contextualize these impressions from different perspectives. They offer scientific explanations, poetic translations and narrative adaptations, thereby adding new, often associative dimensions to the experience of nature.

On the other hand, the landscape is man-made. The beach is artificially accumulated, the waterway is bordered by a stone wall to prevent it from filling up with sand; another wall, the embankment, prevents flooding. Stone banks are installed as wavebreakers, wooden fences as wind shields. A paved boardwalk, a beach bar and beach chairs serve the tourists. Accordingly, the texts are not confined to a contextualization of the natural phenomena, they reflect beach life as well, as when the detective is invited to interrogate passers by (*"so you can walk across the beach, show people the photo and ask: Have you seen this woman?"*) or when the female voice remembers having been at

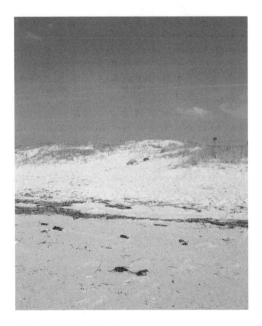

Figure 3. Stefan Schemat,
Wasser,
2004,
Site view (detail), Cuxhaven, Germany
© 2004, Stefan Schemat.
Image courtersy of the artist and Roman Mensing, artdoc.de

the beach as a child (*"I forget the days in the beach chair, covered by a blanket"*). There is a third characteristic of the landscape, represented by a historical sea mark and an abandoned harbor: signaling that navigation was and is an important economic aspect of the region, they also indicate the historical evolution of navigation technologies. Though no textual reference to this is uttered, the underlying structure of the work connects to the topic. When no texts are heard, the sound of sonar is played at frequent intervals, thereby building a kind of subconscious layer interweaving the heterogeneous texts.

Stefan Schemat chose the location for its ambiguous environmental characteristics, where natural phenomena, tourist life and nautical references come together. As mentioned, he emphasized specific locations through the positioning of texts, but he couldn't change or influence them. Rather, sound and texts add another layer to the landscape, enriching it with stories, explanations, associations, and memories. But if I argued that the text does not merely describe the landscape, the landscape also does not merely ground the textual fiction within reality. The text instead transforms the landscape into a world of associations, metamorphoses, and ambiguities. Landscape and text thus build a texture woven from reality and fiction, blurring the boundaries between documentary description and poetic or narrative imagination.

Still, if the work's instructions were followed literally, the visitor wouldn't be able to see the landscape. As described, the visitor is at the outset addressed as a blind detective and asked to close her eyes. This demand shifts our focus to another aspect of the work not yet considered. The work offers a variety of sensations that are not based on sight. As an object of embodied experience, the landscape offers a multitude of different stimuli: in addition to the wind as a characteristic feature of the region, water, sand and tidal flats, stone and asphalt, grasses and wood can be sensed in their heterogeneous materiality. Olfactory sensations are also stimulated, through odors ranging from the salty intensity of the sea air to the artificiality of perfumed sunscreen. Wind and water can be felt and smelled. They could also be heard, if the headphones the artist uses did not seek to prevent background noise. Unlike the visual, haptic and olfactory impressions, the acoustics are subject to the nearly complete control of the artist. The importance of embodied perception in the work thus offers another layer of aesthetic experience. In architecture, this experience always played a prominent role. Its importance in fine arts has been realized mainly since the mid-twentieth century. Allan Kaprow for example, who introduced the concept of happenings, filled the courtyard of a gallery in 1961 with tires to sensitize the visitors to the aesthetics of bodily sensations.[9] Although activation of multisensorial perception can be observed in various fine arts contexts nowadays, it is not a necessary condition of fine arts but marks a smooth transition between the fine and the performing arts, which, since the post-WWII period allowed for crossovers between the genres, as in happenings, action art and performance art.[10]

Schemat's project draws parallels to the performing arts in more than its general arrangement as a time and action based project. It also features concepts of so-called performativity, as defined by Erika Fischer-Lichte. She applies the notion of performativity to contemporary performance practices, emphasizing that the traditional foundation of artistic expression in symbols gives way to the reality and materiality of action. At the same time the traditional distinction between subject and object, in terms of actor and audience or representation and real life, is weakened.[11] For Fischer-Lichte this

is achieved through a provocative violation of norms or a recuperation of real life into the performance. However, this does not indicate a paradigmatic displacement of symbols and illusion through material and reality. Fischer-Lichte specifically identifies the oscillation between these aspects as the main characteristic of performativity. Schemat's work likewise bases form within action, resulting in the grounding of meaning in activity and reality. The materiality of the everyday environment and the acoustically mediated artistic texts also constitute two poles in his work between which the visitor's action and perception oscillate.

However, there are fundamental differences between interactive artworks and performative practices. In performance art, visitors retain the role of audience members, in action art or happenings, they are prompted to participate in actions together with the artist. Nevertheless, in both cases, the realization of the work—regardless of whether the audience remains passive or becomes active—normally requires a co-presence of artist and audience. Fischer-Lichte emphasizes that in the performing arts the simultaneous presence of artist and audience enables an *auto-poietic feedback loop*. She thereby describes the mutual process of negotiation in the course of the performance, controlled neither by the artist nor audience alone. This feedback-loop makes distinctions between aesthetics of production and aesthetics of reception impossible.[12] The work is an event simultaneously created and experienced by artist and audience. Interactive artworks, however, constitute an artistic offer that, once presented, can no longer be modified by the artist. The aesthetics of production and those of reception can be clearly distinguished; the work takes part in both without acquiring perceptible materiality beyond these processes.

Understood as action that is choreographed but not realized by the artist, the interactive artwork differs from the art genres thus far considered. Nor is comparison with music satisfactory, since the realization of interactive art is left to the audience, whereas the musical performer is a trained interpreter who can be addressed as an agent of the artist. In interactive arts, the fact that the audience takes the part of the performer leads to a further characteristic distinguishing such art from other works of literature, fine arts, or music: there are no readers, viewers, or listeners in the narrow sense; the visitor is audience and actor at the same time.

Game Studies and Geopoetics

At this point it seems appropriate to leave the realm of theories of art and to consider another form of aesthetic experience with intriguing parallels to aforementioned criteria: the game. In the game an action is also predefined through frames and rules which can be realized anytime. In addition, the game does not call for the co-presence of producer and player. Nor does the game require an audience, save active participants, who strive for contemplation within action. It shares the ambivalence between real action and aesthetically motivated immersion into symbolic systems.

The comparison of game/play and aesthetic experience is not new, nor is the comparison of game and art.[13] But it was only around the mid-twentieth century that various authors (initially Johann Huizinga, followed by Hans Scheuerl and Roger Caillois)[14] elaborated a list of basic characteristics of the game that explain this analogy.

Notwithstanding partial differences, the consistency of their definitions is impressive. Game and play are characterized as a voluntary activity (Caillois, Scheuerl). The activity can be distinguished from real life and has defined temporal and spatial boundaries (Caillois, Huizinga). It is not productive (Caillois, Huizinga), has no predetermined course or ending (Caillois, Scheuerl), it is rule based (Caillois, Scheuerl, Huizinga), and fictitious/illusionist (Huizinga, Caillois, Scheuerl). Scheuerl adds another characteristic, discussed later: ambivalence.

These characteristics first of all simply substantiate the basic analogies between art and game that lead to their frequent comparison. Theories of the game can nevertheless offer new insights into interactive artworks insofar as they discuss these characteristics through behavioral features. These features, as has been shown, are central to the interactive artwork, as the active role of the visitor marks the aesthetic experience at stake. I focus here on two characteristics identified above; these provide crucial aspects exceeding the analytic possibilities of the humanities tradition. The first are the frames and rule systems defined within the game, guiding the activities of the participant, but at the same time existing independently from the actual course of the game; the second is the role of the visitor as both actor and audience.

Rules

Rogier Caillois examines game/play along a scale ranging from free improvisation up to strict observation of rules:

> [T]he rules are inseparable from the game. [. . .]. Nevertheless the game originally stems from a need for freedom and relaxation. [. . .] This original ability of improvisation and pleasure, which I call paidia, coalesces with a desire to master artificial difficulties, which I suggest to call ludus.[15]

Along this scale, Caillois identifies four variations of game and play: competitions (agon), games of chance (alea), disguise (mimicry), and frenzy (Ilinx). Only competition is characterized by a clearly defined goal which the competing players strive to accomplish. Kati Salen and Eric Zimmerman, in a recent book on game design, apply this criterion to distinguish play from game—a distinction that only exists in English. Whereas they describe play as "free movement within a more rigid structure," they define game as "a system in which players engage in an artificial conflict, defined by rules, that results in a quantifiable outcome."[16] They differentiate three categories of rules: operational rules, constitutive rules and implicit rules. I now discuss the impact of these different kinds of rule systems on Schemat's work.

Operational Rules: Operational rules are the 'rules of play' of a game. They are what we normally think of as rules: the guidelines players require in order to play. The operational rules are usually synonymous with the written-out 'rules' that accompany board games and other non-digital games.[17]

In terms of Schemat's work, these rules are quite simple. On one hand, they indicate the instructions given to visitors borrowing the equipment: they are invited to put on the daypack and headphones, start walking in the direction indicated, remain within a

roughly specified area and come back in no more than two hours. Furthermore, visitors are assigned a mission at the location of the first text: to search for the missing woman. They are also prompted to approach individual locations in order to activate further texts. The latter is actually already part of the second category of rules: *"The constitutive rules of a game are the underlying formal structures that exist 'below the surface' of the rules presented to players. These formal structures are logical and mathematical.*[18] The constitutive logical structure of the system controls the playing of a specific text once the GPS-device sends a defined coordinate. The program also contains further detailed rules regarding specific limits of tolerance, defining the radius of the sound zones, or settings that define what happens if a visitor moves out of a zone while a text is playing.[19]

Both categories of rules discussed so far are central to realization of the work, and while seemingly simple, it is their interconnection with the implicit rules that poses the biggest challenge in Schemat's work: *"Implicit Rules are the 'unwritten rules' of a game. These rules concern etiquette, good sportsmanship, and other implied rules of proper game behavior."*[20] This rule category is the most complex in terms of the reception of interactive art. It is closely related to the question of how participants frame the activity offered by the operational and constitutive rules. If they accept their role as blind detectives, they must obey the request to close their eyes. The primary goal should then be to find the hidden woman, no matter the cost. If they view themselves primarily as recipients of a work of art, they will want to reflect aesthetically on the work, to fathom its structure, to explore the interrelation of the different components of content and form. If they are mainly interested in the technological structure of the artwork, their main goal will be to uncover the underlying program. They will step in and out of special sound zones to see what happens, trying to identify the boundaries of the area or even attempt to unpack the technical devices to see how they work. If they mainly see themselves in the tourist beach life, as participants who happened to pass at the lending station and borrowed the equipment out of curiosity, they will be conscious of their somehow uncommon appearance and behavior, and may be careful not to attract too much attention and not to disturb other tourists, say, by coming close to their beach chairs. The implicit rules can thus not be distinguished from the frame within which participants perceive their activity. Unlike the frames of a game these frames are kept consciously open by the artist. Of course the visitor will not adhere to a specific frame setting as suggested above, but may regularly switch from one attitude to another. A central part of the aesthetic experience will be these unavoidable *frame collisions*, a notion from the work of Gregory Bateson and Erving Goffman[21] that has been applied to the realm of aesthetic experience by Fischer-Lichte. Their relevance for the aesthetic experience of interactive art will be considered more in detail below.

Experiential pleasure

Salen and Zimmerman investigate the effects of the interplay of the different rule systems on the game experience. They identify complexity as an important precondition of games:

> Complexity is intrinsically linked to meaningful play. Playing a game is synonymous with exploring a game's space of possibility. If a system is fixed, periodic, or chaotic,

it does not provide a space of possibility large or flexible enough for players to inhabit and explore through meaningful play. On the other hand, if a system is emergent, exploring possible relationships among game elements is continually engaging.[22]

From the perspective of informatics, Schemat's is a fixed system. The composition of texts in relation to the landscape is defined in advance, each visitor will find the same text at a specific position at any time. Complexity, in Schemat's work, is not based on underlying code, but results from characteristics that exceed informatic structure, and results from the interplay of textual world and physical space (including weather phenomena and social events) activated by the participant (within the boundaries of the constitutive rules) causing texts to appear in ever-changing contexts. Although Schemat's work can thus be addressed as emergent system, to succeed as a game in the narrow sense, it lacks an important quality mentioned above: it is not goal-oriented. Though the solution of a detective story is presented as a goal, it is by no means the basic criterion motivating the interaction. We might remember that at the outset, visitors are tempted to violate an important pre-condition of their assigned role, their supposed blindness.

Yet, even if the aesthetic experience is not designed as a game experience, this does not exclude the possibility of meaningful play. As a basic condition of meaningful play, Salen and Zimmerman reference the experiential pleasure realized within a given structure. This pleasure can be based on physical, emotional, psychological, or ideological sensations and can result from the reception of narrative structures, the solution of assignments, the exploration of unknown territories, self-recognition, illusionist delusion, or social activity. Any of these modes of experience is relevant to the aesthetic experience of Schemat's work: a narrative structure is not merely followed but individually constructed, the visitor is asked to assume various roles, and the framing conditions provoke an oscillation of the experience between reality and fiction.

As a central characteristic of experiential pleasure, Salen and Zimmerman define (game) flow, referring to Mihaly Csikszentmihalyi's notion of flow as "emotional and psychological state of focused and engaged happiness, when a person feels a sense of achievement and accomplishment, and a greater sense of self." Concerning game flow, they deduce:

> One aspect of game pleasure lies in the intensity with which it is experienced, the almost overwhelming sensation of play. Whether the pleasure rests in a cognitive response, an emotional effect, or a physical reaction, the experience of play, and especially play in games, can be strikingly deep.[23]

In Schemat's case, most visitors spent a long time with the work, listening and walking consciously. In addition to the high quality and variety of the text and its intonations, the multisensorial involvement of the visitor together with the close dovetailing of the different sensations is nearly overwhelming. On the other hand, due to the integration of the situation into the daily routine of tourist beach life, it can also be experienced as overtaxing. This is exacerbated as total immersion into the fictional world or into the artistic system is repeatedly impeded.

Immersion/collision of frames

A detailed consideration of strategies of immersion (respectively, its prevention or disruption) helps to understand the interrelations of rule systems and role models within interactive artworks and their impact on the aesthetic experience at stake. The notion of immersion is increasingly related to general situations of intense cognitive involvement and thereby equaled to the concept of flow as described above.[24] Traditionally however, it described aspects of illusionist experiences, especially in VR environments. Michael Mateas paraphrases Janet Murray:

> Immersion is the feeling of being present in another place and engaged in the action therein. Immersion is related to Coleridge's "willing suspension of disbelief"—when a participant is immersed in an experience, they are willing to accept the internal logic of the experience, even though this logic deviates from the logic of the real world.[25]

As we will see, the interrelation of aesthetic experience and immersion, in its ambiguous meaning of illusion and flow, is central to the analysis of interactive artworks and leads to the second characteristic identified as key for their analysis: the role of the recipient as both actor and audience. Already the aforementioned early game theories by Huizinga, Caillois, and Scheuerl emphasize fictionality and illusiveness as basic characteristics of game and play. If within the game, fictionality resides in the activity not being part of real life, within fine arts it denotes the difference between representation and the represented. In interactive artworks, both aspects merge. The participant performs an activity that is distinguished from real life and is presenting and perceiving at the same time.

However, the visual arts as well as interactive artworks offer different possible modes of reception. First of all, a work of art can be so perfectly illusionist that the viewer does not recognize it as such and takes the representation for reality. In interactive art, this would be the case if the user or viewer considered a situation as human communication, although interacting with technical systems. In traditional arts these kinds of effects were occasionally desired, but the idea of perfect illusion (which goes back to the legend of Plinius and Zeuxis) normally denotes a momentary illusion easily uncovered and is primarily relevant in the theory of art.[26] Interestingly, the realm of computer games has adhered to the primacy of illusion, but Salen and Zimmerman criticize this attitude as *immersive fallacy*.[27] They thereby subscribe to a general tendency of modern humanities that questions the value of illusionism as aesthetic principle. As Marie-Laure Ryan summarizes: "opposition to immersion—in both its literary and technological versions—runs rampant in contemporary criticism. The experience requires a transparency of the medium that makes it incompatible with self-reflectivity, one of the favourite effects of post-modernism."[28] There is, however, a middle path between immersion and self-reflectivity: In a probable mode of reception, the viewer realizes the illusiveness of the work, but does not reflect on it, primarily contemplating the technical skills of the artist and the resulting aesthetic structure. This recurs in art history and also applies to works of new media art: the visitor explores technical innovations that have been creatively implemented and interacts without too much

reflection. They are carried away by the work, as they would be in play, without questioning the illusiveness. This corresponds with the mode of activity termed flow by Csikszentmihalyi. Nevertheless, as Bateson emphasizes, each game-action is characterized by meta-communicative processes.[29] The special characteristic of game experience is due to the consciousness that it happens within a game: its activities refer to real life, but happen outside of it. This is the experience already described by Scheuerl's *ambivalence*.[30] It is the consciousness of playing that makes the special pleasure possible.

But though games rely on modes of double consciousness, they avoid internal breaks that would actively unfold this ambivalence, as does a substantial part not only of modern art, which intend to evoke participant reflectivity by scrutinizing their own illusiveness and encouraging a reflection of their media function.[31] Visitors of Schemat's work may defy the supposed goal of the work (locating the missing woman) by listening to a verse of text again and again, just because they like it. They may also further defy the rules of the work, that is, the instructions to close their eyes, because they do not consider them as binding. In terms of the question of blindness, for example, at another location the visitor is explicitly requested to open their eyes—the work invites a subversion of its own rules. At the same time, it invites a constant blurring of boundaries between art world and everyday life and vice versa: the outsider will not distinguish the visitor from an ordinary tourist, the participant will instantly realize her double-role as flaneur (participating in the everyday routines of a health resort) and recipient of art (aesthetically experiencing the activity realized by themselves). The ambivalence of the contemplation of art and tourist activity will guide visitors' reception. They will be conscious of the presumed absurd behavior—wearing headphones at a location offering rich auditory impulses itself. These irritations, already addressed as frame collisions, are basic elements of the aesthetic experience. The reflective mode of reception is the point of dissociation between art and game.[32] The oscillation between realization and rejection of action, observation of rules and free exploration of the artistic offer, identification, and reflection is also principally possible in traditional art forms. But it only becomes manifest in bodily actions in the case of interactive and participatory art. The visitor, in a double role as actor and audience, is invited to reflect on individual action by means of realizing the artwork.

Teri Rueb: *Drift*

The central importance of collisions of frames and the ambivalence between staging oneself and being staged is not restricted to experiences related to a fictitious story, as a comparison with another example of geopoetics will show. The work *Drift* by Teri Rueb was also created in 2004 for the same exhibition at the coast of Cuxhaven which presented Schemat's work.[33] Here, too, the visitor is lent a small daypack and earphones and asked to walk, but this time is encouraged to head toward the mudflats of the Wadden Sea.

The area within which the visitor may move is indicated, but since no initial path or starting point is defined, one meanders through the tidal flats. The walker experiences long periods of narratival silence, during which the natural sounds of the landscape

Figure 4. Teri Rueb
Drift,
2004,
Locative media installation, Cuxhaven, Germany,
visitor experiencing the project, Cuxhaven, Germany
© 2004, Teri Rueb

dominate: birds, wind, water, ship-motors, and one's own movement audible on the sandy, humid ground. Suddenly, the visitor hears footsteps and realizes that, this time, they are not their own. After a while, a voice begins to speak of a hike, a landscape, or a journey. Sometimes a sequence of thoughts will complete, sometimes suddenly discontinue, even if the visitor has stopped to listen to it. After a while, the sound of footsteps will also slowly disappear. Suddenly, another text starts, again heralded by footsteps. It, too, deals with questions of wandering, searching, or getting lost. The work stages fragments of literary text from James Joyce, Thomas Mann, Jean Jacques Rousseau, or Dante, which explore the feeling of being lost and disoriented, as do Dante's introductory verses to the *Divine Comedy*: "Midway upon the journey of our life, I found myself within a forest dark, For the straightforward pathway had been lost," or passages from Jean-Jacques Rousseau's *Reveries of a Solitary Walker*: "I let myself float and drift wherever the water took me, often for several hours on end, plunged in a host of vague yet delightful reveries."

A visitor turning back to hear a text a second time will be disappointed. She will hardly find the text again and end up wondering whether this is due to the difficulties of orientation in the tidal flats, to technical reasons, or if it is a conceptual component of the work. Searching and wandering are thus not only the subject matter of the texts, but also the mode of experiencing the work itself. It often requires long phases of lonesome ambulation through the fascinating landscape. Due to the absence of points of orientation, visitors are thrown back on themselves and their perception of the environment. If they finally enter a zone connected to data, it is like meeting a stranger who reflects on her own loneliness and disappears again.

The reason for the ephemeral nature of the sounds is revealed in a video projection accompanying the work: the texts wander across the landscape in accordance with the

Figure 5. Teri Rueb
Drift,
2004,
Locative media installation, Cuxhaven, Germany,
visualization of sound moving with the tide
© 2004, Teri Rueb

tides. This is why the visitor accidentally stumbles across texts that soon will move to completely different locations. The transience of data space relates to the character of the landscape: the landscape is also subject to constant change, it is flooded at regular intervals and subsequently emerges again in a new shape—determined by the weather, wind and currents of the sea. Sound and landscape form a symbiosis, the ephemeral soundscape is related to the cyclical movements of the tides.

Concerning rule systems, the work shows parallels as well as differences in comparison with Schemat's project. The operational rules are similar: here, too, a device is issued, a region is indicated to the visitor, a maximum duration is agreed upon. But there is no goal inherent in the work, which might be comparable to solving a crime story. The constitutive rules, however, are more complex. In Rueb's work, as in Schemat's, the visitor's GPS-coordinates activate the texts, but these are not permanently linked to the coordinates: the mapping of texts and locations is constantly changing. Only an additional time query defines which text is to be heard at which location. The underlying timetable changes daily according to the tidal calendar. As both Schemat's and Rueb's projects are works of interactive art, one could expect that the implicit rules—in relation to the respective frames, as described above—are similar. But this is not the case. Since in Rueb's work the visitor is not assigned a role within a fictional frame, he needn't decide whether to accept or reject this role. He naturally takes the role of the distanced explorer, analogous to the distanced observation common in the reception of art. But the work resists seamless contemplation by other means. It makes it difficult to contemplate the appearing texts and their relation to the environment, because it foils the expectations many recipients of interactive new media art may still harbor about its technological structure. Interactive new media art is frequently related to the expectation of complex, rich, and direct feedback processes. But Rueb undermines these expectations, allowing for long passages with no activation of sound or text, leaving the visitor alone with nature. Although Rueb does not embed this work in a fictional narrative, immersion is still central to the work and to the production of frame collisions. The different quotations from literature—in various different languages—are not combined into a fictitious setting or story; the texts remain separate, if related by their common topic. But Rueb employs another kind of illusionism, direct sensory deception, to lead

visitors to enhanced perceptions of the work. In their unpredictable intersection within the flow of perception, the natural sounds and mediated soundfiles are hard to distinguish. This is especially true for the footsteps: the visitor, doubting whose footsteps are being heard, those of other wanderers or pre-recorded sounds, remains unsettled, in turn bringing enhanced receptivity to the situations of disorientation outlined in the texts. It follows that in Rueb's work again it is primarily the implicit rules that challenge the aesthetic experience. Again, provoking frame collisions is central to the experience. This time, the work's structure does not collide with the frame of the story world, but with common expectations of new media art.

Spacing and Synthesis

Exploration of the sounds' origins also cultivates exploration of the materiality of the environment. Through the sounds, pre-recorded as well as real, a visitor's attention is focused on their own movement, their gaze turns toward the sandy ground of the tidal flats. The ever- changing tidal flats can be understood as a potent metaphor for our way of life and its foundations in matter. The instrumentalization of nature—or of the perception and experience of nature—as metaphor is possible because of the unique structure of the tidal flats. They constitute one singular plane without fixed roads or suggested tracks, but also without insurmountable obstacles. The possibility of not following paths, of being able to determine the direction of one's way autonomously is highly unusual in contemporary experience. At the same time, the huge plane of the tidal flats is structured by innumerable patterns. Wind and waves daily create new patterns on the humid, sandy ground, net-like structures consisting of bows and channels that open up, merge and divide again; they guide or block the movement of the shallow waters.

Figure 6. Teri Rueb
Drift,
2004,
Locative media installation, Cuxhaven, Germany,
structure of tidal flats, Cuxhaven
© 2004, Teri Rueb

This structure is overlaid by the mobile net of wandering texts. They create an immaterial realm of historical thoughts and narrations, or—from a technical viewpoint—of data streams. This realm is free floating, but connected to the spatial rhythm of nature, wandering with the tides. The French philosopher Michel de Certeau emphasized as early as 1980 that spaces are realized by moving through them:

> The act of walking is to the urban system what the speech act is to language or to the statement uttered. At the most elementary level, it has a triple "enunciative" function: it is a process of appropriation of the topographical system on the part of the pedestrian, it is a spatial acting-out of the place; and it implies relations among differentiated positions, that is, among pragmatic "contracts," in the form of movements.[34]

The German sociologist Martina Löw further analyzes the process of acting out spaces by distinguishing between *spacing* and *synthesis*. Spacing here denotes the construction of space through positioning social goods and persons and through positioning symbolic marks. And for Löw, the construction of space is, in addition, based on synthesis: goods and persons must be connected to build spaces through processes of perception, ideation, and recall.[35] Following Löw, the Wadden Sea is a place where no spacings can happen, or at least they occur momentarily and are blurred immediately. The transience of our spatial connections, our disorientation, and loss of spatial foundations is the subject of Rueb's work. It also illustrates the new qualities of processes of synthesis (perception, ideation, and recall) that not only connect people and matter (instead of goods) to build spaces, but also data and thoughts. Whereas in Schemat's case, the data are constantly bound to locations, Teri Rueb implements fleeting data.

Though Teri Rueb's work is less illusionist, not being tied to a fictitious background story, the interpretation just offered still operates on various levels of illusionism. In addition to the possible sensorial illusions stemming from the overlap of natural sounds and recorded sounds, there is another level of illusion at stake, this time concerning the technical structure of the work. As described, its aesthetic experience is based on a walk through fleeting clouds of sound, through a mysterious data space. Technically, however, the data space is carried along by every visitor within their daypack—all sounds are stored on a handheld computer in the daypack. The only direct connection to Hertzian space is through the integrated GPS-device, which constantly verifies the current position of the visitor. The computer then plays the soundfiles according to position and time (related to the status of the tides). Technically the work does not create or visualize/sonify a constant flow of information on the electromagnetic frequencies that surround us. The aesthetic experience, however, suggests a walk through clouds of sound and text, made perceptible by the participant themselves. This—in a way illusionist—experience develops the intention of the work to sensitize the visitor for the fluctuating streams of data, to connect them to the rhythms of nature as well as to our own real and emotional movements. This variant of illusionism is not directly reflected or disrupted within the work, showing that not every form of illusionism need provoke

reflection through immanent breaks; here, the illusion holds, and constructs an important aspect of the work.

The Aesthetic Experience of Geopoetics

Comparison of these works of Schemat and Rueb shows that the aesthetic experience they offer is strikingly different, notwithstanding the parallels concerning site, technology and the core mechanics of interaction (walk and listen).[36] Schemat interweaves locations, associations, and memories, both of the fictitious protagonists and the visitors of the work. He relates the mysterious heterogeneity of the environment to the mysteriousness of the story, encouraging the participant to interrelate subjective perceptions with those offered by the fictitious and metaphorical texts. Teri Rueb follows another path; she selects not distinctive locations, but a landscape alien to the constitution of permanent spacings, and addresses it as both stage and metaphor for the challenges of modern society, combining an embodied experience of disorientation with literary statements about this topic. She invites the visitor to actively explore an interrelated space of floating data and memories on one hand, natural rhythms on the other.

Marie-Laure Ryan emphasizes that "[d]uring the past twenty years, as structuralism gave way to deconstruction, the focus of interest in ludic metaphors has gradually switched from ludus to paidia, which means from the notion of game as rule-governed activity to that of play as subversion of rules."[37] Though I would not agree that play itself is defined by a subversion of rules, her statement is all the more true for the special form of aesthetic experience at stake in interactive art, relying on but at the same time exceeding play. This is the case because the rules are actively subverted by the artworks themselves to provoke a reflective reception, thereby reinstalling the aesthetic distance necessary for aesthetic experience into the behavioral experience of actively realizing an art piece.[38] Both works rely on frame collisions, they operate at the interstice of different levels of fictionality and artificiality. Though both of them apply a technology that is commonly associated with surveillance, exact navigation, and orientation, both of them rely on an unsettling, disorienting experience. Rueb's work can be interpreted as a critical commentary on the expectations we have of contemporary media society and also new media arts: do digital media really offer the high-tech communication paradise they are praised for, or do we ultimately only lose ourselves within the information flow and within our own expectations? Schemat irritates the visitor by sending her on a search whose failure is pre-assigned. He draws her into different roles and overburdening inconsistencies that nevertheless, due to the intense experience enabled, are fascinating and even addictive. He creates intense layers of mediated experience, challenging the visitor to master personal exposure to the different overlaps of fictionality and reality that become more and more common in our contemporary society.

The works of Schemat and Rueb are representative of interactive works that do not attempt seamless interaction, trying instead to provoke a reflective attitude through

unforeseeable breaks, provocative challenges or unresolved prompts. Through the reflection provoked by frame collisions, the emergence of meaning re-enters the process of the experience. A discussion of Espen Aarseth's characterization of games helps to identify once more the respect in which interactive art exceeds the game: "Any game consists of three aspects: 1) rules, 2) a material/semiotic system (a gameworld), 3) gameplay [. . .] Of these three, the semiotic system is the most coincidental to the game."[39] Even if rules and playful experience are central to the works considered here, the semiotic system is by no means coincidental; in both works we are confronted not with one coherent semiotic system, but with different levels of symbolicality, that, in their dependence on user action and on their material grounding, lead to the state of oscillation between symbolicality and materiality observed by Fischer-Lichte. This oscillation is set into motion only through the active realization of the works, guided by each participant's performative interpretation of their operational, constitutive, and implicit rules, awakening the special modes of aesthetic experience possible within interactive art.

Notes

1. Stefan Schemat, *Wasser*, 2004, Cf. Katja Kwastek, ed., *exh. cat. Ohne Schnur. Art and wireless communication* (Frankfurt: Revolver, 2004), 200–209.
2. Hans Robert Jauß, *Ästhetische Erfahrung und literarische Hermeneutik* (Frankfurt: Suhrkamp, 1991), 83.
3. The distinction between "game" and "play" is a special feature of the English language. To account for the fact that many classical treatises on the game in other languages do not make this distinction, the expression game/play will be used. The difference between the two notions will be discussed in greater detail later.
4. Cf. George Landow, *Hypertext 3.0* (Baltimore: Johns Hopkins University Press, 2006), 251; a recent attempt to combine both approaches is offered by Michael Mateas, "A Preliminary Poetics for Interactive Drama and Games", in *First Person. New Media as Story, Performance, and Game,* ed. Noah Wardrip-Fruin and Pat Harrigan, (Cambridge, MA: MIT Press, 2004), 19–33.
5. Geopoetics is a notion coined by Schemat to describe the interrelation of literary discourse and locative practices effective in his works.
6. Cf. Anette Michelson, ed., *Kino-eye: The Writings of Dziga Vertov* (Berkeley, CA: University of California Press, 1984).
7. In German, this is already suggested by the denomination of these artworks as "Bildende Kunst."
8. Cf. for this and further activities documented by Gerry Schum: Christiane Fricke, *"Dies alles Herzchen wird einmal Dir gehören": Die Fernsehgalerie Gerry Schum 1968– 1970 und die Produktionen der videogalerie schum 1970–1973* (Frankfurt am Main: Lang, 1996). For a general introduction to Land Art cf.: Jeffrey Kastner, ed., *Land Art and Environmental Art* (London: Phaidon, 1998).
9. Jeff Kelley, *Childsplay. The Art of Allan Kaprow* (Berkeley, CA: University of California Press, 2004), 58–62.

10. A good introduction into the interrelations of performance art, action art and their respective use of new media is offered by Thomas Dreher, *Performance Art nach 1945: Aktionstheater und Intermedia* (München: Fink, 2001)

11. Erika Fischer-Lichte, *Ästhetik des Performativen* (Frankfurt am Main: Suhrkamp, 2004), 63–67 and passim.

12. Fischer-Lichte *Ästhetik des Performativen*, 59–61.

13. See a more detailed account of the history of this relation in an earlier German essay on these topics by the author: Katja Kwastek, "Opus ludens. Überlegungen zur Ästhetik der interaktiven Kunst," in *Werke im Wandel? Zeitgenössische Kunst zwischen Werk und Wirkung*, ed. Lars Blunck (Munich: Schreiber, 2005), 155–171.

14. Johan Huizinga, *Homo Ludens: A Study of the Play-Element in Culture* (Boston, MA: Beacon, 1955); Hans Scheuerl, *Das Spiel. Untersuchungen über sein Wesen, seine pädagogischen Möglichkeiten und Grenzen* (Weinheim: Beltz, 1968); Roger Caillois, *Die Spiele und die Menschen. Maske und Rausch* (Stuttgart: Schwab, 1960).

15. Caillois *Die Spiele*, 36.

16. Katie Salen and Erik Zimmerman, *Rules of Play. Game Design Fundamentals* (Cambridge, MA: MIT Press, 2004) 80.

17. Salen/Zimmerman *Rules of Play*, 130.

18. Salen/Zimmerman *Rules of Play*, 130.

19. Salen/Zimmerman *Rules of Play*, 142 explicitly distinguish constitutive rules from the code of a digital game. Though of course there are important overlaps, they emphasize that "there are many other tasks that the code performs in the computer version of the game. The code has to manage the program's inputs and outputs (screen and mouse); the code has to interface with the operating system and memory of the computer."

20. Salen/Zimmerman *Rules of Play*, 130.

21. Gregory Bateson, "A Theory of Play and Fantasy," in *Steps to an Ecology of Mind* (Chicago: University of Chicago Press, 2000), 177–193; Erving Goffman, *Frame Analysis: An Essay on the Organization of Experience* (Cambridge: Harvard University Press, 1974), Fischer-Lichte *Ästhetik des Performativen*, 35.

22. Salen/Zimmerman *Rules of Play*, 165.

23. Salen/Zimmerman *Rules of Play*, 336. They refer to Mihaly Csikszentmihalyi: *Flow. The Psychology of Optimal Experience* (New York: Harper & Row, 1991).

24. Cf. Salen/Zimmerman *Rules of Play*, 452 and Marie-Laure Ryan, *Narrative as Virtual Reality. Immersion and Interactivity in Literature and Electronic Media* (Baltimore, MD: John Hopkins University Press, 2001), 14.

25. Cf. Mateas "A Preliminary Poetics," 21.

26. Cf. Bateson "Play and Fantasy," 182: "Conjurers and painters of the *trompe l'oeil* school concentrate upon aquiring a virtuosity whose only reward is reached after the viewer detects that he has been deceived and is forced to smile or marvel at the skill of the deceiver."

27. Salen/Zimmerman *Rules of Play*, 450: "The immersive fallacy is the idea that the pleasure of a media experience lies in its ability to sensually transport the participant into an illusory, simulated reality."

28. Ryan *Narrative as Virtual Reality*, 175.
29. Bateson "Play and Fantasy," passim.
30. Cf. Scheuerl *Das Spiel*, 88–93. Scheuerl uses the notion of ambivalence to refer to real movement, but also to movement in the figurative sense, between rule and chance, seriousness and amusement, nature and intellect. Already Hans Georg Gadamer, in his discussion of the game, emphasizes its characteristic "to and fro." Cf. Hans Georg Gadamer, *Wahrheit und Methode* (Tübingen: Mohr, 1965), 97. See also Espen Aarseth, "Genre Trouble: Narrativism and the Art of Simulation," in Wardrip-Fruin *First Person*, 45–55, especially 48 regarding ambiguity.
31. Cf. a. o. Victor Stoichita, *The Self-Aware Image: An Insight into Early Modern Meta-Painting* (Cambridge: Cambridge University Press, 1997); Erich Franz, "Die zweite Revolution der Moderne," in *exh. cat. Das offene Bild: Aspekte der Moderne in Europa nach 1945*, ed. Erich Franz (Ostfildern-Ruit: Cantz, 1992), 11–23; Erkki Huhtamo, "Seeking Deeper Contact. Interactive Art as Metacommentary," in *Convergence: The International Journal of Research of New Media Technologies* 1, No. 2 (1995), 81–104.
32. Even if Scheuerl, with the notion of ambivalence, allows for a certain degree of reflection also within game and play, he locates this reflection between the first and the second mode of perception (illusion vs. contemplation), but does not consider a reflection of the game itself. Scheuerl, *Das Spiel*, 88–93.
33. Teri Rueb, *Drift*, 2004, Cf. Kwastek, *Ohne Schnur*, 210–219.
34. Michel de Certeau, *The Practice of Everyday Life* (Berkeley, CA: University of California Press, 1988) 97f.
35. Martina Löw, *Raumsoziologie* (Frankfurt: Suhrkamp, 2001).
36. Concerning the notion of core mechanics cf. Salen/Zimmerman *Rules of Play*, 316f.
37. Ryan *Narrative as Virtual Reality*, 188.
38. Cf. Gonzalo Frasca, "Videogames of the Oppressed. Critical Thinking, Education, Tolerance and Other Trivial Issues," in Wardrip-Fruin *First Person*, 85–94, who discusses questions of aesthetic distance in relation to recent discussions within game studies: "One of the biggest problems of Aristotelian poetics as explained by such theorists as Bertolt Brecht is that spectators get immersed in the stories and lose their critical distance from what is happening on the stage or screen."
39. Cf. Aarseth, "Genre Trouble," 47.

Bibliography

Aarseth, Espen. "Genre Trouble: Narrativism and the Art of Simulation," in *First Person. New Media as Story, Performance, and Game,* ed. Noah Wardrip-Fruin and Pat Harrigan, 45–55, Cambridge, MA: MIT Press, 2004.

Bateson, Gregory. "A Theory of Play and Fantasy," in *Steps to an Ecology of Mind,* 177–193. Chicago, IL: University of Chicago Press, 2000. First publication 1955.

Caillois, Roger. *Die Spiele und die Menschen. Maske und Rausch.* Stuttgart: Schwab, 1960. First French edition 1958.

Csikszentmihalyi, Mihaly. *Flow. The Psychology of Optimal Experience.* New York: Harper & Row, 1991.

De Certeau, Michel. *The Practice of Everyday Life*. Berkeley, CA: University of California Press, 1988.

Dreher, Thomas. *Performance Art nach 1945: Aktionstheater und Intermedia*. München: Fink, 2001.

Fischer-Lichte, Erika. *Ästhetik des Performativen*. Frankfurt am Main: Suhrkamp, 2004.

Franz, Erich. "Die zweite Revolution der Moderne," in *exh. cat. Das offene Bild : Aspekte der Moderne in Europa nach 1945*, ed. Erich Franz, 11–23. Ostfildern-Ruit: Cantz.

Frasca, Gonzalo. "Videogames of the Oppressed. Critical Thinking, Education, Tolerance and Other Trivial Issues," in *First Person. New Media as Story, Performance, and Game*, ed. Noah Wardrip-Fruin and Pat Harrigan, 85–94. Cambridge, MA: MIT Press, 2004.

Fricke, Christiane. *"Dies alles Herzchen wird einmal Dir gehören": Die Fernsehgalerie Gerry Schum 1968–1970 und die Produktionen der videogalerie schum 1970–1973*. Frankfurt am Main: Lang, 1996.

Gadamer, Hans Georg. *Wahrheit und Methode*. Tübingen: Mohr, 1965.

Goffman, Erving. *Frame Analysis: An Essay on the Organization of Experience*. Cambridge, MA: Harvard University Press, 1974.

Huhtamo, Erkki. "Seeking Deeper Contact. Interactive art as Metacommentary," in *Convergence: The International Journal of Research of New Media Technologies* 1, No. 2 (1995): 81–104.

Huizinga, Johan. *Homo Ludens: A Study of the Play-Element in Culture*. Boston, MA: Beacon, 1955. First German edition 1944.

Jauß, Hans Robert. *Ästhetische Erfahrung und literarische Hermeneutik*. Frankfurt: Suhrkamp, 1991.

Kastner, Jeffrey, ed. *Land Art and Environmental Art*. London: Phaidon, 1998.

Kelley, Jeff. *Childsplay. The Art of Allan Kaprow*. Berkeley, CA: University of California Press, 2004.

Kwastek, Katja. ed., *exh. cat. Ohne Schnur. Art and wireless communication*. Frankfurt: Revolver, 2004.

—. "Opus ludens. Überlegungen zur Ästhetik der interaktiven Kunst," in *Werke im Wandel? Zeitgenössische Kunst zwischen Werk und Wirkung*, ed. Lars Blunck, 155–171. Munich: Schreiber, 2005.

Landow, George. *Hypertext 3.0*. Baltimore, MD: Johns Hopkins University Press, 2006.

Löw, Martina. *Raumsoziologie*. Frankfurt: Suhrkamp, 2001.

Mateas, Michael. "A Preliminary Poetics for Interactive Drama and Games," in *First Person. New Media as Story, Performance, and Game*, ed. Noah Wardrip-Fruin and Pat Harrigan, 19–33. Cambridge, MA: MIT Press, 2004.

Michelson, Anette, ed. *Kino-eye: The Writings of Dziga Vertov*. Berkeley, CA: University of California Press, 1984.

Ryan, Marie-Laure. *Narrative as Virtual Reality. Immersion and Interactivity in Literature and Electronic Media*. Baltimore, MD: John Hopkins University Press, 2001.

Scheuerl, Hans. *Das Spiel. Untersuchungen über sein Wesen, seine pädagogischen Möglichkeiten und Grenzen*. Weinheim: Beltz, 1968. First Edition 1954.

Stoichita, Victor. *The Self-Aware Image: An Insight into Early Modern Meta-Painting*. Cambridge: Cambridge University Press, 1997.

Post-Chapter Dialogue, Kwastek and Ricardo

FJR: Contemporary criticism and history of art and literature have evolved in response to the emergence of new expressive practices. Braque could not be analyzed from within a pre-Impressionist sentiment, nor could Ernst, Picabia, or Duchamp. When Minimalism emerged, Rosalind Krauss introduced Merleau-Ponty's phenomenology as critical optic. Your essay likewise makes an implicit case for the intersection between diverse disciplines analyzing the same digital phenomenon. That Schemat's work, for example, can be understood both through a game paradigm and within literary studies, where it can be addressed as a dramatic production, is not typical of new media scholarship, and you construct a rubric of shared understanding. Teri Rueb's work is more expansive, transcending even these approaches. You correspondingly add that "each of these disciplines can offer pertinent perspectives on the work, although each reaches disciplinary limits in interpreting it." I'm wondering whether multidisciplinary meta-analysis, while enlightening, isn't too unwieldy for new media art, and wonder whether you see, from each of these methodologies, the possibility of one unique or unifying voice of analysis that reflects the structural, experiential, the phenomenological, and the immersive uniqueness of artistic directions in new media. I might add that this is not limited to locative art or geopoetics, since highly transmodal work of artists like Kelly Dobson is equally opaque to established critical epistemologies.

KK: I am skeptical of attempts to establish universal methodologies for the analysis of specific art movements. This is all the more true for art genres—and I consider new media art a genre and not a movement. Certainly each art genre has characteristic formal features, that guide their analysis. One common feature of new media art (beyond its use of electronic media) is its foundation both on process and Gestalt. It is astonishing that in a society defined through more and more complex and interrelated processes, the aesthetic implications of this situation are largely neglected. What I find necessary is a new focus of the humanities on process aesthetics. While, for example, with sociology, an autonomous discipline has been established to describe societal processes and while informatics and information theory place great emphasis on developing and describing processes algorithmically, there is no sufficient vocabulary, let alone methodology, to describe the aesthetic of processes.

Nevertheless I would not advocate singular interpretive perspectives that could characterize any genre as heterogeneous as new media art. Of course specific movements within new media art, such as locative art or geopoetics, share common features, as I argued, but in the end, the works are unique pieces with very different artistic strategies. If one's focus is on singular artworks, they can never be embraced by one theoretical approach, and any analysis risks becoming fragmentary if done by one author alone. They need complementing and even contradicting perspectives to enfold their reflective potential and openness to subjective interpretation. Methods are important

for identifying tendencies and relating works to philosophical trends, but for close readings, I prefer keeping the framework open, as artists don't create either "phenomenological" or "semiotic works," and within new media art they mostly don't even create "literary" or "visual artworks." Of course this does not exclude concentrating on special features of works, which is often highly informative; I would just not claim any one universal methodology for their analysis.

FJR: You make clear in this essay that some of the significant originality of any art that is digital or electronic in nature lies in the possibility it holds out for *creative inversions, transformations,* or *variations* of various kinds. One of these is in the inversion of literature's traditional morphologies. Eight decades after its publication, Propp's *Morphology of the Folktale* is still relevant, even clairvoyant, as a roadmap to the forms and pathways of contemporary written and filmic narrative. But in digital media, Propp seems less relevant. In the narrative tradition, the diegetic world is where action happens; the extradiegetic, being what lies outside the frame, observes invisibly. Your observation, however, that in Schemat's locative fiction, "The visitor becomes the physical, conceptual and executive center of the work," whereas "its fictional center, the missing woman, remains hidden" locates just such a creative inversion of traditional form entirely absent from Propp's schema. There is in this inversion a categorical shift: the reader becomes the effective protagonist of the story, seeking, within a fiction, a character who herself is a fiction, for she never speaks, never appears, never leaves trails of her own existence. As a snare, she provides leverage for effecting the shift that conscripts the reader into the story's dimensions, that permits the reader to be plausibly addressed in the second person, and even to be assigned direct orders. The reader, once addressed from within the story by a character in it, crosses the conventional status barrier of readership and becomes a character (already) in the story.

And this is not the only kind of shift that takes place in locative art. In another, the medium itself becomes distributed to a dynamic backdrop, and, rather than being moored to a specific mechanism—a screen, a wall, a printed page, or any device—the story is instead dispersed across the openness of spatial dimensions, and the visitor's physical movement then influences its narratival exposition over that field. As an overloaded sign system–simultaneously a narrative field and a seaside field—the medium itself undergoes an inversive shift of signification against literature's communicative architectures. It matters little that the story is centralized, archived in a backpack— its narratival genotype is encoded with the global coordinates that the visitor will, by entering, trigger, allowing its fictive skein to unfold.

Finally, as if to subvert conventional structure even more, we have your second case study, Teri Rueb's *Drift*, in which the mapping of texts and locations is itself constantly changing. This is akin to the radical geography of the inner self that is experienced in the dimensionless void of a dream state; hearing echoes of site that, on returning to the place where they were first uttered, are now elsewhere, or not at all.

It seems to me that all of these inversions are incredibly helpful in destroying certain fixities to which we have been conventionally bound. In the external world, the permanence and fixity of place that is the monument's signified is precisely what is most distinct from what we experience within the inner subjectivity of creative reverie. It appears that

locative media art is bringing out subjective being into the physical world, annihilating the inner/outer, subject/object divide that the West adulates, but which other cultures, among them the Australian aboriginal worldview, have never quite endorsed.

And so, I don't have a confining question, but feel rather that you have opened the door to an understanding of artistic expression wholly outside of Cartesian thought: merging both objectivist methodology and subjectivist awareness, there is now an extended consciousness of the works, since the approach considers the projective, the aleatory, the physical, and the participatory; and I wonder if this experience of deep meaning, after such close reading, also insinuated itself to your intuition and sensibilities, as it did to mine. Do you feel the rustle?

KK: I definitely do, also in a very practical sense, as challenging common notions and disciplines always prompts not only enthusiasm, but also skepticism and criticism. That is, the "rustle" is present in exhibitions and conferences within the artistic and scientific community of new media art. Also artists themselves still confront these challenges: whereas I consider Schemat's and Rueb's pieces as successful, mature works of interactive new media art, it is obvious that they are dealing with very complex artistic, aesthetic, and technological issues with high standards of artistic production.

To proceed to the core of your statement: I absolutely agree that this artistic approach indicates a key shift within cultural production, due to the location of aesthetics within process and action. It marks a further step in the development from representation to presentation that can be observed within the arts of the last 100 years—though it does not replace the former with the latter but rather combine them in a highly complex interchange of the processual, the material, the subjective, and the symbolical. locative art practices in particular re-implement art not only within public space, but within our social networks and build a bridge from the reflection and distance-based aesthetics of the art world to the everyday processes of aisthesis. As you emphasize, an important artistic strategy at stake is the implementation of inversions. Their complexity is due to the fact that, though they are consciously provoked by the artist, they are not fixed within a representative scheme but grow from within the visitor's experience. The visitor of Schemat's work does not necessarily become a character in the story; she is invited to do so, but may at the same time remain distanced. Therefore I prefer to describe these experiential processes with the notions of oscillation and ambivalence. You might even compare these artistic strategies to deconstructivist tendencies, though I consider the works too much grounded in materiality (and deconstructivism too negligent of actual reception processes) to use this term in my writing.

I absolutely agree that the destroying of fixities is a tendency that is fostered by digital media and reflected within new media art. But of course this reflection is not confined to new media art—as interactive art is not confined to new media art, either. The specific achievement of interactive art is that it allows for an actual and active experience of this situation, whereas non-interactive art is usually confined to representing these tendencies. The two examples I dealt with combine new media technologies with interactive strategies and with a breakout into public space and can therefore not only enhance the interactive processes embedded within the work, but also integrate the complex layers both of everyday life and of digital data/networks within their artistic interpretations of contemporary culture and society.

CHAPTER SEVEN

Self, Setting, and Situation in Second Life

Maria Bäcke

Linden Lab, the company behind the online world Second Life (SL), invites multiplicity with slogans like "Your World. Your Imagination."[1] Yet many SL residents'[2] profiles give evidence of adjustment to group narratives or norms in various social spaces inside the world. They seem to favor already established social and cultural conventions when creating an online identity; hence they also adjust to already existing hierarchies. I argue that residents in SL recreate social orders and power structures similar to ones already existing outside SL, even though they are of course under no obligation to do so. In that sense social and cultural patterns are reproduced and in some cases even amplified. My aim here is to trace social dynamics evident in three groups within this digital space and my hypothesis is that the rules of these social spaces then function as a foundation and guideline for identity formation, and in fact almost seem to prescribe a certain way of acting or behaving. Two of the groups have a clear role-playing profile, based on books and movies, whereas role-playing is not required, although possible, in the third group. All of them are thus removed from the lifeworld by constituting either purely fictive or, conversely, historical constructs, but they can nevertheless provide clues to how the residents think in an environment that is not primarily "real life" based, and in which anything, even a utopia, can be possible. By reading group charters and profile descriptions found in the SL search engine, and studying articles and blogs functioning either as group information channels or journals for individuals in each community, I examine the motivations and power structures driving avatar and online identity construction in role-playing communities, with a focus on the interaction between the overarching "state" power, the Linden Lab, the three communities, their respective role-models, and the rules that govern them, as well as the individuals that are a part of them.

SL is an MMO (a Massively Multiplayer Online environment) "played" over the internet by tens of thousands of users simultaneously. SL cannot be defined as a game (as there is no global game narrative inworld), but is often described as a social platform and its main feature is the possibility to create, and sell, user-generated content. In SL, everything that can be seen, heard, or read has been created by someone; even nature itself is a construction. SL thus offers two kinds of constructs: a social construction of reality, a process exactly the same as in the physical world, and a "physical" construction of the entire digital environment. It is true that architects and city

planners are shaping our physical world, but we are reminded once in a while of an untamed nature that sometimes takes over. This is not the case in SL, where everyone, in a sense, can be their own architect and control their space completely. Therefore, artifacts and environments created in SL can provide clues to people's conception of space as well as any dreams and fantasies they may act out. Sometimes these creations can detail an individual's involvement in groups and communities. For example, if someone is dressed like Darth Vader it probably shows an interest in the *Star Wars®* movies, or if somebody builds a Victorian house it might indicate that s/he is interested in nineteenth-century buildings.[3]

My primary sources are the avatar profiles and the group charter of a *Star Wars*-inspired group,[4] a Gorean group,[5] and a Victorian Steampunk group.[6] These groups are all closely linked to social and highly visual spaces in SL. *Star Wars* enthusiasts have built replicas of places famous from the movies, the Goreans have built medieval cities inspired by John Norman's series of novels and, in the Steampunk case, the residents all participate in building the whole cluster of Caledon sims.[7] All these places have their own written and easily accessible codes of conduct and covenants that shape the social space that is constructed.[8] My reason for choosing these particular groups out of many on the same theme was that they had a sufficient number of members, and that they were accessible in the sense that I was allowed to see the names of all members in a list and click on them to open their individual avatar profile. I primarily looked for information in these profiles—often consisting of both text and images created by the residents themselves and also available through the SL search engine—but I also took notice of the group charters/descriptions.

Additionally, blogs and online articles have been important sources of information about the communities. A *Star Wars* blog,[9] and a machinima[10] forum featuring movies of the game play,[11] give information about *Star Wars* community. Gorean game-play is portrayed in a blog[12] and an article from the Second Life Herald.[13] The Caledon community is represented by two blogs.[14]

The exploration of social and cultural patterns primarily linked to power structures alludes to Michel Foucault's theoretical response to power and repression. He concludes that discipline in itself is not identified with either "an institution" or "an apparatus: it is a type of power, a modality for its procedures, levels of application, targets; it is a 'physics' or an 'anatomy' of power, a technology."[15] This "technology of power" has been put to use by the authorities to discipline and control dissidents and disruptive elements. The panoptic control apparatus was created by the state in order to provide the most economic way (both in terms of money—as little spending as possible—and from a political point of view—as little resistance as possible) to control subjects, to make the most out of the effects of this social power, and to maximize the output of state controlled education, army, industry, or health care.[16] Foucault argues that the efficiency of the authoritative and totalitarian system depends on the docility of the populace and is vulnerable to dissidents or unwilling cogs in the machine, and this is what I especially would like to draw on in the SL context. As I will show later on, the groups I have examined are more or less authoritarian and controlled, and more or less effectively governed, with evidence of both docility and rebellion in the groups.

Linden Lab has also made surveillance possible inworld, from relatively harmless visit lists, with which the owner of a land can see the names of all guests arriving at his or her place, to complete control over another avatar, either by using scripts[17] or an alternative viewer.[18] In this light, Foucault's critique of control and surveillance becomes relevant anew, especially through his development of Jeremy Bentham's concept of the panopticon.[19] A prison guard, unseen by the prisoners, can survey a large number of them from his tower in the middle, and the prisoners in their cells, unaware of if and when the guard is looking, are fostered to believe they are constantly being watched. Subsequently, and in line with the idea of conditioning,[20] the prisoners start to behave as if they are indeed being watched at all times. Foucault is mainly talking about institutionalized power, but I will also try to illuminate how this type of power plays out on an individual and personal level, where a small group of people decides on what rules are going to become institutionalized and how their decisions affect the rest of the group, providing a space for relationships that can be controlling, empowering as well as abusive.

Gilles Deleuze and Félix Guattari's discussion of the nomadic war machine and their concepts of smooth and striated space[21] might suggest a way out of the control apparatus Michel Foucault describes, and their ideas can work both on the level of institutions and individuals. Smooth space, considered to be "nomadic,"[22] "heterogeneous . . . non-metric, acentered, rhizomatic,"[23] is seen as uncontrollable, unsafe, and is liable to frighten those who prefer the "state apparatus," the more controlled, "homogeneous and striated spaces[s] of reproduction,"[24] relying on clear definitions, walls and enclosures,[25] and striving for homogeneity and consensus.[26] Striation aims to bring the smooth under its control,[27] while the smooth uses its tools to subvert the same control.[28] To give an example related to SL: by using inventive and unexpected tools outside conventional categories,[29] or by acting in a way that disrupts situations and environments, often referred to as griefing,[30] some residents in SL attempt to create a smooth space, a space in which they can live out their wishes or fantasies. Linden Lab, on the other hand, works on an institutional level and is in the position of the prison guard. Linden Lab can monitor most things that happen on the grid[31] and they can also punish residents who do not act in accordance with the rules.[32] A similar position is given to the sim owners or community authorities, but power is now transferred from an institutional level to a more regional one. Community authorities can decide on local rules for their land and ban what they label disruptive residents from it. It is in the territorializing/deterritorializing and interaction between the authority (both the overarching and the local) and the single individual that the tensions, processes, and consequences of power are revealed. Smooth and striated are thus in a continuous battle, a continuous "becoming," and, as Deleuze and Guattari show in the following example, the smooth can be transformed into something striated and vice versa: "There is a schizophrenic taste for the tool that moves it away from work and towards free action, a schizophrenic taste for the weapon that turns it into a means for peace, for obtaining peace. A counterattack and a resistance at the same time. Everything is ambiguous."[33] The three groups in Gor, *Star Wars*, and Caledon all have the possibility to be arenas where power hierarchies and authorities can be discussed, questioned, and

subverted; the tension and ambiguity of counterattacks or resistance are the tools of a possible transformation.

Variations of this process can be seen in three different communities. As mentioned before, the first two groups are created in vibrant role-playing communities based on novels or movies providing templates for the "correct" way to "play the game." As becomes evident below, believability is a keyword. The sim owners enforce strict rules on their community, and they use a system of notecards[34] and large information boards[35] to make sure that all residents are aware of what is allowed or not in order for the game-play to remain believable at all times. In a *Star Wars* sim such as Little Mos Eisley visitors must wear clothes that fit the *Star Wars* theme, wear an observer tag if they are new, or a so-called DCS2 RP meter[36] if they are a part of the role-play.

The Little Mos Eisley sim owners/community leaders brusquely separate their social space from SL in general when they state: "This is a private Sim and we enjoy sharing it [with] you and other residents as long as you follow OUR rules. You don't like it? Please leave."[37] This is a clear signal that on this sim the rules are in fact nonnegotiable. There is no leeway, if a visitor finds the role-play disturbing the only solution is to leave and not take part. A similar wording can be found in the notecard received at the Yavin 4 *Star Wars* sim. A few rules centered on combat are

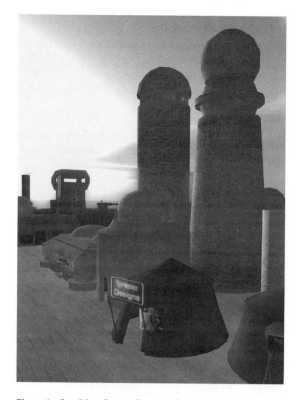

Figure 1. *Star Wars* Game-play at Little Mos Eisley, *Second Life.*

followed by two rules dealing exclusively with the necessity of staying in character on the sim:

4. THE WAY YOU LOOK (YOUR CLOTHES AND YOUR RACE). Do ya wanna play *Star Wars* or dontcha? Please dress in a way that would fit somewhere in the SW universe, and dress in a believably [sic] SW outfit. . . . If you are RPing [role-playing] as a race that is not a recognized race of the *Star Wars* galaxy, be sure you are convincing enough that your race COULD be part of the SW galaxy. You cannot use your race to explain technology or powers you would not ordinarily have in the *Star Wars* galaxy. This will be a judgement call that NOJ[38] will make and you have to abide by what we decide so please make a good effort. . . . You cannot RP a known character from the movies or novels.[39]

5. THE WAY YOU TALK. When you are here, please stay in character. Use (()) or "OOC:"[40] sparingly to talk OOC and rely mostly on IMing. Don't look at a person's name or profile to find out who they are, ask them in character. . . . You don't have to be a SW encyclopedia. If all you know is what you saw in the movies (if you've only seen episodes I–III we'll try not to hold it against you), that is fine. It's not what you know, it's how you say it.[41]

The notecard, which in this context equals the law, the aim of the authorities, thus stresses the coherence and believability of the game-play as the main objective for the community. Moreover, it identifies the authorities as the New Order of the Jedi (NOJ), portrays them as judges and stresses their superiority. The short sentences and somewhat defensive attitude also indicate the distance between those who write the rules and those who are supposed to follow them, and also the type of language that is perceived as authoritative language in the *Star Wars* community. Additionally, the language of the notecard mirrors the language of the players' communication with very informal and sometimes harsh sentences and a large amount of abbreviations. The latter is also visible in the member profiles of the "Galaxy News (*Star Wars* RP)"[42] According to the group charter, this group mainly assumes an instrumental role as a conveyer of information during gameplay.[43]

I will give two typical examples of what the individual role-playing profile[44] looks like in this group:

1. Age: 26—Sex: female—Birth place: Mandalore—Species: Mandolrian [sic][45]
2. Human—34 years old—ex-Mandalorian of Clan Shysa, ex-Mandroxian Syndicate underboss, ex-Imperial Storm Commando, ex-Bounty Hunter.—Specializes in information and infiltration, trained in ranged and hand to hand styles of combat. Highly technologically advanced using the most state of the art equipment ever seen in the galaxy.—Past activities—Has been arrested for smuggleing [sic] and gun running, has caused a few small arms races in the past.—Current activities & affilations [sic]—Unknown[46]

In both cases this is the only thing they choose to write about themselves on the first page of the profile. Both profiles focus on what is seen as essential information in the

game: age, gender (No. 2 is male according to the profile photo), and species. The second profile includes a bit of background history and that is fairly common in several of the profiles in this category: "NN is a Jedi Master from Coruscant. The force was sensitive in him since he was born. Now he is part of the New Order of the Jedi! A Life lover! A born philosopher! He always follows the light!"[47] There are examples of profiles where the descriptions can be slightly more elaborate:

> I am a Knight of the Jedi Order, trained by Master Zoom Killian. Born into mischief and raised by thieves, I grew up on a small industrial planet that is forgettable. I was found by the Order at the age of nine, and raised in its traditions by Master Zoom Killian.[48]

The following short and to the point profile description is written, in a rather authoritative style, by one of the *Star Wars* leaders:

> Jedi Master in the New Order of the Jedi (NOJ), one of the oldest and most enduring of all Orders in Second Life. I am a consular and a scholar. I am also the creator and master of the dreaded form XIII.[49]

The profiles thus establish them as parts of the *Star Wars* game-play and identify their role in the community. The authors of the profiles above seem to wholeheartedly accept the *Star Wars* role, and the profile photos support this, since they are generally of the residents in *Star Wars* attire.

The examples above thus show residents who are happy to portray themselves in accordance with *Star Wars* stereotypes, but there are a few role-players who use their profile to send more mixed messages. One of them actually describes his reasons for entering the *Star Wars* role-play:

> [I]'m tired of being hurt and [I]'m going to the role play to stay for *Star Wars*. I thought [I] had the most perfect girl in the world but [I] got played for a fool, so just like a real dear friend of min[e] [I]'m sinlge [sic] again and its [sic] sucks ass and [I] don[']t like it. want to know more about don't ask.[50]

Another role-player tries to ward people off with the following rather ironic statement:

> ALSO I AM VERY IMPORTANT SO DON'T BOTHER IMMING, TALKING TO ME, OR INTERACTING WITH ME IN ANY WAY BECAUSE I'M TOO IMPORTANT TO RESPOND. I HAVE BEEN PLAYING THIS GAME SINCE I WAS ONE YEAR OLD AND I KNOW EVERYTHING ABOUT IT AND I'VE BEATEN IT TWELVE TIMES AND I'M ALWAYS PROGRAMMING AND DESIGNING HORRIBLE HOUSES. OKAY BYE[51]

Both residents are clearly a part of the *Star Wars* game, but at the same time they are, in their affective state, rebellious vis-à-vis the established view of the game-play. These, most likely young, residents move their involvement in the game to a meta-level and can in fact be said to be "OOC" in their profiles. The first one sees the game

as a safe space where he can heal, the second one clearly plays with the image of the antisocial but brilliant nerd (although slightly different from the other profiles in this group, still an image often linked to the *Star Wars* enthusiast). Both of them are thus creating their identities within the group framework, even though they are giving it a personal twist, which in a sense renegotiates (adds to or comments on) the rules of the *Star Wars* role-playing environment. The residents,[52] who choose not to portray themselves as believable *Star Wars* characters, are generally members of other groups with different focus, primarily other role-playing groups (Gorean, BDSM, World of Warcraft, Everwind etc.), and they therefore ignore the *Star Wars* game rules—unless they choose to join in occasionally.

Star Wars role-players have several forums on the internet as well. The SWRP Community blog is one; the "*Star Wars* Fans in Second Life forum" is another. The first one often functions as a newspaper with detailed accounts of battles or attacks:

> **Attacks in Imperial City** IC Galactic Senate News: At the previous senate meeting on Coruscant, an assassination attempt was planned for Atticus Jetaime (Representative of the New Potentium of Unification). Thankfully Representative Jetaime and the other influential figures (including Chancellor Talmerith Jael) were evacuated from the opera house. The Teras Kasi, a group of force users, are being held responsible for the attack. Both the Teras Kasi & The Consortium are in fact active threats to the galaxy . . .

> OOC Galactic Senate News: If you wish to join the Galactic Senate, many positions are availible.[sic] Positions include senators of planetary factions, representatives of orders or business, advisors, and senator fleets. . . . This group is meant for promoting active RP and major storylines within the SW sims and originality. Thank you![53]

The language above is far more formal than the language in the *Star Wars*-related note-cards and profiles above, imitating the style of a newspaper. The SWRP Community blog also posts entire role-play dialogues, which are almost literary in their form. It should be noted that it is the residents themselves that write the non-dialogue passages (while having the dialogue). This is again an example of more elaborate and formal language:

> **The Rivalry of Chaos and Atticus . . .** Atticus Jetaime comes up to the 2nd floor and stops in his tracks . . . Atticus Jetaime shakes his head, "Chaos . . . can't get enough of me, eh?" Collin Weder glances up at the arrival of Atticus and slowly reaches for his saber. Nymph Zenith lounges comfortably, her slender curved form seated as if she has never left the place . . . her head lifts and a smirk is on her crimson lips . . . she smirks "ohhh the ego to think i'm here for you." Atticus Jetaime grins, "I think very highly of myself. And who is your . . . friend?" Collin Weder takes a step over to the couch and finds a place next to Chaos, looking back at Atticus he smiles evily before answering. "The new ruler of this planet, and who are you??"

> Atticus Jetaime laughs doubled over, "Oh . . . that would be a nice trick . . . The Selkath rule this planet, under the protection of the Empire." Nymph Zenith lifts her hand for Meph to stand down she doesn't see Atticus as a threat . . ., she inspects her nails a bit,

modified to sharp and deadly points . . . "oh him, no one that you need to be concerned of" smirks a dreadful glint in her eyes "But you can call HIm Darth Mephistopholes, know this name well it will bring fear to this land" she winks and smirks as Meph knows no modesty. Collin Weder grins. "Mrs jael's empire i assume?"[54]

The newsflash and the dialogue above show examples of the role-play in the *Star Wars* role-playing sims in SL and the dialogue actually seems to show a power battle between two people who both want to be "rulers of the planet." The fact that the two latest examples are written in a more nuanced language might indicate that this is simply a mark of leadership; being articulate becomes an indication of power.

What we have seen above are not faithful copies of the movies (and as indicated above, this is also not the intention), but they can instead be classified as a continuation of, and homage to, them. The battles and attacks resemble the ones in the movies, both in their physical and verbal form, and the tone of the dialogue shows the characters' faithfulness to the movies. The *Star Wars* illusion is upheld. The "*Star Wars* Fans in Second Life forum" on the other hand focuses on more instrumental aspects of *Star Wars* gameplay: the clothing and armor, the vehicles, the combat, the different regions and groups as well as more general rules. It resembles the straight-to-the-point and instrumental attitude of the "Galaxy News (*Star Wars* RP)" group. A comparatively common way of expression in this community is machinima. There are several movies linked to the *Star Wars* community both on the SWRP Community Blog and on YouTube. The movie "SWRP on Second Life—Trailer"[55] mainly provides some sense of what role-play can be like, with battleships, meetings, guards, and various species addressing questions of power, of good and evil. Another machinima, the "Second Life: Byss Event (June 16, 07),"[56] shows a battle.[57] These examples—blogs, forums as well as movies—display no dissent or discussions of the game rules at all.

All these texts establish the *Star Wars* environment as a discursive and rhetorical arena, a social space. The players are generally good at maintaining the illusion, perhaps the reason is that they rarely have any reason not to. The game-play is specified as *Star Wars*-inspired, and anyone who has no interest in playing along is simply asked to leave or does not come there in the first place. However, even though the *Star Wars* movies provide an example to follow, they are not what ultimately counts. The notecards make it clear that it is the sim owners who decide on the rules. There are certainly smooth spaces available in the *Star Wars* role-playing community, however, and those are primarily linked to character formation. The residents do pick roles of their own choice, but it has to be done within the boundaries the sim owners have set up. The *Star Wars* sims in SL are ultimately controlled spaces. The sim owners are the judges as well as the jury in "*Star Wars* land"—"This will be a judgement call that NOJ will make and you have to abide by what we decide"—and if anyone does not play the game the way they want, he or she can quickly find themselves outside the sim border, unable to get in again.

A similar attitude can be seen in the next community: SL Gor. Just like *Star Wars* RP, the Gorean community is a loose-knit one. Several sims are joined together under the big umbrella, SL Gor, but they are owned by residents with different ideas about the type of Gorean game-play they prefer and want to see played out on their land. The role-play is based on John Norman's 25 books on Gor[58] portraying a controversial Sci-Fi world, which advocates a strict hierarchy where strength is valued highly,

where men are valued higher than women and where the latter is seen as "the submissive natural helper" and slave.[59] The novels and the role-play in SL have a pervasive misogynistic motif and a prominent BDSM theme; in fact, these features are institutionalized.[60] Psychological and sexual domination/submission and slavery is what the controversial Gor community has become known for inworld, and there are persistent rumors about non-Gorean residents being captured and "collared." Estrella Canadeo, previously a "kajira," a type of Gorean slave, and still role-playing a submissive and slave, has explained it in the following terms:

> I often find myself defending Gor among "non-gor" Second Lifers. The most common question, "Is it true that women can be caged and raped at will?" Yes and no. Women are caged when wandering in a gorean sim in earth [non-Gorean] clothes, but it's not usual or recommended to rape the girl. In fact most sims have a clause that will protect girls from unwanted approaches. I always tell people who ask that all gorean sims have visitor tags, but if you do find yourself captured and don't want to be there, explain in an OOC IM to the capture you don't want to be in gor and tp out. Some sims will ban you after you tp out, which my reply to those who object is "well you didn't want to be there anyway."[61]

Canadeo thus confirms the Gorean habit of capturing especially female avatars that have, perhaps out of curiosity, wandered into their sims. There are warnings, however. Similarly to the *Star Wars* example, notecards are handed to visitors arriving at the Gorean Port Cos. The notecards states that both citizens and visitors are required to act in character and true to their Gorean roles (as described in the books of Gor). Furthermore, a resident in Gor must be in human, adult avatar form and has to wear the appropriate kind of dress.[62]

If a resident wishes to join Port Cos, they can be "collared as slaves."[63] The problem might be that regular visitors might not have read the books or Gor and therefore they do not know what is expected of them, but the notecard encourages them to find out before entering. The Gorean role-players seem to prefer not having any dissidents among them, which is confirmed by Canadeo:

> There are stories of [rebellion] happening within the books Norman writes, but it's usually brief as the girl quickly realizes that her only true happiness is when on her knees, and so there's no reason to struggle. SL Gor follows accordingly. Kajirae are not usually feisty, they follow their Master's orders, quite happily, and those who do not frequently are frowned upon. . . . There's nothing wrong with this, in fact I discovered that almost all Masters within Gor truly enjoyed the easiness and acceptance of a girl's submission. And why not? Men, Masters, come to Gor in order to be in control, to be surrounded by the type of women that Norman describes who are very aware of their need to serve. And they've come to the right place, SL Gor very accurately tries to make that point to kajirae. If all the women within Gor constantly challenged this control, it would simply contradict itself, and the attraction that most have to Gor would be lost.[64]

Estrella Canadeo, an independent law student in the physical world, thus identifies at least a few of the mechanisms behind the role-play on Gorean sims: it draws women (or

Figure 2. Slave in Gorean role-play.

men) who have the need of being submissive, and men (or women) that have the need to dominate. Those are the most basic rules of their role-play. There is even a custom-built Second Life viewer for hardcore Goreans, the Real Restraint viewer, which enhances a master's control over his or her slave even further, since it takes away the possibility for the slave to dress, stand, and send instant messages to other people.[65] Judging from Canadeo's description above and from the similarities between the profile descriptions below, there definitely seems to be a strong Gorean canon to adhere to, a canon the majority of Goreans seem happy to follow.

When examining the "Slave's [sic] of Gor" group[66] it becomes evident from the avatar profiles that they all follow the Gorean rules and are in human form. The photos show that Gorean slave dress code means wearing "silks," which amounts to being naked or almost naked. The few "free women" among the 219 avatars are wearing less revealing clothes and quite often a veil. According to the group charter, the purpose of the group is to create a "way for all slaves of Gor to talk and learn and help one another in a world of Men."[67] The function of the group is thus to provide a supportive framework for the slaves in SL Gor, which can be seen as an attempt to renegotiate the Gorean social space. A support group is apparently seen as a better alternative than individual rebellion in the Gorean context.

The profiles make it evident that there is a gender issue involved as well. Most of the avatars are female and have chosen "Gorean-looking" avatars.[68] Most profiles are

written in a similar way, and the following is a typical example:

> Captured and Collared by Master SirCalis Drake 02.03.07. Restricted White Silk
> Kajira. this girl is not to recieve IM's, notes, gifts, or friendships without her Master's
> permission. this girl may be punished by any Free if she is found displeasing, any
> harm depleating [sic] her value, compensation will be expected.[69]

Whereas quite a few of the residents in the Galaxy News group above are members of
several groups, that have little or nothing to do with the *Star Wars* theme, this is not the
case in the "Slave's [sic] of Gor" group. Often the avatars seem to be created for Gorean
role-play exclusively, either because that is the only thing the player is interested in
or because the player has multiple avatars and the Gorean avatar is kept separated
from any other the player might have. Underlining what Canadeo describes above, the
Gorean rhetoric and ideas are displayed in numerous profiles:

1. SL gives me the opportunity to be who I always wanted to be. . . . a shy and sub-
 missive girl. Here I can dress like I want, look like I want . . . There's one thing left:
 finding a gentle Mistress whom I can serve with my heart and my soul.[70]
2. Bond-maid of Ianus Bade. Jarls Axe of Axe Fjord. ~red silk unrestricted with my
 Master´s permission~ This girl is to be perfectly pleasing to all Free Persons of Gor.
 she may be punished according to the traditions of Gor, for any or no reason. Girl's
 Jarl asks only that you do not damage her, lower her value, or kill her unless you
 intend to replace her. [71]

The theme of domination/submission returns over and over again and in most cases
the profiles are written "in character." Only a small number of profiles state conditions
about what they want or not on a meta level (in OOC mode): "I love roleplaying, espe-
cially capture roleplay. (I don't do mutilation, please ask before doing any sort of sex rp
and I like to caged for long periods and I can't dominate)"[72] and "No Mutilation, Scat,
or ageplay."[73] Even fewer show signs of active or assertive behavior, and then it is some-
times expressed in a passive way: "With her Master's permission, this girl is permitted
to wear daggers . . . and use them if needed:)"[74] One has requirements that have to be
met before she can settle into the role of

> a submissive female [who is] seeking for a mature and responsible Master to give her sl
> life over to. is into slavery, torture, humiliation, and servitude of any sort. does, how-
> ever, enjoy good conversation and someone who is able to meet that requirement. will
> not mindlessly submit to any tom, dick or harry who attempts to exercise his domin-
> ant "rights" over her, just because he is a dom. earn my respect and submission, not
> expect me to serve it up on a silver platter just because you think you can dom.[75]

Yet another resident assumes a slightly more assertive stand:

> NN was born and raised in a small village on the southern outskirts of Torvaldsland.
> Upon her eighteenth season, she decided to set out upon her own looking for adven-
> ture. her travels have already brought her more than she had bargained for, but the

resourceful Northerner has managed to fend for herself. [She] want[s] to: capture, kidnap, forced RP.[76]

Only a few have profiles that are focused on other groups and communities than the Gorean ones,[77] which, unlike the *Star Wars* example above and the Caledon one below, further underline the tendency to separate Gorean role-play from other types of game-play in SL. As Canadeo has shown, the domination/submission power hierarchies, and the often sexual tension they bring, seem to be the core aspect for the majority of Gorean role-players but it is also the feature that is most controversial and targeted in the discussions about SL Gor. Raddick Szymborska, a male Gorean role-player, explains the essence of Gorean game-play: "Gorean roleplay is harsh. This is a feature, not a bug. I come to Gor to roleplay like Ghengis Khan, not Miss Manners."[78] Szymborska's comment underlines the dominant and violent aspect of Gorean game-play, and Mikal Snakeankle, a slave-owner in SL, reacts against non-Goreans opposing his way of playing and attempts to correct the widespread—and, from his point of view, misconceived—ideas about SL Gor:

> Do I interfere with my online slaves real life? No. Do I wish to? No. That is their life. . . . Do my slaves kneel in non-Gorean or D/s sims? Not unless they are with me. Do they call non-Goreans Master or Mistress? Only if said persons arrive in our land. . . . Do I punish them? Yes, when they need it. But what you don't comprehend is this. They come to Gor, fully knowing what is to be expected. If this is what they decide down the road isn't for them. Leave. I won't stop you. You also aren't banned from my land for leaving. You are banned if you leave and then harass, badger, cause trouble through actions, words or deeds. Not uncommon in other lands either. . . . If someone caused troubles via words or actions. Yes I will ban. Period.[79]

Snakeankle thus uses the very common argument that everyone is free to choose whether they want to take part in Gorean role-play or not. He also underlines the difference between the rules on "his land" and Non-Gorean land. Non-Gorean Jot Zenovka's comments on both the aspect of choice and the difference between Gor and non-Gor: "If you don't like the rules, don't go there. . . . The Gor notecard I read is explicit in it's [sic] description of non-rules and dangers. I didn't go there. lol. But neither was I offended simply because I didn't understand the gameplay."[80] In yet another comment the signature Noyeh, who role-plays as a Gorean slave, further underlines consent: "Unlike the real gor we do not have chattel slavery we have consensual slavery only!!!! Anyone that is choosing to roleplay in Second life as goreans is doing so as consenting adults. At anytime any slave or any Free Person on that list can walk away."[81] The view of Gorean role-play as consensual and confined to some areas of SL is thus firmly rooted. But even though Snakeankle argues that he distinguishes between role-play in SL and life in the physical world, Artemis Fate, long-time SL resident and former Gorean slave, points out that there is a category of more serious Goreans, life-stylers or "true Goreans," who live out the Gorean philosophy in the physical world as well.[82] In contrast to the view of the comment authors above, Fate highlights the inherent

inequality and the possible emotional impact of Gorean role-play from a Gorean slave's point of view:

> As to be expected, the relationship dependency is skewed. Men are encouraged to treat their slaves like objects and women encouraged to give everything they have to men. . . . The girl . . . is taught to be dependent and totally in love with her Master. To be sold to another so is a form of rejection. This sort of sting can be more mild, with the girl a little depressed at each time she's traded off. However, some have gone into a full breakdown and have inflicted pain on themselves or others.[83]

Artemis Fate describes her first response to the pro-slavery Gorean role-play as a "turning on."[84] Initially, describing herself as both intrigued and unprepared, she was "indoctrinated into the community for months, before [she] managed to take an overall look at what's happened and realized how much [she] had changed."[85] Fate draws the reader's attention to the conditioning she has experienced and still sees taking place in the Gorean community.

> For some slave girls in Gor communities, John Norman's books are mandatory readings. Each book has the repeated theme that women are naturally slaves to men. The moral of every story is that neither men nor women can be happy unless they follow this nature. This is the big lie that is repeated again and again.[86]

But why is this repeated over and over again? John Norman's novels have inspired SL Gor in terms of setting and culture, but for slaves the books seem to be used mainly as a way of illustrating and enforcing the idea of dominance and submission that is so much in focus of the community leaders, the authors of the notecards and the comments above. A quick comparison with descriptions of the novels[87] show that SL Gor is no replica, but rather a digital environment where the sim owners are allowed to pick and choose among the themes in John Norman's novels, very much like the *Star Wars* communities develop their role-play with the movies as a foundation, but not a rulebook. The leaders of SL Gor are trying to create their own "consensual hallucination," to use William Gibson's term, and, while much of Norman's vision is played down,[88] the the most important feature, the one that need to be agreed upon, is the slave–master relationship. I argue that this is the cornerstone for the fantasy being built in SL and a part of the conditioning, the reason why the Gorean moral is "repeated over and over again." It is an important part in the process of creating acceptance for, indeed institutionalizing, dominance and submission. Artemis Fate describes the procedure: "If a slave girl obeys, she is rewarded. If she disobeys, she's shamed and punished. If she speaks her mind or questions the philosophy, then she's threatened with expulsion from the sims."[89]

Fate describes SL Gor as "cult-like" and even gives tips on how to save someone who has been drawn into it. She suggests that conditioning affects the mind whether it processes events happening in the physical or digital world, and therefore anything that happens in SL can also have an impact on that person in the physical world. As a response to people who claim that the solution is to teleport away or log out, she again draws parallels to the physical world, to patterns of abuse within families: "[Women

who are being abused] CAN do this [leave], but WILL they do this? It sort of applies to battered women syndrome, a woman CAN walk out from her husband that beats her, but she doesn't."[90] Anon also highlights the issue of the community's role in the conditioning:

[I] was in Gor on SL for 6 months, as a slave, and [I] always had conflicting feelings about it, and seeing it phrased the way [Artemis Fate has] here is really eye opening. [I] n my experience, most of the "masters" [I] met in Gorean sims were not smart enough to do the conditioning you speak of. BUT, many of the "free women" and other slaves were very manipulative on this level.[91]

According to her, the Gorean community thus plays an important part in conditioning slaves, making them behave in what the Gorean society consider "appropriate" ways.

Sandra-Dee, another freed slave, points to yet another problem which highlights the barriers between Gor and mainstream SL society. She attests that

[i]t is difficult to reconnect with the friendships that were left to smolder while in the Gorean way of life and thinking. Some of the friends remember you and others are gone forever. It is important to make new connections outside of Gorean thought and to reinvent your persona in SL.[92]

She highlights the need for a safety net to facilitate the way back to "normal" thinking and continues by giving an example:

I sat on the dock of one of the Gorean sims and chatted with several slave girls. One mentioned she had entered the Gorean world through the act of being raped while in roleplay. . . . Yet when asking her WHY she returned she could not put it into words and just said . . . it was only her second time back online after the incident.[93]

Several of the residents who are commenting thus return time and time again to the risk of Gorean role-play resulting in traumatic experiences. The signature "Just a thought" gives a friend's view of the impact of Gorean role-play:

I cannot even remember the number of times I've seen friends get into this lifestyle. . . . and had it destroy who they once were. . . . I've always been there when those friends come back, needing a shoulder to cry on because of something their Mast or Mistress did to them. The part of it that really wrenches at my gut is when they come to me for compassion and support, then turn and go to their master or mistress once it's all over—just like anyone in an abusive relationship.[94]

It becomes obvious from the descriptions above that Gorean role-play certainly has bothering elements, where the line between role-play and reality is blurred. As a submissive both in the physical world and in SL, Miraren Firefly, puts it like this:

So, in short, what worries me is this: Roleplaying emotionally problematic scenarios is well and good, if what you're doing is actually roleplaying. However, once you

become emotionally engaged, and are channeling yourself through your avatar—which [I] think is what happens with the majority of Goreans, and indeed a large portion (probably a majority) of SLers as a whole—the problematic elements of the Gorean scenario start having an actual impact. Girls form actual emotional bonds to their Masters quite frequently, both in mainstream BDSM/D/s and in Gor, online. Therefore, if their avatar is killed, while they do not die, there is still emotional impact. This emotional impact would not be there in any significant amount if they were truly roleplaying, but quite often it seems that they are only projecting roleplaying elements and personae onto their actual selves. This is dangerous.[95]

The comments above show the battle for acceptance of an alternative and controversial way of living. On the one hand, Gorean role-play is displayed as a voluntary and consensual agreement between adults choosing to play out such scenarios in a digital environment, which can be left or shut down. Not surprisingly, masters are more inclined to defend Gor and point out that it is a voluntary decision to join the role-play or not, but what they choose not to see is that, to some people, the hierarchical system is not just role-play, but rather something that affects them deeply. As shown above, the role of the slave or submissive can be problematic. There are indications that this type of role-play can actually become harmful to individuals, altering their way of thinking, feeling and acting. One is reluctant to log into SL again, another highlights the danger of "channeling yourself through an avatar," and the writer of the article, the former slave, is now fighting on the barricades for those who, like her, have felt trapped and miserable in the Gorean context.

Returning to the former Gorean, but still submissive slave, Estrella Canadeo, and finding her at a moment when she has been shopping for animals in SL without her master's knowledge, a situation that shows her fear of disciplinary actions and her wish to be seen as a "good girl" by her master. Her guarded behavior while waiting for his reaction, as well as her joy when he approves of her actions, underscores the ideas seen above:

When he returned I lead him around the land, pointing out each animal and waiting nervously for his approval. It was surprising, how my life in SL had unconsciously affected my behaviors. . . . I was feeling I had taken too much of a liberty. Needless to say I was relieved to hear "This is amazing Essie! You've made the place so much more alive."[96]

Canadeo thus spells it out. She notices how her role-play as a submissive in SL affects her way of thinking in both the physical and the digital world. She is in fact surprised by her own need for approval, and how her behavior and subconscious wishes have been altered. Canadeo is feeling that she is a bad slave when she wishes she is not as submissive as she is supposed to be from a Gorean point of view. The next dialogue gives indications of some of the strategies her master uses to maintain control over her:

My Master: Well, for the most part, I'm following what you stated when you told me how you like being dominated
Estrella Canadeo: I know

Estrella Canadeo: and I'm glad . . .

My Master: It's my role to push at your boundaries, Essie

My Master: You might sometimes get angry with me for doing so.

My Master: I'm prepared for your anger, and I think it's natural. Submission is a trait that needs nurture.

Estrella Canadeo: I don't like being angry at you, you're so kind to me.

My Master: But when you had to deal with the consequences, you felt anger

My Master: Right?

Estrella Canadeo: yeah

My Master: Of course you did. In your real life you're a capable independent woman. Men don't push you about.

My Master: That doesn't have to change in you. The difference is that I'm not "men," I'm your Master. And I'm not pushing you about, I'm exerting control that you've willingly offered me.

My Master: So, feeling angry is natural. But looking past it, and processing that deeper message is where submission, and the acceptance of my control, come in.[97]

It becomes clear that submission does not come naturally even though both the "natural laws" of Gor and Canadeo herself indicates that this is how it is supposed to be. She is torn, but knows that she is supposed to happily accept her role as a submissive, still she becomes angry when her master asserts his dominance over her. Canadeo is almost quiet in the above dialogue while the master is defining her, putting what he thinks she feels or ought to feel into words. He tries to distinguish the difference between the way she acts independently in the physical world where men "don't push [her] about," but he then says that he should be able to since he is her master, and he says that without making it clear whether this is only inside SL or not. This might give indications of his own innermost wish: to stand above other men, to have control over both situations and people in general and her in particular. And since he is "so kind," it might be seen as self-evident that he should be able to get away with that. It is not self-evident that Canadeo will stay in the submissive role, however, since she admits that she

> enjoy[s] the fight now and then . . . There will be some days where I am content to be an obedient slave, and other days where I will push at my boundaries. And I think this fluctuation truly mystifies my poor Master as the good little kajira he knew so well will sometimes go out of her way to test his dominance. So why do I do it? I believe there is one most basic and obvious reason. Because there's excitement in the struggle.[98]

Again, this goes against the Gorean credo that a woman "realizes that her only true happiness is when on her knees" and gives indications that Canadeo's reasons for choosing a submissive role might not be complimentary to her master's reasons for choosing a dominant one. If she decides to try out a submissive role for the sake of (sexual) excitement and tension, and he prefers the dominant roles for the thrill of being in control, of exerting his power over another human being, there are bound to be clashes, clashes that the institutionalization of Gorean power structures are supposed to prevent. The unnaturalness of these power structures creates a removed

(but emotional and psychological) violence that is perhaps an unavoidable part of the game, as Raddick Szymborska indicates above. After all, his role-model in the dominant role-play he prefers is Ghengis Khan. The defensive tone of Mikal Snakeankle's comment above indicates his disapproval of being questioned about his dominant role-play. With aggressive wording he attempts to silence or undermine the authority of the female author, thus attempting to transfer the game-play into a non-Gorean arena outside of SL. His attempts to dominate clearly do not stay within the boundaries of SL Gor. In contrast to the more fantasy-based *Star Wars* game-play, Gorean role-play is thus more geared toward the building and testing of power structures both on a social and an individual level. The striations in Gorean community make it difficult for anyone who does not wish to play the game in line with the rules to negotiate a new deal inside SL. Indeed, the Real Restraint viewer takes power and control even further and seems to provide a digital version of Jeremy Bentham's panopticon. Still, it would be impossible to make the slaves use this viewer unless the masters already had a significant hold of the slave's emotions. The slaves have to be conditioned, as Fate suggests, in order become docile enough to accept the totalitarian system of Gor, and the dialogue between Canadeo and her master, as well as the attitude of Snakeankle and Szymborska, might give clues to how this conditioning is carried out. Estrella Canadeo's account shows that many things can be discussed and argued about in SL Gor, but the power hierarchy between master and slave is nonnegotiable. In fact, the gulf created between the Gorean community and the rest of SL facilitates the control we see on Gorean sims. It makes it difficult for slaves who have lost all outside contacts to leave, should they wish to do so. The people reacting against the dominant/submissive role-play of Gor, both in the offline world and in the rest of SL, seem to be regarded as unwilling "cogs in the machinery" to be kept out completely or quickly asked to leave if they do get in. There are a few smooth spaces, where this negotiation could take place, and Artemis Fate's article shows that it is indeed available—but not inside SL Gor.

As will become evident, there is a striking difference between SL Gor and the "Independent State of Caledon," a nineteenth-century Steampunk Victorian nation-state—the third and last community to be explored in this essay. Caledon has no model, no movie or novel, to follow and the Caledonians do not define their community as a role-playing one, but, although it is not required, there is an element of role-play present in the Caledon sims. According to the "Visitor's introduction" in the covenant signed by Governor Desmond Shang, the residents encourage "19th century period clothing, politeness, and activities" but consider a visitor, who is just him- or herself "more than good enough."[99] In Caledon it is primarily the building of the environment that is in focus and anyone who wants to take up residence there has to adhere to the following rules:

Caledon has a 19th century Victorian theme. Structures are to be Victorian, or perhaps a thatch roof house, old Tudor, castle, Celtic cottage, or maybe a hobbity hole or treehouse. That sort of thing. Inside your home or shop decorate as you like. Try not to let modern stuff be glaringly obvious from the outside. An occasional small Japanese gazebo or that sort of not-exactly-theme kind of thing is okay. Magic, steampunk, and fantasy items are encouraged![100]

There are thus no requirements other than the visual ones. Visitors do not have to be dressed or behave in a certain way, and no prior knowledge is needed about the community.

Governor Shang is the famous front figure and owner of all the Caledon sims. Together with a small group of people he created and populated the first Caledon sim in early 2006, "[a] small, windswept isle at a temperate latitude with wild creatures, country estate life, and sights and sounds that were common well over 100 years ago" complete with "weather and seasons."[101] Shang describes that they

> have a very *real* society [t]here. Everything from humble shopkeepers, inventors, clothiers, writers, explorers, titled gentry, doctors, tavern keepers . . . you name it! . . . Caledon has been blessed by its residents: deservedly famous artisans, the incredible shopping, the landmark Caledon Trolley. All of this added up to some of the most desirable addresses on the grid—not for being posh, but loveliness and warmth.[102]

This lovely and warm place has a few rules:

> No "yard sales," "walking signboard avatars," outdoor malls, huge signs ESPECIALLY land-for-sale signs, casinos, gambling for $L, camping chairs & c., scamming, Ponzi schemes, fraud & c., clubs (small pubs ok), racial slurs or hate speech, or combining sexual activities of any kind with underage avatars.[103]

These are the short rules that guide the Caledon community, and Shang is the benevolent despot who makes the decisions about anything that happens there.

Desmond Shang has reacted strongly against the market economy promoted by Linden Lab, especially in the form of land speculation, and the Caledon society has created its own rules in this area:

> Don't use the State of Caledon for land speculation. I have a long track record of keeping parcel prices ridiculously low to foster an accessible community. . . . For decent, honest folk simply trying to move around or leave, I am happy to help connect them with interested parties waiting to get Caledon land. That's a "win-win" for everyone.[104]

The group I have selected, the "Imperial Navy of Caledon," is smaller[105] than the *Star Wars* and Gorean ones, but the group shows the general aim and attitude in Caledon. They are dressed in nineteenth-century clothing and present themselves in a Caledon context. The group charter states:

> The Imperial Navy of Caledon's sworn duty and responsibility is to guard, defend and generally hang about on the seas, ponds, rivers, lakes, streams, wellsprings, waterways and oceans of the Independent State of Caledon in boats whilst wearing big hats. Really big hats. It is while wearing bigs [sic] hats that our daring, resolute and courageous Naval Force shall at all time encourage fantastical, jolly, and enjoyable maritime shenanigans.[106]

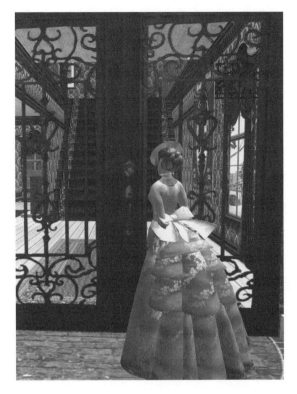

Figure 3. Building at Port Caledon, *Second Life*.

The tone of the group charter is much more playful than any of the texts from the previous groups and the same playful attitude is evident in the member profiles as well: "Circus strongman turned Professor of High Adventure. Owner of a flying circus and possibly the first steam elephant with a taste for people"[107] and, a little bit longer:

> An all-too-curious, flighty-and-silly, very-very-serious mechanical girl who likes hyphens-and-things. "Cornelia" stands for Central Operations Repository for a New Entity (Capable) of Love, Intelligence, and Awareness. Fond of song, dance, fine literature, pretty dresses, clunky gears, black taffy, people in masks, fuzzy monsters, etc. Oh, and hyphens.[108]

There are several references to, and in some cases quotations from, literary works by authors like T. S. Eliot, Lewis Carroll, and this one from Rudyard Kipling:

> When I was a King and a Mason—A master Proved and skilled, I cleared me ground for a palace Such as a King should build. I decreed and cut down to my levels, Presently, under the silt, I came on the wreck of a Palace Such as a King had built![109]

The profiles are in themselves, in most cases, much more elaborate, and perhaps more "literary," than the member profiles of the other groups:

> I came from a distant land to see what the world had to offer to a young pixie with a taste for adventure. I found a very nice circus strongman to look after me (well, more like the other way around, but you get the idea . . .) and a mad scientist to tease (yay!). And I've only killed him once, so far . . . I mostly wander about in Caledon (a truly wonderful, friendly place) when I'm not helping NN with the Circus. I like it here, there are far fewer things that eat pixies.[110]

Another example:

> Wife to the handsome, talented and charming NN. Countess of Primbroke, in Caledon. Originally from Upper Canada, a colony of Great Britain, My explorer father took my mother, brother Gunnar and I into Rupert's land at a young age, where he met with an untimely end. Our mother remarried to Mr. Eclipse, a learned man with a wandering foot as well. On an expedition, they contracted typhoid and died, leaving their children to their own devices. Now residing in the Oregon Territory.[111]

The language is influenced by the more formal way of addressing fellow residents that is common at Caledon. This is apparent in several of the profiles and is clearly a prominent feature of the Caledon community, as Caledon resident Ordinal Malaprop points out.[112] Malaprop has noticed how even visitors begin to use a more formal and polite way of speaking when they are in Caledon. The use of "Sir" and "Madam" is not infrequent, and many visitors end up expressing concerns about feeling underdressed.

Judging from the amount of information on the internet, as well as the friendly greetings upon arrival, Caledon is a very open community. Additionally, information about Caledon is to be found on Wikis,[113] and Caledon even has its own wiki and forum—the Caledon Wiki and the Caledon Forum. Many of the Caledonians are also ardent bloggers. The formal language can be noticed in these as well, regardless of blog content and interests. Otenth Paderborn writes about what he encounters in his virtual life: social events in Caledon, comments on Linden Lab decisions as well as fellow Caledonian bloggers. He rallies against both the Linden Lab decision to gain greater control over their trademark, but also against Linden Lab turning off the possibility to comment on SL Maintenance blog posts, in a, by Caledon standards, characteristically cheeky and ironic way:

> Over on the Official [our favorite virtual world] Blog, they have comments turned off on a post informing us of Group Chat Maintenance: You may experience temporary disruption in group chat. The disruption will consist mainly of group chats ending and receiving errors when chatting within the group. Closing the group chat tab and reopening the chat should restore the group chat function. And that would be different how? [April 13, 2008 edit: removed link as well as name, because if they don't want me using their name, they don't deserve to get any search ranking from me, either.][114]

Following Paderborn's critique of Linden Lab decisions, Ordinal Malaprop reacts against the lively discussion about copybots—programs that can copy and redistribute someone else's creations in SL.

> Let us be clear on a few details in this instance. There is nothing at all *new* about any of this. . . . as far as I can see, this "copybot 2" is just a simple modification of the "testclient" that is freely available. Anyone with any interest could make a similar product, we are not talking about Programming Genii here. There are *no physical countermeasures*—at least, none which will prevent people from copying designs and textures as presented in SL. Anyone attempting to sell you an item which claims to "defend against copybot" is as much a fraudster as anyone duplicating your design and selling it. . . . The only countermeasures, therefore, are *social* ones. There is the option of relying, instead of on simple product sales, on things which cannot be duplicated—services, customised versions, work on special and personalised products. . . . The other part of this is that the Gods of the World, the Blessed Lindens, must actively enforce matters of copyright and duplication, to a far greater degree than they do at the moment.[115]

Her blog posts are, just like Paderborn's, often critical towards various Linden Lab decisions. Malaprop has become known as a talented scripter and programmer and in this blog post she encourages the authority, the Linden Lab, to take responsibility for things that are not working inside SL. To promote and safeguard copyright policies and market ideologies has been Linden Lab's focus from the beginning,[116] and Malaprop points out that their programming, in this case, is in fact counterproductive to that aim. She argues that this issue has to be dealt with by other measures, social ones, which Linden Lab has avoided as much as possible, since this ultimately involves strengthening an organization within the company to function as a police and juridical system. This is something that exists, and it has grown larger and more influential over the last few years, but copybots have not yet led to any results in terms of legislation. Malaprop's interest in the issue, as well as her critical view of it is, in itself, in line with Caledon's history of subversion of Linden Lab policies.

Both Paderborn and Malaprop thus use the verbal and argumentative skills so commonly used in Caledon community to take parts in debates centering on the running of SL. They are a part of SL, but at the same time they are open to experimenting with alternatives. Just like Governor Shang, they are prepared to discuss regulations and policies or negotiate alternative governing, programming or economic structures on their own. All three are individuals executing their right to criticize the "government" the way they would do in a democratic country. But Linden Lab is a private company. From a Linden Lab perspective the company is providing a service, SL, to clients, a service brought to them as it stands. Development and programming is mainly controlled by the company and it has not encouraged extensive input from the residents (although a small group of SL residents has been invited to give input and Ordinal Malaprop is a part of this group). There seems to be no real forum for this type of discussion with the "Gods" (as Malaprop ironically refers to the Linden Lab), neither inside nor outside SL, and this highlights the difference between viewing SL as a service versus seeing it

as a community or platform for creation, communication, and interaction. This seems to be the main power struggle in the Caledon context. The residents' profiles show that the majority is happy inscribing themselves in the Caledon context, and they seem to have little reason to oppose Desmond Shang, perhaps because the covenant does not include extensive regulation for the community. Instead the focus of the power struggle in Caledon seems to be Linden Lab decisions and strategies.

Hence, all three communities—*Star Wars*, Gor, and Caledon—deal with different types of power issues. The *Star Wars* role-play is partly defined by the movies on which it is based, but the rules and regulations, decided upon by the sim owners, shape the game as well—there is a "right" way to play the game. This right way to play the game can be seen in machinima found on YouTube, on blogs and forums as well as inworld. On another level there is a fight for power *inside* the game, originating in the fight between the "Galactic Empire" and the "Rebel Alliance" in the movies. Judging from the animated dialogue from the *SWRP Community blog*, this seems to be a lighthearted and enjoyable experience in SL *Star Wars*.

The use of power is far more visible in the dominant/submissive-oriented culture of SL Gor. The exercise of power and violence facilitated and condoned by Gorean rules has a strong pull on role-players wanting to explore either the dominant or submissive role. As the comments bear out, this power game can have serious repercussions. My examples indicate that the wish to explore such roles—dominant as well as submissive—has a basis in the offline person, and the experiences in the digital world then become personal in a way that does not seem to be the case in the *Star Wars* examples above. Events taking place in SL influence the emotions of the person behind the avatar to an extent that might not be unproblematic. Something that reminds us of panopticism happens indeed under the gaze of a controlling and dominant Gorean master in SL.

All three communities are based on rules that differ from ordinary SL regulations. These rules set the scene for the game-play that evolves on the sims, and are more or less intrusive for the individual. They have a comparatively large impact on the *Star Wars* game-play, they function as a foundation for the rules every individual slave owner imposes on their slaves in SL Gor, and in Caledon they provide a general platform to build on, pointing out the direction for the community but they do not regulate how people "play the Caledon game." It is up to the individual residents to choose whether they want to play a role or not, whether they want to build, script, or socialize or not, as well as the level of focus they choose to put on Caledon.

While the *Star Wars* role-play is primarily built on straightforward rivalry between two opposing sides, with the *Star Wars* movies as a template, the Gorean role-play is less clear-cut. Slaves and masters are, on the one hand, on opposing sides, as can be seen in charter of the "Slave's [sic] of Gor" group. Estrella Canadeo shows, on the other hand, that the bond between master and slave can grow strong and result in an alliance against other masters as well as other slaves. A part of the Gorean game-play is also the antagonism between Gor and non-Gor. There is a strong reaction in the larger SL community against Gorean ideology, since it is perceived as patriarchal to the extreme, which leads to defensive reactions on both sides and the closing of Gorean "borders." This is far from the openness of Caledon, where there are no

identifiable enemies. The discussion in the blogs[117] sometimes targets Linden Lab, but it generally takes place in an attempt to change attitudes and policies in a democratic and collaborative spirit.

The various texts I have examined show that residents creating their avatars in SL role-playing sims respond to the authority in each group or community. The striations, rules, are usually adhered to, and they are, as in the Gor case, even seen as an essential part of the role-play. The Gorean community attempts to minimize the influence of a smooth way of thinking, but at the same time it thrives on the very dichotomy. SL Gor becomes a good example of the ambiguity noticed by Deleuze and Guattari. There would indeed be no need for dominance if a slave were a hundred percent submissive. A master would not fully show his dominant side unless he had a slave to punish and there would be no need to put surveillance on a completely docile slave. The tension would be resolved. And when a slave is ready to claim the space, smooth or striated, he or she wants and needs without considering the reaction of a master, the tension of the dominant/submissive power game would also be lost. The game lives only when a slave is both submissive and resistant, and a master both dominant and lenient. A similar tension is expressed as the war between two enemies in the *Star Wars* role-play. The power game of winning and losing provides a similar kind of tension and it is therefore interesting to see the contrast between the former two and a community like Caledon, that is not based on this kind of tension. Caledon has its own way of "playing," which is not based on power hierarchies but rather on providing a open and tolerant arena for whatever is interesting to each resident and does not violate the community rules. All the three communities have the possibility of functioning as social spaces facilitating negotiation and subversion, but, as we have seen, the different communities deal with opposition in various ways. The discussions in Caledon show that it is possible to have a fruitful dialogue within the community, but also, especially in Malaprop's case, in their contacts with Linden Lab. Ironically enough, there is one particular feature of SL that is relevant to the current discussion: Linden Lab's early and often useful banning option, with which landowners can shut out unwanted visitors.

A final dimension of consequence that might be considered points to the game developer's role and impact on community, group, and character formation. The banning feature Linden Lab has chosen to program into their platform has a side-effect, since it makes it easy to effectively silence serious opposition and limit unwanted people's access with a simple "You don't like it? Please leave." Both landowners and visitors are fully aware of the power of possibility to throw out unwanted visitors if they do not leave voluntarily. Ultimately, this makes true negotiation of social space impossible in SL. The take-it-or-leave-it approach, "it's my fantasy (and my money) and this is the way I want my space" is easily enforced and defended. Politicians in the physical world confront similar issues and many realize that quick fixes are not viable options, and this is perhaps also what Linden Lab is discovering. In the past they have attempted to solve social problems with programming, slowly realizing that this often results in more problems and that social guidelines are indeed needed. Although not a traditional government ruling over a piece of physical land, Linden Lab still has taken on governing responsibilities. They have become the "state" in Michel Foucault's terms. Unlike most physical governments, however, Linden Lab is a company and its

main interest lies in generating revenue. They have a less complicated aim than most governing bodies: Their role is to provide, in the most economic way, a platform on which people want to invest their time and money. As any company, they will want to spend as little time as possible on unhappy customers and as much time as possible on harvesting the revenue. From that point of view, it is generally not a problem for them to have residents who role-play in *Star Wars* sims, SL Gor, or Caledon. Involvement in these communities (any community, for that matter) increases Linden Lab's chances for creating a prospering company, and therefore they do not take a stand if, for instance, Gorean slaves feel abused. A solid financial situation is important as an incentive both on an individual and governmental level. Money can indeed buy the "perfect fantasy" in SL. The idea of a "consensual hallucination," to use William Gibson's term, has a strong impact on most residents, however. What happens if other residents are unwilling to play along, if they are unwilling to create their avatars in accordance with the community rules decided upon by someone in power to do so? There are quite a few empty sims in SL which in itself raises many questions around governance in the digital world. What level of control is necessary for a community to function? What level of freedom is necessary for residents to feel creative and be able to fulfill their wishes and fantasies? What is it worth for Linden Lab to have paying residents on their platform? What is it worth for a resident to have other residents to play with and whose rules are to be followed?

Notes

1. *Second Life*, http://secondlife.com.
2. Residents refers to the users of the digital 3D world *Second Life*.
3. This is my source material, some of which is available inside and some outside the online world, but all sources center on life in SL and the groups to which the residents belong.
4. The Galaxy News (Star Wars RP). Group charter can be found in the SL search engine.
5. The Slaves of Gor. Group charter can be found in the SL search engine.
6. The Imperial Navy of Caledon. Group charter can be found in the SL search engine.
7. On November 4, 2008, there are 45 Caledon sims, all found using the *Second Life* inworld map. Second Life simulators (sims or regions) refer to areas hosted on a Linden Lab server with their own characteristics, rules, and themes.
8. Maria Bäcke, "Construction of Digital Space: Second Life as a fantasy or a work tool," *The Virtual—Interaction. A conference 2007*, (Södertörn University College, forthcoming).
9. SWRP in Second Life blog, http://swrpcommunity.blogspot.com/ (accessed on April 21, 2008).
10. Machinima is a *portmanteau* of "machine cinema." Gamers create movies of their game-play or sections of it, edit the films and put them up on YouTube or other forums.

11. The Second Life Tribe, http://www.secondlifetribe.com/ (accessed on April 20, 2008)

12. Estrella Canadeo. Thoughtful Kajira's Weblog: The Delicate Dance between Beauty, Submission, and Intelligence, http://thoughtfulkajira.wordpress.com/ (accessed on April 18, 2008).

13. Second Life Herald, http://www.secondlifeherald.com/ (accessed on April 21, 2008).

14. Ordinal Malaprop, An Engine Fit for My Proceedings, http://ordinalmalaprop.com/engine/ and Otenth Paderborn, Tenth Life: The virtual life of Otenth Paderborn. http://otenth.homefries.org/ (both accessed on April 22, 2008).

15. Michel Foucault, *The Foucault Reader*, ed. Paul Rabinow. (New York: Pantheon, 1984), 206.

16. Foucault, *The Foucault Reader*, 207.

17. Scripts are pieces of programming, written in the Linden Scripting Language (LSL), and used to make an avatar perform certain tasks in SL.

18. A viewer is the "web browser" through which SL is viewed and explored. Linden Lab open sourced it on January 8, 2007, http://blog.secondlife.com/2007/01/08/embracing-the-inevitable/ (accessed on March 15, 2008). An alternative viewer has been distributed within the Gorean community, the "Real Restraint" viewer. This viewer makes it possible for a Gorean master to completely control his slave, http://www.erestraint.com/realrestraint/ (accessed on April 24, 2008).

19. Panopticism, means roughly translated, seeing all. This is a concept Michel Foucault elaborated on in his chapter "Panopticism." *The Foucault Reader*, ed. Paul Rabinow. (New York: Pantheon, 1984) that originally was conceived of by Jeremy Bentham. *Panopticon:Ppostscript*, (London: printed for T. Payne, 1791).

20. Conditioning has its origin in Ivan Pavlov's experiments with dogs. They were conditioned, by repetitively using various stimuli, to unconsciously behave in certain ways.

21. Gilles Deleuze and Félix Guattari, *Nomadology: The War Machine*. Transl. Brian Massumi. (New York: Semiotext(e), 1986), 34–36.

22. Ibid., 51, 53.

23. Ibid., 34.

24. Ibid., 38.

25. Ibid., 51.

26. Ibid., 41.

27. Ibid., 59.

28. Ibid., 60.

29. Unconventional categories could be related to for instance gender or race, or anything else that attracts attention and is seen as inventive or unusual. Many conflicts between groups in SL often centers on whether residents prefer a human form to furry (animal avatars), fantasy shapes or objects such as fire bolts or toasters.

30. Griefers are gamers who, instead of pursuing some goal in a game, decide to disturb and harass other gamers. In SL, well-known griefers such as the Patriotic Nigras, http://www.patrioticnigras.org/, aim to destroy the game experience by taking down sims or create (scripted) explosions for targeted groups such as the Goreans and the Furries.

31. Grid is a computing system. In SL it refers to the servers providing SL.
32. Linden Lab rulings are posted on the Incident Report page, http://secondlife.com/support/incidentreport.php, and new regulations are announced on the SL Blog, http://blog.secondlife.com/. Second Life community standards, The Big Six, regulate the residents' behavior towards each other on the grid, http://secondlife.com/corporate/cs.php-
33. Deleuze and Guattari, *Nomadology*, 88–89.
34. Notecards are a way of giving a large amount of information in written form in SL. These notecards can be put in an object (such as a button) that can be clicked, upon which the resident receives the notecard and can read the information.
35. Information boards can display a little amount of information but are visible without being clicked upon (as opposed to notecards, note 25).
36. A DCS2 RP meter on a Star Wars sim is programmed to give information about how much "life" a resident have left, or their rank in combat.
37. Little Mos Eisley notecard. Given on the Little Mos Eisley sim in SL.
38. NOJ, the New Order of the Jedi, is the name of the group of leaders at Yavin 4.
39. Role play rules for the New Order of the Jedi and their Jedi Temple grounds on Yavin 4. Notecard given on the Yavin 4 sim in SL.
40. OOC: out of character, not taking part in the role-play.
41. Role-play rules for the New Order of the Jedi and their Jedi Temple grounds on Yavin 4. Notecard given on the Yavin 4 sim in SL.
42. Galaxy News (*Star Wars* RP) is a fairly large *Star Wars* group with 233 members.
43. Galaxy News group description/charter found in the SL search engine. The aim is to provide "recent and updated news in all the systems of the *Star Wars* RP Galaxy. For roleplay purposes when attacks are staged, Updated news released, New Bountys are Placed, Crimes commited, New Systems Items or Technology released, or local information needed to know, it can be placed here."
44. Out of 233 members, 130 have profiles directly aimed at *Star Wars* role-play and 117 are members of five or more *Star Wars*-related groups.
45. SL resident profile found in the SL search engine.
46. Ibid.
47. Ibid.
48. Ibid.
49. Ibid.
50. Ibid.
51. Ibid. Caps in the original.
52. 93 out of the 233 in the group.
53. SWRP Community blog, http://swrpcommunity.blogspot.com/ (accessed on April 20, 2008).
54. Ibid.
55. SWRP on Second Life – Trailer, http://www.youtube.com/watch?v=y9hjB2dptRg (accessed on April 20, 2008).
56. Second Life: Byss Event (June 16, 2007), http://www.youtube.com/watch?v=F2qfEv62v3A (accessed on April 20, 2008).
57. Searching YouTube with the keywords "Second Life" and "Star Wars," I found 32 videos with similar themes (April 24, 2008), and it can be concluded that *Star*

Wars machinima makers in SL usually adhere to the community rules in terms of staying true to the Star Wars movie role-model and staying in character (but not the well-known characters from the movies) also when creating their works. The settings look correct and so do the actors.

58. *Tarnsman of Gor* (1966) and *Outlaw of Gor* (1967) are the first two novels in John Norman's Gor series.
59. Wikipedia, http://en.wikipedia.org/wiki/John_Norman (accessed on April 24, 2008).
60. Ibid.
61. Canadeo, Estrella. "The Bad Rap." *Thoughtful Kajira's Weblog: The Delicate Dance between Beauty, Submission, and Intelligence*, posted February 25, 2008, http://thoughtfulkajira.wordpress.com/2008/02/25/the-bad-rap/?referer=sphere_related_content/ (accessed on April 18, 2008).
62. Port Cos notecard given on the Port Cos sim in *Second Life*.
63. Ibid.
64. Canadeo, Estrella. "Minx." *Thoughtful Kajira's Weblog: The Delicate Dance between Beauty, Submission, and Intelligence*, posted Feb 17, 2008, http://thoughtfulkajira.wordpress.com/2008/02/17/minx/ (accessed on April 18, 2008).
65. Canadeo, Estrella. "Restrained." *Thoughtful Kajira's Weblog: The Delicate Dance between Beauty, Submission, and Intelligence*, posted March 24, 2008, http://thoughtfulkajira.wordpress.com/2008/03/24/restrained/ (accessed on April 18, 2008).
66. The "Slave's [sic] of Gor" group has 219 members.
67. Slave's [sic] of Gor group charter found in the SL search engine (accessed on August 24, 2007).
68. Two hundred and six of the residents have chosen female avatars; there are only 13 male ones in the group. As many as 174 of the 219 residents have created profiles perfectly in line with the Gorean role-model. One hundred and twenty-six of them are members of more than five Gorean-related groups, and in general they seem to be dedicated to Gorean ideals.
69. SL resident profile found in the search engine (accessed on October 5, 2007).
70. Ibid.
71. Ibid.
72. Ibid.
73. Ibid. In SL ageplay refers to "depictions of or engagement in sexualized conduct with avatars that resemble children." Critics have compared this to paedophilia (even though the person behind the avatar most likely is an adult). Linden Lab banned ageplay inworld on November 13, 2007, http://blog.secondlife.com/2007/11/13/clarification-of-policy-disallowing-ageplay/ (accessed on March 25, 2008).
74. SL resident profile found in the search engine (accessed on October 5, 2007).
75. Ibid.
76. Ibid.
77. 25 group members are a part of other groups as well.
78. Raddick Szymborska, comment on "The Problems of Gor – Part 1," The Second Life Herald, comment posted Nov 28, 2006, http://foo.secondlifeherald.com/slh/2006/11/the_problems_of.html#comment-25869544 (accessed on April 21, 2008).

79. Mikal Snakeankle, comment on "The Problems of Gor—Part 1," The Second Life Herald, comment posted November 30, 2006, http://foo.secondlifeherald.com/slh/2006/11/the_problems_of_1.html#comment-25977589 (accessed on April 21, 2008).

80. Jot Zenovka, comment on "The Problems of Gor—Part 1," The Second Life Herald, comment posted August 8, 2007, http://foo.secondlifeherald.com/slh/2006/11/the_problems_of.html#comment-78808784 (accessed on April 21, 2008).

81. Noyeh, comment on "The Problems of Gor—Part 1," The Second Life Herald, comment posted October 22, 2007, http://foo.secondlifeherald.com/slh/2006/11/the_problems_of.html#comment-87203292 (accessed on April 21, 2008).

82. Artemis Fate,"The Problems of Gor—Part 2," The Second Life Herald, November 29, 2006, http://foo.secondlifeherald.com/slh/2006/11/the_problems_of_1.html#more (accessed on April 21, 2008).

83. Artemis Fate."The Problems of Gor—Part 1," The Second Life Herald, November 27, 2006, http://www.secondlifeherald.com/slh/2006/11/the_problems_of.html and "The Problems of Gor—Part 2," The Second Life Herald, November 29, 2006, http://foo.secondlifeherald.com/slh/2006/11/the_problems_of_1.html#more (both accessed on April 21, 2008).

84. Ibid.

85. Ibid.

86. Ibid.

87. John Norman's novels are described as multifaceted universe, a "counter earth" with its own language, philosophy and history. The hierarchical theme seems indeed to be strong, but not as much at the forefront as it is in SL Gor, http://www.worldofgor.com/reference.aspx.

88. Ibid.

89. Artemis Fate, "The Problems of Gor—Part 2," The Second Life Herald, November 29, 2006, http://foo.secondlifeherald.com/slh/2006/11/the_problems_of_1.html#more (accessed on April 21, 2008).

90. Artemis Fate, comment on "The Problems of Gor—Part 2," The Second Life Herald, comment posted December 1, 2006, http://foo.secondlifeherald.com/slh/2006/11/the_problems_of_1.html#comment-26003352 (accessed on April 21, 2008).

91. Anon, comment on "The Problems of Gor—Part 2," The Second Life Herald, comment posted November 29, 2006, http://foo.secondlifeherald.com/slh/2006/11/the_problems_of_1.html#comment-25930800 (accessed on April 21, 2008).

92. Sandra-Dee, comment on "The Problems of Gor—Part 2," The Second Life Herald, comment posted November 29, 2006, http://foo.secondlifeherald.com/slh/2006/11/the_problems_of_1.html#comment-27043069 (accessed on April 21, 2008).

93. Ibid.

94. Just a thought, comment on "The Problems of Gor—Part 2," The Second Life Herald, comment posted December 22, 2006, http://foo.secondlifeherald.com/slh/2006/11/the_problems_of_1.html#comment-26871906 (accessed on April 21, 2008).

95. Miraren Firefly, comment on "The Problems of Gor—Part 2," The Second Life Herald, http://foo.secondlifeherald.com/slh/2006/11/the_problems_of_1.html (accessed on April 21, 2008).
96. Canadeo, Estrella. "The Slave Who Made a Home." *Thoughtful Kajira's Weblog: The Delicate Dance between Beauty, Submission, and Intelligence*, posted February 12, 2008, http://thoughtfulkajira.wordpress.com/2008/02/12/the-slave-who-made-a-home (accessed on April 18, 2008).
97. Canadeo, Estrella. "Along the Road." *Thoughtful Kajira's Weblog: The Delicate Dance between Beauty, Submission, and Intelligence*, posted February 4, 2008, http://thoughtfulkajira.wordpress.com/2008/02/04/along-the-road/ (accessed on April 18, 2008).
98. Canadeo, Estrella. "Minx." *Thoughtful Kajira's Weblog: The Delicate Dance between Beauty, Submission, and Intelligence*, posted February 17, 2008, http://thoughtfulkajira.wordpress.com/2008/02/17/minx/ (accessed on April 18, 2008).
99. Caledon covenant as seen upon arrival to Caledon (accessed on October 3, 2008).
100. Ibid.
101. Ibid.
102. Ibid.
103. Ibid.
104. Ibid.
105. The Imperial Navy of Caledon has 39 members, 32 of whom belong to the Caledon community both visibly (in the photos) and in writing (in the written presentations) according to the profiles, (accessed on October 5, 2007).
106. Imperial Navy of Caledon group charter, available in the SL search engine (accessed on October 3, 2008).
107. SL resident profile found in the search engine (accessed on October 5, 2007).
108. Ibid.
109. Ibid.
110. Ibid.
111. Ibid.
112. Maria Bäcke, "Construction of Digital Space: Second Life as a fantasy or a work tool." *The Virtual—Interaction. A conference 2007.* Södertörn University College (forthcoming).
113. Second Life Wiki. "Independent State of Caledon," http://secondlife.wikia.com/wiki/Independent_State_of_Caledon (accessed on April 18, 2008).
114. Otenth Paderborn. "No Comment." *Tenth Life: The Virtual Life of Otenth Paderborn*, posted March 12, 2008, http://otenth.homefries.org/2008/03/12/no-comment/ (accessed on April 18, 2008).
115. Ordinal Malaprop. "The 'Copybot' Word," *An Engine Fit for My Preceedings* posted March 3, 2008, http://ordinalmalaprop.com/engine/2008/03/03/the-copybot-word/ (accessed on April 18, 2008).
116. "What is Second Life?" http://secondlife.com/whatis/ (accessed on December 5, 2008).

117. Ordinal Malaprop, *An Engine Fit for My Preceedings* http://ordinalmalaprop.com/ engine/ and Otenth Paderborn, *Tenth Life: The Virtual Life of Otenth Paderborn*, http://otenth.homefries.org/ (both accessed on April 18, 2008).

Bibliography

Bentham, Jeremy. *Panopticon: Postscript.* London: printed for T. Payne, 1791.

Bäcke, Maria. "Construction of Digital Space: Second Life as a fantasy or a work tool." *The Virtual—Interaction. A conference 2007.* Södertörn: Södertörn University College (forthcoming).

Caledon Covenant. In Second Life on Caledon (searchable in map), select "about land" and then read under tab Covenant. (accessed on April 23, 2008).

Caledon Forums. http://www.caledonforums.com/index.php (accessed on April 23, 2008).

Caledon Wiki, The. "The Caledon Wiki: Archives of the Independent State of Caledon in Second Life." http://www.caledonwiki.com/index.php?title=Main_Page (accessed on April 21, 2008).

Canadeo, Estrella.*Thoughtful Kajira's Weblog: The Delicate Dance between Beauty, Submission, and Intelligence.* http://thoughtfulkajira.wordpress.com/ (accessed on April 18, 2008).

Deleuze, Gilles and Félix Guattari. *Nomadology: The War Machine.* Transl. Brian Massumi. New York: Semiotext(e), 1986.

Fate, Artemis. "The Problems of Gor—Part 1." The Second Life Herald. http://www.secondlife-herald.com/slh/2006/11/the_problems_of.html (accessed on April 21, 2008).

—. "The Problems of Gor—Part 2." http://foo.secondlifeherald.com/slh/2006/11/the_problems_of_1.html#more (accessed on April 21, 2008).

Foucault, Michel. *The Foucault Reader.* Ed. Paul Rabinow. New York: Pantheon, 1984.

Galaxy News (*Star Wars* RP). Group description found in the SL search engine. (accessed on October 5, 2008).

Gibson, William. *Neuromancer.* New York: Ace Books, 1984.

Imperial Navy of Caledon. Group description found in the SL search engine. (accessed on October 5, 2008).

Little Mos Eisley. In Second Life at Little Mos Eisley (searchable in the SLsearch engine). Notecard given upon arrival. (accessed on July 24, 2007).

Malaprop, Ordinal. *An Engine Fit for My Proceedings.* http://ordinalmalaprop.com/engine/ (accessed on April 22, 2008).

Paderborn, Otenth. *Tenth Life: The Virtual Life of Otenth Paderborn.* http://otenth.homefries.org/ (accessed on April 22, 2008).

Port Cos. In Second Life at Port Cos (searchable in the SL search engine). Notecard given upon arrival. (accessed on August 5, 2007).

"Role play rules for the New Order of the Jedi and their Jedi Temple grounds on Yavin 4." Notecard upon arrival at Yavin 4. (accessed on August 1, 2007).

Second Life (application).

"Second Life: Byss Event (June 16, 07)" http://www.youtube.com/watch?v=F2qfEv62v3A (accessed on April 18, 2008).

Second Life.com. http://secondlife.com (accessed on December 4, 2008).

Second Life Herald. http://www.secondlifeherald.com/ (accessed on December 6, 2008).

Second Life Tribe, The. http://www.secondlifetribe.com/ (accessed on December 6, 2008).

Second Life Wiki. http://secondlife.wikia.com/wiki/Independent_State_of_Caledon (accessed on April 21, 2008).

Slaves of Gor. Group description found in the SL search engine (accessed on October 5, 2007).

Star Wars Fans in Second Life Forum. http://swfansinsl.forumcircle.com/ (accessed on April 17, 2008).

SWRP Community blog. http://swrpcommunity.blogspot.com/ (accessed on April 17, 2008).

"SWRP on Second Life – Trailer." http://www.youtube.com/watch?v=y9hjB2dptRg (accessed on April 18, 2008).

Wikipedia. "John Norman." http://en.wikipedia.org/wiki/John_Norman (accessed on April 18, 2008).

World of Gor. http://www.worldofgor.com/reference.aspx (accessed on December 17, 2008).

Post-Chapter Dialogue, Bäcke and Ricardo

FJR: In your analysis, Second Life (SL) is more than a constellation of digital play-spaces but evinces something unique to the social collective in virtuality, namely that in such spaces there are participatory ethics of behavior that influence the creation of identity:

> All these places have their own codes of conduct and covenants that shape the constructed social space, and my hypothesis is that the rules of these social spaces then function as a foundation and guide-line for identity formation, and in fact almost seem to prescribe a certain way of acting or behaving.

This suggests that a distinction in SL between *character* as a created collection of appearances and group-influenced actions, and *identity*, as something more primeval that is formed as a case of participation in spaces where the constructed character would seem to belong and make sense. Is this in your work a valid distinction? Is there a rationale for layered kinds of being in a world that is highly symbolic and theatricalized?

MB: Yes, your observation is correct. Most people seem to envision an environment such as SL as a free space where their actions have little or no consequences for them personally and this is how they enter the world. Some expect to play a role that is clearly separated from who they are in the physical world, some seem to use the online character as a shield for their offline self. The moment if and when they get emotionally involved can be defined as the moment when their online experience changes, and when their actions and people's responses to them might begin to affect their way of thinking. I do think people choose what context and environment they like to be a part of based on the level of engagement they are willing to participate on, a level that might correspond to their needs or fears on a deeper psychological level and thus very relevant for them on the level of identity.

FJR: SL points to a world of specialized behavior in a space that does not allow physical embodiment but has everything else. In my view, the extensions of the physical world into a world that is decidedly un-physical produces a tension that promotes a kind of obsession of being. Can you elaborate on the connection between this social sensibility and the desire for participation in a realm in which physicality is missing?

MB: There are a number of possible connections and I would say that SL is not entirely "un-physical." On the one hand the perceived lack of physicality can be very liberating. Obviously, any possible physical danger of social interaction is gone. It is impossible to punch someone on the nose in SL other than in a symbolic or verbal way, and therefore it seems safe to act out basically everything. A second example is people who create avatars very far away from the person they are in the physical world, for instance, by changing the gender or using animal or cartoon avatars. Both

examples highlight the seemingly straightforward way in which SL can be seen as completely un-physical compared to the physical world. However, when a resident encounters the mental or verbal version of that punch on the nose and notices that it might still hurt, if only mentally, or when someone is forced to reveal that their real gender is different from the one they are using inworld, causing distress to those who thought they "knew" him or her inworld, it becomes evident that the *simulated* physicality of SL matters. It is used to give cues about who and what people are. The experiences in SL show that physicality is indeed deeply rooted in the mind. It points to how people think about their own and other people's bodies, shows how they are judged by appearance, and draw attention to processes where groups are formed and negotiated. It highlights, and, yes, it does indeed create an obsession, around the construction of identity, of being. Being in an online world is in itself an exploration of what "simulated physicality" really means and what cues we look for when meeting someone unknown. Preconceived ideas of social interaction are often questioned and our need for physical anchoring can be studied when the unquestioned physicality of the "real" world is not self-evident anymore.

FJR: Your focus on behavior in SL suggests the possibility of designating the *gesture* as the unit of analysis in distributed representations of self. The closest one comes in contemporary art and literature is a similar category of gesture, a term which I do not mean as identical with the gesturalism of Pollock, de Kooning, Kline, Motherwell, or Hofmann, but rather as a notion of behavior or form that calls attention to itself, as in the polyphony that Bakhtin calls carnival. The gesturation of SL invites direct reference to the idea of the grotesque body in Bakhtin's allusion to Rabelais idea which Terry Harpold has termed a figure of unruly biological and social exchange. Harpold's characterization of the early Renaissance grotesque, I think, could be applied to SL aesthetics and ethics:

> In grotesque art, the borderlines that divide the kingdoms of nature in the usual picture of the world were boldly infringed—There was no longer the movement of finished forms, vegetable or animal, in a finished and stable world; instead the inner movement of being itself was expressed in the passing of one form into the other, in the ever incompleted character of being.

> Grotesque art is an art of transitional spaces, founded on precise observations of natural forms, but exaggerated all out of proportion, to a point where the texture of the gaps between objects overruns their boundaries.[1]

What role does gesture play as the basis of interaction in SL, and what aesthetic dimension does gesture assume there?

MB: Gesture or the grotesque, in the way they take shape in SL, associate with the creation of what Deleuze and Guattari call smooth space, a space where a person can be or do whatever he wants and where predefined behavior or rules do not exist. The decision to use an avatar that stands out, that is grotesque or "larger than life," signals the resident's wish to widen the metaphorical space he or she has at their disposal. If someone has chosen an "unnatural" giant dragon shape, people immediately know

that this cannot be even close to what this person looks like in the physical world and this fact seems to facilitate new ways of interacting. Nationality, race, gender, or age are not taken for granted, but have to be verbalized (if the need occurs). In SL, I have noticed that some people avoid the grotesque. They are afraid of that which defies definition. In SL Gor, for instance, one is not actually allowed to have multiple avatars or assume a nonhuman shape. On the other hand, there are also many people who embrace its possibilities for transformation and transition. A shape can always be changed into another in seconds. The large number of stores inworld, where shapes ("avatars") are sold, offer a wide range: from super heroes, skeletons and ghosts to spiders, dragons, jellyfish, pumpkins and toasters. All these shapes facilitate taking on new roles and different behavior, roles and behavior that are then accepted or rejected in the groups or communities in which the individual residents take part.

Note

1. Terry Harpold, "The Grotesque Corpus," *PERFORATIONS* 2, no. 3 (1992).

Bibliography

Harpold, Terry. "The Grotesque Corpus." *PERFORATIONS* 2, no. 3 (1992).

CHAPTER EIGHT

Looking behind the *Façade*: Playing and Performing an Interactive Drama

Jörgen Schäfer

"Interactive Drama": Interactivity and/versus Literary Imagination

Façade by Michael Mateas and Andrew Stern is a response to widespread unease with mainstream computer games. Although Mateas and Stern explicitly acknowledge that commercially successful games offer players well-formed experiences insofar as they are "set in a simulated world with real-time 3D animation and sound, and offer the player a first-person, continuous, direct-interaction interface, with unconstrained navigation and ability to pick up and use objects,"[1] they criticize the fact that, in these games, the player only has *local agency*. This kind of agency only impacts the emergence of the story in one particular game level, and therefore it only "results in the feeling of having many things to do (places to go, objects to fiddle with) without having any sense of why any one action would be preferable to another."[2]

What may be satisfactory for ego-shooters and all types of games that focus on physical actions of the player's avatar (such as running, jumping, shooting and fighting) remains disappointing for games or game-like experiences that aim at unfolding a complete story with a certain narrative coherence without having to rely on non-interactive cut-scenes for interweaving successive playable game levels. Referring to the controversy between "narratologists" and "ludologists" on the boundaries between narrative and games, Mateas and Stern argue that there can be no satisfying solutions as long as game designers fail in offering what they call *global agency* in the sense that a player's actions would have meaningful and longer term effects on the overall story.[3] They therefore aim at creating "interactive experiences about human relationships" by providing "an artificial intelligence system that uses knowledge about how stories are structured to construct new story-like experiences in response to the player's moment-by-moment, real-time interaction."[4]

With this goal, Mateas and Stern's project aims to counter fundamental objections that, among others, Michel Chaouli leveled against literature in computer-aided media in general. In an article in *Critical Inquiry*, Chaouli raised the key question of whether we can "imagine formal configurations in the computer medium, distinguishable from other arrangements within the same medium, that introduce the

reader-recipient into the kind of fictional world that myths, fables, novels, plays, and films open up."[5] In Chaouli's view most digital literature has been rather mundane so far because it systematically averts the literary imagination or the aesthetic difference, which has always been essential for our understanding of literature. His ideal is the traditional "closed" novel or drama, in which we can easily identify a plot with an exposition at the beginning, a conflict and a climax in the middle, and a solution of the conflict at the end of the story. Such a text, of course, does not allow anything to be deleted or added, least of all banal users' ideas or computer-generated elements. Therefore his main focus lies on the question of how complex fictional worlds might be constructed by the digital medium. It is no surprise that in his view most digital literature does not live up to man's deep-rooted desire for mutually telling fictional stories or performing dramatic plays since, of all things, interactivity—that, in principle, allows users to modify data in computer-aided media at any stage—has become the biggest obstacle for successful literary communication: If, for example, the reader-recipient of any hyperfiction is obliged to click a link at some point without having a clue why to do so, or if the player in an interactive drama is free to act as himself rather than as a drama character, his/her aesthetic pleasure is constantly lead astray in a very literal sense.[6]

Granting that Chaouli adopts a radical and ostensibly simplistic position that overlooks most avant-garde fiction and theater, we should not easily dismiss his arguments—although we could ask whether the recipient of a literary piece must inevitably accept the gap between author and reader or playwright, director, actors, and audience, which in Chaouli's argument is inflated to a sort of anthropological constant.

With these reservations in mind, I prefer to follow a different approach that tries to identify both common ground and differences between expressive genres and media adaptations. Given that a migration of literary forms from printed texts into computer-aided media apparently is taking place, digital literature must contain invariant structures of repetition that only—in spite of any differences caused by distinct media of production, transmission, and reception—enable us to speak of "literature" as a single field. My main assumption is that for reading and analyzing digital literature *as "literature,"* the *semantics of literary concepts need be more durable than the pragmatics of communicative acts.* Even where theorists aim at developing new and more adequate methods, terminologies, or categories, they should not disregard the *literariness* of their subject matter. They therefore must inevitably start thinking from those concepts that have been historically developed in literary studies. Among those "structures of repetition," *literary genres* still play an important role since they *reflect core aspects of literariness.*[7]

To be sure, computer games share at least two characteristics with narratives and dramas: first, they all represent *fictional worlds*; second, fictional action is necessarily *separate* from real-world action. It should thus be possible to identify morphological and functional equivalents that allow the mutual substitution of game elements with either narrative or drama elements. Yet, many features of games, narratives, and drama are in opposition to each other as regards who the agent of the action is, what motivates him/her, how s/he performs the action and how action comes to an end.

Rethinking Genre Theory: Games, Narrative, and Drama

Mateas and Stern aim high: "To be interactive drama," as a goal, "an experience should have rich, emotive, socially-present characters to interact with, and a strong sense of story progression that is organically and dynamically shaped by the player's interaction. Additionally, the player's primary interactions should be with the characters."[8]

The aim of involving players in *dramatic* action and putting them in conflict with the characters can only be achieved if game designers and software engineers succeed in elevating the quality and impact of both *natural language conversation* and nonlinguistic communication (facial, manual, and bodily gestures) between characters in the game world to another level. User-centered discourse, principally talk and argument, in current computer games is typically limited to selecting from a set of pre-scripted expressions, and there is nothing close to *dramatic dialogue*. This is the desideratum on which Mateas and Stern have placed great weight: To enable human players to communicate in natural language with the game system itself is the crucial precondition of "dramaticness."

Before discussing *how* Mateas and Stern refer to the principles of drama, I want to briefly clarify what these principles are. From standard handbook and dictionary definitions, we take drama as being about a *conflict between characters* that is not narrated by a narrator but enacted as *present action* that the audience witnesses. It carries and conveys the plot through *dialogue* and—when performed—also through gesture and facial expression; and it is not suited primarily for silent reading but for *theatrical performance in real time*.

In an essay tellingly titled "A Preliminary Poetics for Interactive Drama and Games," Michael Mateas proposes a theory of interactive drama based on Aristotle's *Poetics*—strictly speaking, on Brenda Laurel's interpretation of Aristotle (Figure 1)—that explicitly adopts principles of *classical theatrical drama* that nonetheless are to be "modified to address the interactivity added by player agency."[9] Mateas first takes up Aristotle's idea of achieving a sense of cohesiveness by following the rule of the three unities of *plot, place* and *time*. This rule means that a play should have only one single plot line, which ought to take place in a single location and within one day, in order to make the plot more plausible and thus comply with Aristotle's notion of *mimesis*. Second, he refers to those six qualitative parts of drama that are pivotal to Aristotelian poetics, which Laurel has illustrated in a multi-level model:

> There are six parts consequently of every tragedy, that make it the sort of tragedy it is, viz. a plot, characters, diction [i.e. the use of language], thought, spectacle [i.e. everything that is seen], and melody [i.e. everything that is heard]; two of them arising from the means, one from the manner, and three from the objects of the dramatic imitation. Of these, its formative elements, then, not a few of the dramatists have made due use, as every play, one may say, admits of spectacle, character, plot, diction, melody, and thought.[10]

In Laurel's model, the so-called "formal cause" represents the authorial point of view, whereas the "material cause" corresponds to the recipient's perspective. Toward the aim of integrating interactivity into the Aristotelian framework, Mateas introduces

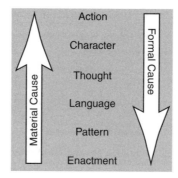

Figure 1. Brenda Laurel's Illustration of Aristotelian Theory of Drama[a].
[a]Brenda Laurel, *Computers as Theatre* (Reading, MA: Addison-Wesley, 1991), 51.

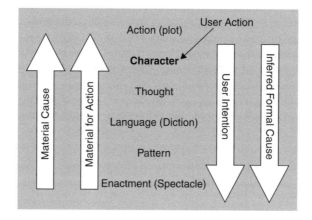

Figure 2. Michael Mateas' Model of Neo-Aristotelian Theory of Drama[a].
[a]Mateas, "A Preliminary Poetics," 24.

two additional causal chains on the character level (Figure 2).[11] The so-called "*material affordances*," which are defined as "constraints from below," prescribe that, in the fictional world, players have to deal with *believable agents* whom they can assign intentions and motivations. Characters need to be able to *express emotions* "with a strong sense of *immediacy* and *presence*, whose very *aliveness* results in the audience experiencing a sensation of danger or unpredictability, that anything is possible."[12]

This, however, has significant effect on the *motivational logic* of a drama as represented in the Aristotelian model. If the dramatic logic is modified into a game logic, the actions of characters in the fictional world inevitably become *options;* their decisions then become independent from motivational logics and instead are at the player's disposal.[13] Therefore the dramatic logic, which has always been dependent on genre structures and genre conventions that have imposed a certain constraint, is under a sort of *collaborative agency* of author(s), player(s), and media system(s). In such interplay, none of the various participating "actors" or "actants" is able to assert

his/her/its agency, and therefore a variety of alternative plots inevitably becomes possible.

In Mateas' and Stern's approach additional *formal constraints from above* in addition to the material affordances are the required means for curtailing the number of outcomes producible by integrating a sort of tension arc into interactive drama. This appears to be the only way to frame the player's actions with any dramatic logic.[14] Such a tool for mapping dramatic structure, which resonates in Mateas and Stern's concept of interactive drama, is Gustav Freytag's "Pyramid," itself an application of Aristotle.[15] Freytag famously attributed a specific dramatic function to each of the five acts: The first act serves as exposition that introduces the main characters and hints at the coming conflict. In Act II, the tension increases as the conflict between the protagonist and his antagonists develops. The climax or turning point in the third act is the moment, in which the protagonist's fortunes change irrecoverably for the worse. Then the moment of tragic recognition, during the falling action in the fourth act, is followed by further events that delay the catastrophe. In the fifth act, a solution to the conflict, a *catharsis,* is presented.

At first view, however, it seems ironic that the designers of *Façade* attempt on one hand to utilize the latest media technologies for creating dramatic experiences, but, on the other, explicitly refer to the oldest, most traditional theoretical drama model. One might also argue that Mateas and Stern's approach is based on a very general and *un*historical definition of drama that surprisingly ignores exactly those participatory genres in twentieth-century theater aimed at dissolving the boundaries between actors and audience. In her studies on the aesthetics of the performative, Erika Fischer-Lichte emphasizes that in avant-garde theater of the early twentieth century—and even more in so-called *"postdramatic theater"*[16] from the 1960s—audience reactions were no longer to be suppressed. In contrast, playwrights and stage directors initiated what Fischer-Lichte calls *performative theater.* They aspired to establish a *feedback loop between actors and audience* by introducing new participatory strategies to provoke audience reactions, thereby involving the audience (at least potentially) as a sort of *inter-actors.* What takes place on stage is no longer only a representation of a dramatic text; the performance is the product of the bodily co-presence and *real-time interaction of actors and audience.*[17]

While participatory avant-garde theater invited audience interactions in order to break with the Aristotelian tradition of the three unities, the computer-aided interactive drama *Façade,* surprisingly tries to meet its formal requirements.[18] To affirm the player's influence on the behavior of a character, the system has to offer those two different forms of agency I mentioned earlier: the player needs to have *"local agency"*—something that conventional computer games have reliably provided so far. The main problem to be solved if *Façade* is to provide motivational logic of the characters is the question of *"global agency"*: the player's own agency needs to have an effect on the trajectory of the story.

Intertextuality and Genre Evolution: Marital Drama from Stage to Interactive Media

It is against this theoretical and historical background that I am interested in *why* Mateas and Stern classify *Façade* as "drama" and how they justify this classification.

I first would like to introduce a model that enables us to *elaborate both the structural differences and the common subject matter* of *Façade* and "traditional" drama, and then I will try to examine some *intertextual references* to Edward Albee's marital tragedy *Who's Afraid of Virginia Woolf?*,[19] from which Mateas and Stern admit to have derived the idea for "an intimate, kitchen-sink drama"[20] about a marriage in crisis.

I already referred to Aristotle earlier in order to emphasize that dramatic action implies *personal agents*, who, as Aristotle said, "must necessarily *have their distinctive qualities both of character and thought;* since it is from these that we *ascribe certain qualities to their actions,* and in virtue of these that they all succeed or fail."[21] In the 1970s, Jürgen Link worked out a structuralist approach to drama analysis that implicitly refers to Aristotle by arguing *that the character qualities motivate the plot*. Link assumes that drama characters can be classified by way of contrast or correspondences of distinctive qualities that trigger the dramatic action. Each individual drama is therefore distinguished by a unique "configuration" or constellation of figures within the fictional world. For this approach, it is essential that the characters as such *not* be the elements within the drama's configuration. This analytical model rather operates on the characters' smallest *semantic qualities*, that is, either "social" or "natural" attributes that have both explicitly and implicitly been made in the play's secondary text or by the characters in the play. As a semantic field, such a configuration can be represented in a matrix, in which antagonistic attributes, interests or ambitions are contradictory to each other and thus, during the temporal progression, become the driving forces for conflicts between the characters:

> Plays are characterized by the fact that the main part of the text [. . .] is constituted through the medium of the characters. Any piece of dramatic text is a function or an integral part of the dramatic character. This suggests that there is a close correlation of the (non-temporal) configuration and the (temporal) evolvement of the dramatic text.[22]

In the case of *Who's Afraid of Virginia Woolf?* for instance, these could include "natural" attributes such as age/generation, temper, gender, physical appearance, or rather "social" attributes such as education, rank, professional success, ambition, alcoholism, and so on.[23] From this configuration, a *dramatic logic* can be drawn, according to which different plot lines cannot be arranged in any order because the characters' possible actions are limited by dramatic conventions. Moreover they are subject to an—as Rainer Leschke put it—"imperative of dramatic motivation"[24] of conflicts, which is determined by the "difference of normative character qualities."[25] As previously mentioned, the action of a drama thus evolves when dominant semantic qualities of protagonist and antagonist come into conflict with each other and thus trigger the plot. Therefore, according to Link, any drama can be understood "as a *particular selection taken from a set of combinatorially possible intersections of qualities* within a matrix that can be arranged in linear succession according to explicit rules."[26] Of course, in each drama only a marginal number of possible combinations are actually selected. There is always one protagonist designated as the leader of the action whose qualities determine the main conflict. Consequently only those other combinations are selected that support this dominant conflict.

In *Who's Afraid of Virginia Woolf?*, George and Martha, a married couple in their late forties and early fifties, have invited Nick, a new young professor of biology and his petite wife Honey to their house after a party. George is a history professor at a college headed by Martha's father. Martha, in the list of characters, is described as "a large, boisterous woman, fifty-two, looking somewhat younger. Ample not fleshy,"[27] and, at a later stage, after having changed her clothes, even as "most voluptuous."[28] During the entire play, Martha and George have a fierce and scathing argument in front of their guests. Nick and Honey, on the one hand, are irritated and even disgusted by their host's behavior but, on the other hand, they cannot escape their fascination with the occurrence.

In a significant scene at the end of Act II, Martha seduces Nick blatantly in front of George who, however, does not get upset but calmly continues reading a book—which makes Martha even more frustrated and furious.[29] From this episode, we can identify the play's configuration. Martha, who is permanently frustrated and choleric, regards George as a failure whose academic career has gone awry, particularly when compared to that of her admired father. Her bitterness and her discontent are the motivations of her ongoing attacks on George and thus drive the dramatic action forward. The other relationships between the characters are related to this main conflict.

The argument culminates in Martha committing adultery with Nick who is handsome and career-minded and thus, in Martha's view, represents the opposite of her husband. As a natural scientist, he is convinced of technological progress, whereas George is fraught with a brooding intellectual skepticism. This opposition has an important dramatic function: If George and Nick would get along with each other, Martha could not leverage her sexual advances to Nick against her husband. From time to time, however, signs of affection between Martha and George resurface, and undermining the open hatred and aggression, prevent the characters from devolving into stereotypes.[30]

In principle, the configuration of marital drama provides the opportunity for a multitude of conflicts. But as my brief examination of the Albee play's configuration shows, in stage drama as well as in film or TV drama, only those semantic oppositions that determine the main conflict will substantiate in characters and become acted out. *In interactive drama, by contrast, player interactions make it at least difficult, if not ultimately impossible, for game designers to determine a preference for a particular conflict and thus trigger the plot into one predetermined direction.* From the player's viewpoint, this is undesirable insofar as a strictly determined plot would constrain his agency. Therefore the dramatic oppositions from the configuration, at least potentially, are to be *playable options* in interactive drama. In *Façade*, authorial control has deliberately been reduced in order not to over-constrain the *player's* first-person engagement within the dramatic world. Yet, at the same time, for supporting the concomitant player/*spectator's* "third-person reflection across multiple experiences in the world," the plot needs to be structured "such that each run-through of the story has a clean, unitary plot structure, but multiple run-throughs have different, unitary plot structures."[31]

This paradox, however, is not easy to resolve since a number of difficult problems must be overcome: What keeps the player from interacting and thus putting a plot into action that is contrary to the aesthetic requirements of an Aristotelian story arc? What

prevents him from—either intentionally or by chance—precisely conducting those conflicts that are not determined from the intersection of qualities? We might imagine the outcomes, for example, in the aforementioned scene from the Albee play, if the first-person player had to assume the role of Nick and was *not* having sex with Martha, but with his wife: That turn would certainly be peculiar given Nick's invitation to a colleague's house, but it would not support the main conflict of the play. Or what happens to the story if players take Mateas and Stern at their word and really act as themselves in a way that does not fit within the dramatic world? Imagine you, as the player, would start talking about some gossip instead of immersing into the conflict between Martha and George: This would breach the consensus of boundary between playful actions in games and dramatic actions in the fictional world since, as we have seen, only in games can the boundary between the factual and the fictional be crossed.[32] How can surprising behaviors and actions of characters be generated while, at the same time, preserving the dramatic coherence and consistency?

Interactive Drama: Integrating Player Agency into Aristotelian Dramaturgy

We may take as self-evident that providing agency to both programmable media systems and recipients—and thus making them players—leads to a new kind of aesthetic experience: in "traditional" literary experience, reading a novel or a poem or watching a theater performance triggers an interplay between the linear sign strings on the paper or the actor's expression, the intertextual references of the text and the imaginative process in the recipient's mind. This interplay has always been understood as a sort of reflection on perceptions, thoughts and interactions of human beings. In computer-based media, we generally have to think in terms of *distributed agency* that describes the output of interactive processing as the more or less contingent product of hybrid systems of human activities, sign operations, and machine activities.[33] It is thus in computer-aided processes that the user immediately takes over the role of a creative player in a game-like experience that acts as an *intervening* force and thus determines the actions of characters in the fictional world.[34]

And so we must negotiate activities on different levels of action, ones that call for particular attention to the relationship between the factual and the fictional domains. While the boundary between the factual and the fictional world in a game is a *conditional boundary* solely defined by game-rules, in narrative and dramatic contexts, there is an *unconditional boundary*, which, as Jochen Venus argues, needs to be strictly accepted in order to preserve the "willing suspension of disbelief."[35] Computer-aided interactive media, in principle, make the framing of the fictional world by rendering such an unconditional boundary impossible. Consequently, the design goals of interactive drama are conflicting ones: on the one hand, the recipient/player ought to have an aesthetic experience comparable to that of the audience of a classical drama, namely one of "enactment, intensity, catharsis, unity and closure"[36] which requires that the boundary between the factual and the fictional be strictly observed. On the other hand, unlike Aristotelian drama, interactive drama must also provide the player

with a strong sense of first-person *agency as character within the story,* which cannot be brought into compliance with the first premise.[37]

For that reason, the development and implementation of an efficient "*drama manager*" is of central importance: The *Façade* drama manager is an artificial intelligence plot system with a library of basic plot elements, so-called "beats"[38]—each of which, of course, must be written in advance by the authors— and uses knowledge about the structure of well-formed plot arcs to construct new experiences, which ought to have the force of dramatic necessity.

The smallest unit is a so-called "*behavior,*" a "small computer program, or procedure, that performs a bit of dramatic action for a character."[39] Since Grace and Trip almost always perform in sync together, these procedures are programmed as "*joint dialog behaviors.*" On the next hierarchical level, there are 27 "beats," which consist of 10–100 "joint dialog behaviors" and thus are the smallest *dramatic* unit.[40] These beats are collections of so-called "beat goals" which are activated in response to the player's input and the current level of story tension.[41] In addition to the beats, there is in *Façade* also a variety of so-called "*mix-ins,*" which are "small- to medium-sized narrative situations about supporting, related or tangential aspects of the drama."[42] The insertion of mix-ins enhances the authenticity and the believability of the dialogues. The progress of the plot is ensured by combining beats and mix-ins, which are measured according to the "*story values.*" These values reflect attained tension levels in comparison to an ideal "tension arc," modeled in the style of Freytag's pyramid. They also reflect the player's affinity with Grace and Trip, all the previous actions of the player and the

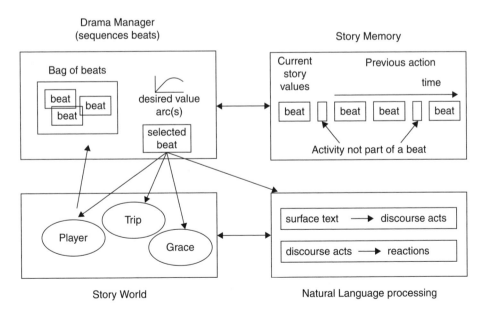

Figure 3. Façade Interactive Drama Architecture[a].

[a] Mateas and Stern, "Façade: An Experiment," 8.

degree of Grace's and Trip's self-awareness.[43] *Scenes*, however, are collections of beats designed in analogy to the acts in Aristotle's or Freytag's models.

But even the best drama managing system would not be able to involve players in *dramatic* action if game designers and software engineers failed in "providing at least a limited form of natural language dialogue."[44] Therefore the artificial intelligence system has to be able to *recognize every possible natural language input in each individual discourse context* and thus allow the player to communicate with the non-playing characters. In *Façade*, the player is free to "say" anything s/he wants at any time using the keyboard. Grace and Trip speak back with (pre-recorded) spoken voice. There is also another communication channel for so-called "embodied interaction," that is, emotional gesture as well as facial and body animation that are to "carry emotional and symbolic weight, and should have a real influence on the characters and their evolving interaction."[45] Clearly then, every expression, every player action—insofar as the AI system successfully interprets it and generates a reaction that makes sense in the given context—determines the beat sequencing and thus shapes the Aristotelian story arc.

Experiencing *Façade*: Player Agency and Drama Experience

At the beginning of *Façade*, the player is not presented with much information about the story and its background. S/he assumes the role of a first-person character invited for drinks by his/her old friends Grace and Trip, a married couple in their thirties, whom s/he has not seen for quite a while.[46] After the player has selected his/her own name and gender (which has an influence on flirting), the game begins with her/him at the front door of the apartment. This is the only non-interactive cut-scene in *Façade*. From inside, s/he overhears Grace and Trip fiercely arguing about where the wine glasses are. A moment later, however, Trip opens the door and kindly welcomes his guest. In this beat, an initial affinity of the player with Trip—and therefore with Grace, too—is established.

The apartment, which Grace and Trip presumably have just moved into, is furnished sparsely. The highlight is a large panorama window that offers a spectacular view onto the downtown area of an unidentified city. This apartment with a corridor and a kitchenette provides the complete setting of the drama, which, of course, may be used to indirectly characterize Grace and Trip and thus contribute to the drama's configuration: it creates the impression of being occupied by young professionals who want to live in fashionable ambience but do not feel stylistically confident in decorating. The location of the apartment suggests that Grace and Trip are socially and financially successful. There are scarcely any further characterizations of Grace and Trip, and since the interface design is minimal and comic-like without, for example, photo-realistic elements, their physical appearance, unspectacular clothing and hairstyles provide no more than a sketchy, provisional portrait of these characters.

This rather fuzzy characterization of Grace and Trip, however, has a function: in order to not prematurely rule out possible variations of the plot, the characters cannot be elaborately portrayed from the outset, as this would prescribe a configuration that might thus determine a particular dramatic logic. Instead, the individual traits of

Figure 4. Grace and Trip in their apartment.

Grace and Trip are revealed only subsequently—*depending on the gameplay*. From the initial argument between Grace and Trip about the whereabouts of the wine glasses, for instance, the player cannot infer who has provoked the quarrel and what his/her motivations may be. If this were kept in strict analogy with *Who's Afraid of Virginia Woolf?*, Grace would be identified as aggressor, and further plot development would be limited. It would then be rather implausible for the player to side with Grace.

As soon as the player enters the apartment, Grace and Trip immediately try to get him/her on their side. Mateas and Stern call this expository part of their drama the "*affinity game*." From here, as the player becomes involved in their argument, the plot unfolds. Every move and expression has an immediate effect on the affinity with Grace and Trip, and thus affects the tension level and draws information about the state of their marriage out of them. As soon as the expository greeting beats are over, the plot gets more non-linear and thus playable.[47] Several beats can follow, depending on the tension level and on whether the player's input fits into the topic of conversation.

Next, reflecting the second act in Freytag's pyramid, further circumstances related to the main conflict are introduced. There are several possible beats to follow, which make use of different conflict potentials. In the "DiscussGracesDecorating" beat,[48] for example, Grace tries to make the player criticize her decorating in order to "express her hidden frustration of choosing an advertising career instead of art, and to rile up Trip who finds such self-deprecating talk embarrassing."[49] It thereby becomes clear that the diction and the tone of Grace's and Trip's expressions are dependent on their affinity to

the player. The dialogue within that beat also predetermines the topics of conversation in the following beats. While the global mix-ins promote greater realism, they also help to introduce controversial topics into the so-called "*hot-button game*," as allusions to topics such as marriage, divorce, sex, or jealousy.

However, the illusion of a perfect world soon turns out to be only a fragile façade behind which the marriage is rapidly falling apart. As soon as a pre-defined tension level, which represents the plot climax, is reached, the so-called "CrisisBlowupBeat" is sequenced, which Mateas and Stern describe as follows:

> After the accusations are thrown, the one who is most bothered by the events so far overall will then turn to you and pose a Dramatic Crisis Question. This yes-no question is inspired by the overall direction that the drama has been moving in so far; it is meant as a binary test for determining whose side you are really on; Grace and Trip do not give you the option of being neutral (attempting to not answer is effectively not giving the question asker the answer they want). Depending on your answer, one of them will feel rejected by you, will throw out one last hurtful accus-ation to the other, and flee to the kitchen.[50]

The so-called "*therapy game*," which represents the falling action, is not only the most complex part of *Façade* but also the part of the drama that requires the highest degree of player agency. By means of linguistic expressions, the player can either esca-late the quarrel or appease the conflict and, by adapting a "therapeutic" strategy, help to save a marriage that seemed irretrievably broken. In the "ending beats," conflict is resolved either by Grace and Trip coming to terms with each other or by their marriage definitely falling apart. In any case, the player must leave the apartment; either being ejected while the argument audibly continues, or by leaving behind friends who have agreed to make a new start.

Conclusion

What rejoinder can conclusively be given to Chaouli's initial fundamental criticism? Is it really the case that aesthetic pleasure and critical examination of literary texts and dramatic performances in computer-aided interactive media are suppressed *in principle*? Or is it possible to challenge this verdict, since it seems possible—at least gradually—to realize dramatic logic in interactive media? Chaouli himself suggests a way out of the dilemma, which resembles that which Mateas and Stern follow. For Chaouli, fiction—literary or otherwise—must embrace two major shifts to accommo-date computational media:

> First, it needs to recognize that the role of the reader familiar to us from print changes in the degree to which the links between textual elements remain seman-tically underdetermined. Second, fiction somehow needs to manage the fact that the user's navigational decisions can be driven by motives wholly divorced from the fictional world, provoking a crisis of fictionality. The fictionalization of reception is one way of addressing both shifts, for a fictionalized "interaction" would be severely

limited by the boundaries of the fiction, thus rendering the fictional world a larger, more complex, and more interesting space to inhabit.[51]

To solve the problem posed by Chaouli, one must succeed in organizing the interaction of the player-recipient with the AI system in a way that prevents transgressing the "unconditional boundary" and disturbing or even undermining the *aesthetic* experience. As regards the double role of player and recipient, this requires the first-person *agency* as character within the story to be *semantically* determined in accordance with a dramatic logic. Only when this occurs can third-person *reflection* on the dramatic story become possible at all. This has, of course, been regularly inscribed in drama's own history, for the tradition of the "play-within-play"—from Shakespeare's *Hamlet* to Ludwig Tieck's *Puss in Boots* or Pirandello's *Six Characters in Search of an Author*—had already integrated the "fictional spectator" within the dramatic action.

Literary genre conventions—and not only narratological but also dramatic ones—still bear major relevanace and influence. Even such rigid formats like the traditional "closed form" of drama still are indispensable in the configuration and performance of dramatic conflicts within computer-aided media. However, one essential media-induced difference of interactive drama from "traditional" stage drama is evident: The conflicting qualities in a drama's configuration and therefore the motivational logics of characters are not only at the producer's but, to a high degree, *also at the computer system's as well as at the player's disposal*. It is *due to* the computing power of today's artificial intelligence systems that there is growing autonomy of technical medium within the processes of communication between human and machine. And, at the same time, it is *in spite of* this computing power that the player's individual motivations and intentions as well as his nonintentional behavior influence the sequencing of plot elements by constantly crossing the boundary between the fictional and the factual. These actions and intentions of the player cannot be predicted by any means.

Therefore one may argue, as do "ludologists," that there still is a (probably unavoidable) conflict between the contrary goals of providing player agency and of ensuring a high degree of coherence in form and content by authorial constraints.[52] One certainly should also take Mateas and Stern's self-critical listing of failures and hindrances into consideration, to wit, that *Façade*'s drama manager does not yet give the player enough global agency or that the natural language interface does not yet satisfy the player's expectation to be able to "naturally" communicate with the non-player characters. But for all that, as I hope to have demonstrated, we remain reliant on literary genre theory—in the immediate case, drama theory—if literary studies are to merge emerging aesthetic forms with computational media.

Notes

1. Michael Mateas and Andrew Stern, "Writing *Façade*: A Case-Study in Procedural Authorship," in *Second Person: Role-Playing and Story in Games and Playable Media*, ed. Pat Harrigan and Noah Wardrip-Fruin (Cambridge, MA: MIT Press, 2007), 186.

2. Michael Mateas, "A Preliminary Poetics for Interactive Drama and Games," in *First Person: New Media as Story, Performance, and Game*, ed. Pat Harrigan and Noah Wardrip-Fruin (Cambridge, MA: MIT Press, 2004), 25.

3. It was Janet H. Murray who first defined "agency" as "satisfying power to take meaningful action and see the results of our decisions and choices," thus differentiating it from mere "interactivity" as intentional and aiming at generating meaning and aesthetic pleasure. Cf. Janet H. Murray: *Hamlet on the Holodeck: The Future of Narrative in Cyberspace* (Cambridge, MA: MIT Press, 3rd edn, 2000), 126.

4. Michael Mateas and Andrew Stern, "Façade: An Experiment in Building a Fully-Realized Interactive Drama" (paper presented at the Game Developers Conference, San Jose, CA, March 4–8, 2003), http://www.lcc.gatech.edu/~mateas/publications/MateasSternGDC03.pdf (accessed on November 26, 2008), 2.

5. Michel Chaouli, "How Interactive Can Fiction Be?" *Critical Inquiry* 31, no. 3 (2005): 604.

6. Ibid., 607ff.: " 'Interactivity'—high communicativity of any sort—interferes with the unfolding of literature, particularly with writing that means to lead us into fictional worlds. Even the technically modest oral narrative demands a highly artificial communicative situation: someone speaks, and all others remain silent. [. . .] [I]n order for art to occur, communication must be distributed unevenly: some narrate, write, dance, or sing, while others listen, read, or watch. [. . .] Not only aesthetic pleasure but critical engagement, too, paradoxically depends on shutting down (or at least severely diminishing) the return channel of communication, for only when participants are released from the labor constructing a text on a material or topological level (becoming 'passive recipients' in that respect) can they become hermeneutically active and think their own thoughts about what they are reading, seeing, or hearing. [. . .] Increased interactivity entails diminished freedom while reading."

7. A possible solution to the dilemma of applying genre definitions to digital "works," "projects," "pieces"—or however we prefer to call the objects of our interest—has recently been foreshadowed by Joseph Tabbi who argues that more generic and more qualitative terms are needed in a time of transition: "*narrativity* or *fiction* more generally than *novel, poesis* more generally than *poem, conceptual writing* more generally than *essay*"—we could add "*dramaticity*" or "*dramaticness*" more generally than "drama." Joseph Tabbi, "Toward a Semantic Literary Web: Setting a Direction for the Electronic Literature Organization's Directory." http://eliterature.org/pad/slw.html (accessed on November 26, 2008).

8. Brenda Bakker Harger, "Behind Façade: An Interview with Andrew Stern and Michael Mateas," http://www.uiowa.edu/~iareview/mainpages/new/july06/stern_mateas.html (accessed on November 26, 2008).

9. Mateas, "A Preliminary Poetics," 19.—There is a second line of argument in Mateas and Stern's public statements on drama: In an interview with the *Iowa Review Web*, Stern argues that they had opted for drama only for pragmatic reasons because it appeared "easier on the whole to achieve than comedy." In contrast to "comedy," the term apparently connotes "tragedy" and only provides an indication of a story with a serious subject or tone. This, however, is not in line with the common usage of "drama" as an umbrella term that summarizes both "tragedy" and "comedy" (Brenda Bakker Harger, "Behind Façade," loc. cit.).

10. Aristotle, *The Complete Works of Aristotle: The Revised Oxford Edition,* vol. 2, ed. Jonathan Barnes (Princeton, NJ: Princeton University Press, 1984), 2320.

11. Mateas, "A Preliminary Poetics," 25: "The player has been added to the model as a character who can choose his or her own actions. This has the consequence of introducing two new causal chains. The player's intentions become a new source of formal causation. By taking action in the experience, the player's intentions become the formal cause of activity happening at the levels from language down to spectacle. But this ability to take action is not completely free; it is constrained from below by material resources and from above by authorial formal causation from the level of plot. The elements present below the level of character provide the player with the material resources (material cause) for taking action. The only actions available are the actions supported by the material resources present in the game. The notion of affordance from interface design is useful here. In interface design, affordances are the opportunities for action made available by an object or interface. But affordance is even stronger than implied by the phrase 'made available'; in order for an interface to be said to afford a certain action, the interface must in some sense 'cry out' for the action to be taken. [. . .] *A player will experience agency when there is a balance between the material and formal constraints.* When the actions motivated by the formal constraints (affordances) via dramatic probability in the plot are commensurate with the material constraints (affordances) made available from the levels of spectacle, pattern, language and thought, then the player will experience agency. An imbalance results in a decrease in agency."

12. Michael Mateas and Andrew Stern, "Structuring Content in the Façade Interactive Drama Architecture" (paper presented at Artificial Intelligence and Interactive Digital Entertainment, AIIDE 2005, Marina del Rey, CA. June 1–3, 2005), http://www. interactivestory.net/papers/MateasSternAIIDE05.pdf (accessed on November 26, 2008), 1.

13. Rainer Leschke: "Narrative Portale: Die Wechselfälle der Verzweigung und die Spiele des Erzählens," in *Spielformen im Spielfilm: Zur Medienmorphologie des Kinos nach der Postmoderne,* ed. Rainer Leschke and Jochen Venus (Bielefeld: Transcript, 2007), 200.

14. "In non-interactive drama, understanding the formal chain of causation allows the audience to appreciate how all the action of the play stems from the dramatic necessity of the plot and theme. In interactive drama, the understanding of the formal causation from the level of plot to character additionally helps the player to have an understanding of what to do, that is, why they should take action within the story world at all. Just as the material constraints can be considered as affording action from the levels of spectacle through thought, the formal constraints afford motivation from the level of plot. This motivation is conveyed as dramatic probability. By understanding what actions are dramatically probable, the player understands what actions are worth considering." Mateas, "A Preliminary Poetics," 25.

15. Cf. Gustav Freytag, *Technique of the Drama: An Exposition of Dramatic Composition and Art,* transl. Elias J. MacEwan (New York: Blom, 1968).

16. The term was coined by Hans-Thies Lehmann, *Postdramatic Theatre*, transl. Karen Jürs-Munby (New York: Routledge, 2006).

17. In such performances, the focus explicitly is on "the *feedback* loop as a self-referential autopoietic system with a strictly open and unpredictable denouement that can neither be interrupted nor intentionally controlled through staging strategies." My translation from Erika Fischer-Lichte, *Ästhetik des Performativen* (Frankfurt am Main: Suhrkamp, 2004), 61.

18. Mateas, "A Preliminary Poetics," 31.

19. It goes without saying that Albee's drama, whose film adaptation starring Elizabeth Taylor and Richard Burton has left its mark on collective cultural history, with predecessors and successors in various media: From August Strindberg's *The Dance of Death* (1900) and Friedrich Dürrenmatt's adaptation *Play Strindberg* (1969) to Ingmar Bergman's TV drama *Scenes from a Marriage* (1973) and movies such as Steven Soderbergh's *Sex, Lies, and Videotape* (1989) or Woody Allen's *Husbands and Wives* (1992).

20. Brenda Bakker Harger, "Behind Façade," loc. cit.

21. Aristotle, *Complete Works*, 2320 (my italics).

22. My translation from Jürgen Link: "Zur Theorie der Matrizierbarkeit dramatischer Konfigurationen," in *Moderne Dramentheorie*, ed. Aloysius van Kesteren and Herta Schmid (Kronberg: Scriptor, 1975), 197 (my italics).

23. These attributes are specified according to binary criteria, for example, "natural" attributes such as age/generation (old/young), temper (choleric/self-controlled), gender (male/female), physical appearance (attractive/unimpressive), or rather "social" attributes such as (psychological) state of mind (contented/discontented), education (high/low), rank (influential, powerful/powerless), professional success (successful/unsuccessful), ambition (ambitious/unambitious), alcoholism (drunk/sober), etc.

24. Leschke, "Narrative Portale," 199.

25. Ibid., 204.

26. My translation from Link, "Zur Theorie der Matrizierbarkeit dramatischer Konfigurationen," 197 (my italics).

27. Edward Albee, *The Collected Plays*, vol. 1: 1958–65 (Woodstock, New York: Overlook Duckworth, 2004), 153.

28. Ibid., 185.

29. Ibid., 270ff.

30. At the beginning of Act III, e.g., after having had sex with him, Martha scorns Nick for his servility, by which he only wants to promote his career, and recalls her early romantic feelings for George. Cf. Albee, *Collected Plays*, 276f.

31. Mateas, "A Preliminary Poetics," 27.—For pragmatic reasons, they therefore limited *Façade* to a one-act play that takes the player only 15–20 minutes to play through but allows replayability for 6 or 7 times before the player eventually gets an idea of all the story variations. Therefore the one-act play does not reflect the crisis of Aristotelian drama as it—according to Peter Szondi, in his famous *Theory of the Modern Drama* (Minneapolis: University of Minnesota Press, 1987)—had been the case around 1900.

32. Cf. Jochen Venus, "Teamspirit: Zur Morphologie der Gruppenfigur," in *Spielformen im Spielfilm: Zur Medienmorphologie des Kinos nach der Postmoderne,* ed. Rainer Leschke and Jochen Venus (Bielefeld: Transcript, 2007), 304.

33. *Façade,* for example, is the product of an, in Mateas and Stern's words, "interplay between the culturally-embedded practices of human meaning-making and technically-mediated processes." Mateas and Stern, "Writing *Façade,*" 183.

34. Cf. Peter Gendolla and Jörgen Schäfer, "Playing With Signs: Towards an Aesthetic Theory of Net Literature," in *The Aesthetics of Net Literature. Writing, Reading and Playing in Programmable Media,* ed. Peter Gendolla and Jörgen Schäfer (Bielefeld: Transcript, 2007), 17–42.

35. Venus continues: "Due to its conditional boundary, the fictionality of a game always stretches out into the factual. It is reflexive in a very specific sense. Game rules *distinguish* game-compliant behavior from behavior that transcends the boundaries of the game. [. . .] In a game, the outside of the game is continuously present." My translation from Venus, "Teamspirit," 305ff.

36. Mateas, "A Preliminary Poetics," 28.

37. In a strict sense, the differences between game, play and drama are even more complex. In modern drama, there has always been an inherent aesthetic interdependency of play/playfulness and seriousness, of the fictitious actions within the fictional world and its real-world counterparts. This aesthetic requirement is certainly more difficult to meet for an "interactive drama" like *Façade,* as it has to make the player *reflect* on the difference between the domestic argument in *Façade* and domestic arguments in general or even his/her own marital problems.

38. In his seminal book *Story: Substance, Structure, Style, and the Principles of Screenwriting* (New York: Regan Books, 1997), screenwriter Robert McKee defines a beat as "an exchange of behavior in action/reaction these changing behaviors shape the turning of a scene" (37). Referring to McKee, Mateas and Stern specify this definition for their purposes: "in traditional dramatic writing, the definition of a *dramatic beat* means a small exchange of dialog between characters that advances the story in some small but meaningful way. In *Façade* that notion is actually closer to what we call *beat goals.* In *Façade,* what we refer to as beats are actually collections of beat goals. In hindsight, we might have chosen to refer to beat goals as *beats,* and referred to beats as *beat collections* or something similar." Mateas and Stern, *Behind the Façade* (Portland, OR: Procedural Arts, 2005), 8.

39. Mateas and Stern, *Behind the Façade,* 7.

40. For a complete list of beats cf. Mateas and Stern, *Behind the Façade,* 9.

41. Mateas and Stern, "Façade: An Experiment," 11.

42. Mateas and Stern, *Behind the Façade,* 8.

43. For in-depth information on story values and beat scoring cf. Mateas and Stern, "Architecture, Authorial Idioms and Early Observations of the Interactive Drama *Façade,*" (Technical report, Carnegie Mellon University 2002), http://reports-archive.adm.cs.cmu.edu/anon/2002/CMU-CS-02-198.pdf (accessed on November 26, 2008), 22ff.

44. Ibid., 28.

45. Mateas: "A Preliminary Poetics," 30.

46. There are three characters in *Façade*, because this is, as Mateas argues, "the minimum number of characters needed to support complex social interaction without placing the responsibility on the player to continually move the story forward. If the player is shy or confused about interacting, the two computer controlled characters can conspire to set up dramatic situations, all the while trying to get the player involved." Mateas: "A Preliminary Poetics," 29.
47. A detailed overview of all the possible beats and mix-ins of *Façade* is given in Mateas and Stern, *Behind the Façade*, 12–34.
48. Besides the possible beats at this stage are "ExplainDatingAnniversary," in which Trip attempts to remind the player that it was him who introduced Grace and Trip to each other ten years ago; "FightOverFixingDrinks"; "ItalyTripGuessingGame" and "PhoneCallFromParent."
49. Mateas and Stern, *Behind the Façade*, 14.
50. Ibid., 20f.
51. Chaouli: "How Interactive Can Fiction Be?" 616.
52. Cf. Gonzalo Frasca: "Online Response [to Michael Mateas: 'A Preliminary Poetics']," in: *First Person*, 23f.

Bibliography

Albee, Edward. *The Collected Plays*, vol. 1: 1958–65. Woodstock; New York: Overlook Duckworth, 2004.

Aristotle. *The Complete Works of Aristotle: The Revised Oxford Edition*, vol. 2, ed. Jonathan Barnes. Princeton, NJ: Princeton University Press, 1984.

Chaouli, Michel. "How Interactive Can Fiction Be?" *Critical Inquiry* 31, no. 3 (2005): 599–617.

Fischer-Lichte, Erika. *Ästhetik des Performativen*. Frankfurt am Main: Suhrkamp, 2004.

Frasca, Gonzalo. "Online Response [to Michael Mateas: 'A Preliminary Poetics']," in *First Person: New Media as Story, Performance, and Game*, ed. Noah Wardrip-Fruin and Pat Harrigan, 23–24. Cambridge, MA: MIT Press, 2004.

Freytag, Gustav. *Technique of the Drama: An Exposition of Dramatic Composition and Art*. Transl. by Elias J. MacEwan. New York: Blom, 1968 (German original: *Die Technik des Dramas*. Leipzig: Hirzel, 1863).

Gendolla, Peter, and Jörgen Schäfer. "Playing With Signs: Towards an Aesthetic Theory of Net Literature," in *The Aesthetics of Net Literature. Writing, Reading and Playing in Programmable Media*, ed. Peter Gendolla and Jörgen Schäfer, 17–42. Bielefeld: Transcript, 2007.

Harger, Brenda Bakker. "Behind Façade: An Interview with Andrew Stern and Michael Mateas." *The Iowa Review Web*, 8, no. 2 (June/July 2006), http://www.uiowa.edu/~iareview/main-pages/new/july06/stern_mateas.html (accessed on November 26, 2008).

Laurel, Brenda. *Computers as Theatre*. Reading, MA: Addison-Wesley, 1991.

Lehmann, Hans-Thies. *Postdramatic Theatre*. Trans. by Karen Jürs-Munby. New York: Routledge, 2006.

Leschke, Rainer. "Narrative Portale: Die Wechselfälle der Verzweigung und die Spiele des Erzählens," in *Spielformen im Spielfilm: Zur Medienmorphologie des Kinos nach der Postmoderne*, ed. Rainer Leschke and Jochen Venus, 197–224. Bielefeld: Transcript, 2007.

Link, Jürgen. "Zur Theorie der Matrizierbarkeit dramatischer Konfigurationen." In *Moderne Dramentheorie*, ed. Aloysius van Kesteren and Herta Schmid, 193–219. Kronberg: Scriptor, 1975.

Mateas, Michael. "A Preliminary Poetics for Interactive Drama and Games." In *First Person: New Media as Story, Performance, and Game*, ed. Noah Wardrip-Fruin and Pat Harrigan, 19–33. Cambridge, MA: MIT Press, 2004.

Mateas, Michael, and Andrew Stern. "Architecture, Authorial Idioms and Early Observations of the Interactive Drama Façade." Technical report CMU-CS-02–198, Carnegie Mellon University 2002, http://reports-archive.adm.cs.cmu.edu/anon/2002/CMU-CS-02–198.pdf (accessed on November 26, 2008).

Mateas, Michael, and Andrew Stern. "Façade: An Experiment in Building a Fully-Realized Interactive Drama." Paper presented at the Game Developers Conference, San Jose, CA, March 4–8, 2003, http://www.lcc.gatech.edu/~mateas/publications/MateasSternGDC03.pdf (accessed on November 26, 2008).

—. "Structuring Content in the Façade Interactive Drama Architecture." Paper presented at Artificial Intelligence and Interactive Digital Entertainment (AIIDE 2005), Marina del Rey, CA. June 1–3, 2005, http://www.interactivestory.net/papers/MateasSternAIIDE05.pdf (accessed on November 26, 2008).

—. *Behind the Façade*. Portland, OR: Procedural Arts, 2005.

—. "Writing Façade: A Case-Study in Procedural Authorship," in *Second Person: Role-Playing and Story in Games and Playable Media*, ed. Pat Harrigan and Noah Wardrip-Fruin, 183–208. Cambridge, MA: MIT Press, 2007.

McKee, Robert. *Story: Substance, Structure, Style, and the Principles of Screenwriting.* New York: Regan Books, 1997.

Murray, Janet H. *Hamlet on the Holodeck: The Future of Narrative in Cyberspace.* 3rd edn. Cambridge, MA: MIT Press, 2000.

Szondi, Peter. *Theory of the Modern Drama.* Minneapolis: University of Minnesota Press, 1987.

Tabbi, Joseph. "Toward a Semantic Literary Web: Setting a Direction for the Electronic Literature Organization's Directory." http://eliterature.org/pad/slw.html (accessed on November 26, 2008).

Venus, Jochen. "Teamspirit: Zur Morphologie der Gruppenfigur," in *Spielformen im Spielfilm: Zur Medienmorphologie des Kinos nach der Postmoderne*, ed. Rainer Leschke and Jochen Venus, 299–327. Bielefeld: Transcript, 2007.

Post-Chapter Dialogue, Schäfer and Ricardo

FJR: Your analysis of *Façade* makes evident the significant difference between electronic poetry and drama, one being open and able to exploit disruption as a means for intimacy, and the other, conversely, bound to semantic continuity that is additionally complicated by the need to embrace much of the real-time input of a user to influence outcome. The latter genre makes clear the similarity between interactive story and the methods of artificial intelligence in devising computational spaces for optimal choice combinations, as are necessary in chess and other games. One challenge to such new media work is making the necessary methodological distinction between structural and phenomenological approaches. The former emphasizes the architecture of the work, hence the bearing of Jürgen Link's rule-based matrix (despite having been devised in the 1970s), and the latter takes the work from the slant of personal perception and experience of it and its dramatic substance. You identify the dialectic between interactivity and narrative. Can you elaborate on the boundary between playful actions in games and dramatic actions in the fictional world and why it is that "only in games can the boundary between the factual and the fictional be crossed"?

JS: I'm dealing with the structural and medial conditions of "digital," "electronic" or "net literature" (however you prefer to label the subject matter) with the aim of developing a theory of literary human–computer interaction. It is evident that interactive processes between a computer system and its users cannot completely be specified and controlled in advance. Instead, modes of use or user behavior can only be *partially* specified. Of course, this is a truism, although many people in the humanities have not yet realized the far-reaching consequences.

But that's only one side of the coin: If we are interested in digital *literature*, we must also aim at developing more adequate theories and methods that are more specific than general HCI approaches. Such approaches can be applied to all sorts of interactions with computer systems and to various kinds of pragmatic communication via computer networks. Therefore, and this points to my second goal, we always have to raise the question of the specific *literariness* of pieces such as *Façade*, which inevitably means to put them into the contexts of literary history and literary theory.

This, in my view, is only possible by resuming and, if necessary, revising canonical theories and conceptions. The structural approach of Link (which I refer to in my essay) is only one example; other approaches such as phenomenological, formalist, hermeneutic and—which I personally think are particularly promising—reader-response theories should also be used. Likewise genre theories certainly are among those conceptions that should not be dismissed prematurely. For centuries, they have successfully framed literary communication, and they still determine the contextual knowledge of writers and readers, or, in more general terms, of producers and recipients in *all* media of literature—in books as well as in stage performances or in computer-based and networked media.

Don't get me wrong: I'm neither saying that these approaches are sufficient for analyzing digital works, nor do I consider the "literary" as an ontological quality that we, as literary scholars, do always *a priori* grasp in all its details—and which we therefore only have to recognize when analyzing a particular work. I'm rather interested in identifying how the "literary" emerges *in* the process of literary communication—and this certainly varies in different media settings. If I acknowledge Mateas's and Stern's claim to regard *Façade* as an interactive *drama*, I do this because I'm interested in finding out *whether* and, if yes, *how* the dramatic quality emerges in computer-based media, how it can be distinguished from dramatic situations in other media and what it has in common with them.

This leads me to the crucial point of the dialectic between interactivity and narrative: The viewpoint, which I tried to develop, may help to settle the controversy between "narratologists" and "ludologists." For good reasons, "ludologists" like Espen Aarseth or Markku Eskelinen have challenged the hegemony of narratological approaches by focusing on the gaming aspects of "cybertexts" or "interactive stories" such as game rules, player strategies, and player agency and by highlighting the structural differences and incoherencies between computer games and traditional literary genres. But in polemically attacking "narratologists" they often overshot the mark, for example, when Eskelinen declares stories to be "just uninteresting ornaments or gift-wrapping to games."[1] They are partial to far too narrow definitions of narrative that, in Marie-Laure Ryan's words, "presuppose a verbal act of storytelling and exclude consequently the possibility of mimetic forms of narrative, such as drama and movies."[2]

The narratologists-versus-ludologists controversy would certainly be facilitated if narratologists themselves were in agreement on the meaning of their key terms. As Fotis Jannidis has pointed out, "narration" has often been mistaken for "plot": While "narration signifies the medial representation of a self-contained storyline" and thus emphasizes the dependency on the medium (in relation to the prototype of oral narration), "plot" should be defined more precisely as "a sequence of chronologically ordered and causally linked events."[3] I agree that computer games can be satisfactorily explained neither by narratological nor by ludological approach, as the latter only are a symptom of the upheavals in the entire media system following the paradigm shift in computing from algorithms to interaction. If we learn a lesson from Jannidis's distinction, it is that, other than "narrative," "plot" as an all-encompassing transmedial category can well be applied to drama. It is somewhat surprising that drama theory has been overlooked in these debates, although Brenda Laurel had already documented distinctions between drama and narrative in her influential *Computers as Theatre*, basing her analysis on standard Aristotelian terminology. Laurel distinguishes drama from narrative by means of three dichotomies: "enactment" versus "description," "intensification" versus "extensification," "unity of action" versus "episodic structure." This can only be touched upon in my case study, and therefore my argument may appear sketchy in some respects. In a broader context, it would certainly be necessary not only to refer to Aristotelian poetics but also to discuss the tradition of the so-called "open form of drama" in more detail, for example, the "play-within-the-play," not to mention all the efforts undertaken by happening and performance artists in getting the audience involved into the action.[4]

This would help differentiating between the involvement of the fictional spectator and the factual involvement of the player of a computer game who navigates his/her avatar and types his/her/its utterances on the keyboard. Wavering between saying "his/her" or "its" already indicates the ambivalent role of the player as both an actor who is part of the events and a spectator who is on the outside. The *Façade* player manipulates the actions of the character, of *his/her* character, and thereby the events in the fictional world from an outside perspective. It cannot be clearly figured out how the utterances and behaviors of one character in the fictional world, on the one hand, relate to the actions, emotions, and thoughts of other characters, and, on the other hand, to the player's real-world behavior and intentions. This is what I mean when I refer to Venus's distinction of two types of boundaries between the factual and the fictional: In computer games, there is a *rule-based* boundary that, at the same time, separates *and* connects the domain of the fictional world, in which the characters are running, fighting, talking, with the factual domain of the "real" person using his input devices in "real" space for controlling events in the "virtual" space. Players must constantly cross this boundary in order to get ahead in a game, and, at the same time, what happens in the fictional world affects the physical real-world action of the player. This is a different kind of reflexivity than that between the fictional world and the imagination of the reader of a story or the audience of a drama performance. It should be our ambition as literary scholars to understand the nature of this difference.

FJR: With the experience of an immersive work of fiction like *Façade*, there comes an inescapable sense of provocation to our sensibilities, to our belief in the boundaries of readership and participation. At times, one feels very much a character in the work, and at others, there is a felt resistance to join the social dynamic of its inner reality. This boundary of belief is, of course, largely in your analytic sights in this essay. It is ironic that as the substance of literature and art have been expanded from physical out to kinetic, symbolic, computational, and otherwise unconventional media, questions seem to become more persistent as to the nature of that literary and artistic substance embodied in new forms. The very notion of what aesthetic means has, if we agree with Donald Kuspit, come to an end. So it seems fair to suppose that when, in 1934, John Dewey asserted that "aesthetic experience is imaginative," the world was more certain of that imaginative domain than it is today. It is as if genres and media of literature and art, rather than exist in the space of a context-free adjectival quality like *literary*, *poetic*, or *aesthetic*, instead depended on certain stability of form. Something insufficiently discussed in new media scholarship is the contextual psychology that informs interactive works and into whose frames the reader or user must surrender, and of which *Façade* is a case study, both promisingly and problematically. We are, after all, aware that something very personal in us—credulity—is being elicited by a system without sensibility to cultivate it in a human way, whatever that means. In this sense, *Façade* is not merely a system of interactive story cognition, but a systemic prompt for emotional understanding and engagement. Is it fair, you believe, to think of *Façade* in prevalently psychological terms, and if so, what might this render visible to the possibility and predicament of involvement in the conditions and spaces of new art and literature?

JS: First, I'm not convinced that the notion of what "aesthetic" means has really come to an end, as Kuspit argues. I've always been skeptical about such obituarizations, as there is subsequent evidence to the contrary. Yet I think that human–machine interaction, in particular, has or, at least, should have a strong impact on aesthetic theory. On one hand, in terms of *aisthesis*, computer systems and interfaces inaugurate new modes of perception; on the other hand, to pick up the topic we addressed earlier, there is a growing demand for *aesthetic* reflection in new media art and literature criticism.

Your second question, addressing the contextual psychology of art and literature in new media, is a very tricky one, but presumably the most fundamental question at all, which definitely must be brought into focus. I'd like to give only a tentative answer at present. If you think of *Façade* in psychological terms, it certainly falls short of the mimetic qualities of a stage drama, and, yes, I assume that every user experiences the resistance to join the "reality" of the fictional world you mentioned.

The difference between a computer game and a drama is more complex than could be described in my essay. The drama gains its tension from the inherent paradox between "play" and "reality," between playfulness and earnestness, which draws the audience's attention into the scene. For achieving the same effect, an interactive drama would have to successfully elicit the player's empathy with the protagonists in a similar way, for example *Façade* would have to provoke the audience to reflect upon a marital argument that the audience could relate to their own experiences and imaginations, and it then would have to enable them to experimentally explore and reflect again the consequences of their behavior in such situations, and so on.

Whether *Façade*, in that sense, may be regarded as drama or play or as game, to a certain degree, depends on the player. You can play *Façade* following different strategies. For example, you can aim at immersing into the conflict between Grace and Trip and so your primary intention is to get a sort of dramatic experience. As a player, you can do that by taking offers, which the characters confront you with, or by making offers to them in a helpful or even unhelpful way if you aim at bringing the characters apart. If you act in this way, you can have at least certain moments of a dramatic experience, even though they might yet be very limited.

But you can also play *Façade* as a game, for example, if you try to have fun with them or if you try to break the marriage up. You will test the limits of the software and that is a sort of winning/losing game. For example, if you come into their apartment and do nothing else but kiss one of them, they will be slightly irritated at first but soon throw you out of the apartment. At the beginning you have to decide if you're male or female and choose a name, so you can go in as a male character and only kiss Trip to try to find out if there is some sort of gay scenario. And there isn't; he throws you out of the house very soon. So these are game strategies which aim at testing the limits of the *Façade* system.

To get back to your question: Although I think *Façade* is a promising prototype of an interactive drama, the limitations I mentioned make it also difficult to regard it as a valuable drama from a literary point of view. I remember one panelist, in a discussion of my paper, pointing at his experience (which probably can be generalized) that he always ends up with an experience which is more to do with learning what a simulation of a drama would be like, rather than actually taking part in a drama that he would

pay for a ticket to go see. He's certainly right: There is the inescapable danger that the attention shifts from the aesthetic aspect and from the interest in the human conflict to the goal of simply overcoming the software.

Notes

1. Markku Eskelinen, "The Gaming Situation," *Game Studies* 1, no. 1 (July 2001), http://www.gamestudies.org/0101/eskelinen (accessed on November 26, 2008).
2. Marie-Laure Ryan, *Avatars of Story* (Minneapolis: University of Minnesota Press, 2006), 184.
3. Fotis Jannidis, "Event-Sequences, Plot and Narration in Computer Games," in *The Aesthetics of Net Literature: Writing, Reading and Playing in Programmable Media*, ed. Peter Gendolla and Jörgen Schäfer (Bielefeld: Transcript, 2007), 283.
4. Brenda Laurel, *Computers as Theatre* (Boston et al.: Addison Wesley, 1991), 94f.

CHAPTER NINE ·

Artificial Poetry[1]: On Aesthetic Perception in Computer-Aided Literature

Peter Gendolla

I

My thoughts on the possibilities of machine-aided poetry follow some of those pre-sented by Noah Wardrip-Fruin who championed Christopher Strachey as "the first digital artist" in saying that "once there were stored program digital computers, all that remained (for our field to take its first step) was for someone to make literary or other artistic use of one. I believe that—in 1952, working on the Manchester Mark I—Christopher Strachey was the first to do so."[2] Here Wardrip-Fruin positions digital literature in contrast to its traditional forms with a decisive difference, with the asser-tion that literature has at all times directed its attention to the specific forms, struc-tures and methods of the combination of letters into significant texts.

> I mean "literature" (and "literary") as a way of referring to those arts we sometimes call fiction, poetry, and drama (as well as their close cousins). I mean the arts that call our attention to language, present us with characters, tell us stories, and make us reflect on the structures and common practices of such activities.[3]

He asserts that these still are all only more or less artistically arranged relations between firmly stored data or sets of data that could be recognized as literature quite indepen-dently of the media, whether they are the pages of a manuscript or book, or the inter-faces of film, video, or TV. However, the computer for Wardrip-Fruin supplies what is not already available in the aforementioned storage-media, namely the alteration or adaptation of the data *during* the process of reception. Aesthetic attention, then, neces-sarily needs to be directed not only toward predetermined relations of data but also at the dynamics of their processsualization. Accordingly, in quoting Chris Crawford, who suggests the term "process intensity,"[4] Wardrip-Fruin answers his own question "What do we need to read, to interpret, when we read digital literature?" with "We must read both process and data."[5]

Wardrip-Fruin, however, also declares this as insufficient for differentiating the specific forms of digital literature, given that the literary avant-garde of the

twentieth century was also essentially interested in processes:

> This is true, of course, not only for work in digital literature, . . . but also for composers such as John Cage, artists such as those associated with the Fluxus group, and dramatists such as Augusto Boal. In all of these cases, we are interpreting works that emphasize data and process to differing extents . . . and which cannot be fully interpreted from a sample output.[6]

But in what specifically emerges from the unique possibilities of computer-created interaction, digital forms have taken a decisive step *beyond* both traditional as well as avant-garde literary forms. His point is that the "reading" of such (digitalized) literature requires that as much emphasis be placed on the machine's interaction as on the machine's text itself: "To read digital literature well, we need to be specific about system behavior and user experience—and explicitly aware that data's impact on experience is at least as great as process and interaction."[7]

II

I am in agreement with this dual stipulation, and without delving into Wardrip-Fruin's further classification of forms, roles, and functions of this interplay of objects, processes, people, and machines,[8] only pose one further underlying question: what *is* it that characterizes—or better, considering the very short existence of these forms— what *might it be* that characterizes the specific *artistic* element, the *literariness* of these processes and interactions?

My opening quote characterized literature as the domain of "the arts that call our attention to language, present us with characters, tell us stories, and make us reflect on the structures and common practices of such activities," although we might understand this definition as still somewhat incomplete. That is, *all* texts, by linguists and philologists alike, are characterized by their attention at language; *every* newscast presents us with characters and stories; every commentator makes us reflect their structures and practices. All this is a matter of a first necessary turn of texts towards themselves. They certainly have to turn and twist, to knot and condense *beyond* that in order to make "literature" as an artistic series of letters and words, into word-art or language-art—in whatever medium it may exist.

By no means is it sufficient that a book appears in a book (or a text in a film, in TV, or in a computer-game). Decisive in this is the need to designate *in which way* the text appears in the text, or *in which way* the medium appears in the medium. Thus *both* the plane of narrative that comprises subject, story, and characters, as well as the forms of its appearance, presentation, and arrangement have to be reflected upon in a very specific way.

Consider the canonical example at the dawn of the European novel, in 1604, namely *El Ingenioso Hidalgo Don Quixote de la Mancha* of Miguel de Cervantes Saavedra.[9] Here a model was created that has lastingly endured through literary history: a knight/ hero—who has become "insane," has gone beyond normal perception through reading—is trying to change fiction into reality—and is destined to fail.[10] This model is

mirrored in the individual episodes in ever new and intricate techniques and finally the whole first book is mirrored in the second one. Time and again the previously read literary texts are absurdly materialized, first imaginarily and then practically, so that literature is allowed its own crazy or paradoxical "life," by recounting itself as unlivable. In a similar way, and during the same period in time, Shakespeare's Hamlet tries to ascertain the truth of a suspicion by staging theater in the theater and all events in the play end in catastrophes. In 1856, too, Emma Bovary in Gustave Flaubert's novel has read too many romances and looks at men from this perspective, in the end, poisoning herself. Or Aureliano Buendía in Gabriel García Márquez' *One Hundred Years of Solitude* (1967) finds the selfsame book, *One Hundred Years of Solitude*, and reads incessantly in order to arrive at the page in which he encounters *this very book*, in order to find his fate: He "dies"—in other words: the search of a deep meaning ends in a short circuit.

As a certain resume: In Stanisław Lem's book *The Perfect Vacuum* consists of nothing but reviews of non-existent, fictitious books, including *The Perfect Vacuum* itself. There are 16 texts reviewing invented novels, narratives, and scientific essays by invented authors and invented publishers. But actually this is only true for 15 of the texts. The sixteenth text, the first review of the book, reviews the book *The Perfect Vacuum* by a certain Stanisław Lem, first published in Warsaw in 1971 by Czytelnik Publishers. This is indeed true, we hold the book of this author in our hands and it was indeed published in 1971 in Warsaw by Czytelnik. The book then is no longer a *perfect vacuum*: self-referentiality suddenly and densely refills and the objects of the book begin to exist while it is (in)scribing itself in the act of describing the act of writing.[11]

All of these fictitious realizations generate something that is nonexistent. They generate a paradoxical, self-destructive and self-constructive figure. This is what I mean by *literariness*: In literature there originates a unique, purely aesthetic distinction compared with all historical, normative, or functional meanings and uses of language.

Even the third quality of digital literature, called "new" by Wardrip-Fruin, namely, that of interactions between readers or viewers with the literary processes, can already be found in the literatures of so-called modern times. The reader of *Don Quixote*, for example, is in just this same situation as its hero—he himself is a reader who is supposed to take a story for real in which someone becomes lunatic through reading. Accordingly, the reader would have to throw away the book; he would have to distance himself *physically* from the text in order not to succumb to the fate of its hero. In the same way the spectator seeing *Hamlet* in the theater would have to get up and leave in order not to become insane like the main character. Time and again great literature puts its readers into this paradoxical situation: They are drawn into the scenes of the literary text and at the same time are distanced from it—they are tensely hooked onto the medium from two sides. Readers "*inhabit*" literary texts without being able to really *be* in them; they start an intense—quite physically real—interaction with the fictitious events. Traditional literature, then—in whatever traditional medium—has always been much more than it is being granted from the perspective of the latest media—and digital literature is (quite a bit) less than is attributed to it by some.

III

I should like to attempt to illustrate this conception of literature with "small" poetic forms: In relation to the aforementioned prose and dramatic forms, aesthetic difference is much more difficult to ascertain for lyrical or other poetry. To begin with, poetry always seems "self-reflexive" in the sense of being concentrated on forms of perception. From the light lyrics of Joseph von Eichendorff's romantic love-poetry— "Es war als hätt' der Himmel / Die Erde still geküßt . . ."[12] ("It was as if heaven had quietly kissed earth . . .")[13])—to the heavily hermetical social traumata of Paul Celan's "Schwarze Milch der Frühe wir trinken sie abends / wir trinken sie mittags und morgens wir trinken sie nachts . . ."[14] ("Black milk of daybreak we drink it at sundown / we drink it at noon in the morning we drink it at night")[15])—the specific perception is as directly present in the "as if" of the first example as it is in the confrontation of "black milk" with "us" in the second.

But at first this specific form of aesthetics is simply self-constructive; it creates itself or that speaking entity ("It was as if . . ."—"as if" for whom? And who is the "we" who drinks black milk?) *without* distancing itself instantaneously from itself and accordingly from the other texts that can be related to it or that might be hinted at or that simultaneously or previously could be associated with it. Neither does the text dissociate itself from the fixated meanings, as in the above example of *Don Quixote*. In this manner everything remains presumptuously dense, metaphysical—well, "kitschy." In order to avoid that, the "material" of language has to be reflected upon further and in a different manner. The reader's way of using language has to be attacked in order to allow him to experience the aforementioned aesthetic difference; his own system of using language—that he has learned and practiced for many years—has to be damaged. A conflict has to be established between his own and the symbolic system that is offered to him. Insofar it is insufficient to merely combine verses found on pages that have to be cut open into ever new sonnets, as for example in Raymond Queneau's *Cent Mille Milliards de Poèmes*.[16] The new sonnets also have to reflect this very same activity (as they do in Queneau's text)—and in a similar way the poetry machine has to/should reflect the independence of text-creation, the detachment of author *and* reader by a program, the "humanization of the machine"—something that all the nice "Cent mille milliards"-programs don't do at all and therefore only present more or less clever, but in the end boring electrifications of the handiwork that is still necessary in Queneau's "Ur"-book.

Only in this way digitalization can become literary, and can be experienced as art, can be seen as an aesthetic method of transferring or exhibiting a *neuronal* into an *electronic* creativity. In the same way as Timm Ulrichs' sequel to the first sentence of the gospel according to St John: "AM ANFANG WAR DAS WORT AM" ("IN THE BEGINNING WAS THE WORD IN") turns our attention away from the *metaphysics* of language and to the *physics* of language with one single additional word, with a minuscule repetition.[17] In this same way in the process of digitalization our attention should be directed to the peculiar automatization in which symbolic work becomes independent. Or, better yet—thinking of the futility of all the efforts of

the sad knight from La Mancha or the futile love-projections of Emma Bovary—our attention should be turned to the impossibility to make machines *as machines* do symbolic work.

If we follow Italo Calvino's statement that isolated literary texts created by an author and that can be read by a reader do not exist because they can always only exist as a never-ending interplay between the generation and reception of texts, creating and obliterating meanings by filling the presented strings of letters with imaginary and individual (non-)sense,[18] then the step taken by digitalizing the poetic cannot have been made with the unquestionable calculability of symbolic processes, on which the summarized expansions of the man-machine combinations or interactions of Wardrip-Fruin are based. This step should rather then be one that turns our attention to the "ghostlike" dimension of symbolic processes which break open even there again and again, creating new forms of *aesthetic* perception of non-predictability. To produce this aesthetic wonder the mere capability of poetry machines to generate and line-up "well-formed" syntagms is not sufficient. It rather is crucial that the paradigmatic fields generated by them, or better, that the horizons of association producing the "ghostlike" possibilities or variants of contextualization that suddenly emerge in the interfaces between the encoding by machines and the decoding by humans, be *poetically* "correct." Aesthetic or literary demands are only fulfilled through a *double* reflection: by opening up *both intertextual and intermedial realms of allusion*, by *simultaneously* combining imaginary and physical-medial elements of man and machine.

With the present processual character of digital poetry it is of course very difficult to make such demands comprehensible. I will try to do so, determining, as it were, the culinary essence of a meal by analyzing its photograph and referring to the recipe. To that end, I will have to completely rely on the reader's imagination. In a first step we can observe the love-letter "poetry" generated by a program Christopher Strachey wrote in 1952:

> Darling Sweetheart You are my avid fellow feeling. My affection curiously clings to your passionate wish. My liking yearns for your heart. You are my wistful sympathy: my tender liking. Yours beautifully M. U. C.[19]

Indeed, this plays with the language of "love"—but it is really only the most quotidian and pedestrian way of combining words. Here language is at first nothing but the combination of empty elements into—more or less—meaningful ones. The "more"—in other words, the *how* of the combinations—will decide everything. The examples taken up here do not present references to other love-poems; nor does this poetry refer to itself as machine-generated; nor again is it especially reflective. To experience more, we need continual *dialogue* about possible meanings of these word-combinations, about the "intentions" of the machine, which do not exist, but onto which we can project. The nonexistent cognitive autonomy of the artificial intelligence can get us into trouble, if what happens in the interaction between human and machine goes beyond putting us in a stream of associations, as the majority of the so-called poetry machines seem to do.[20]

David Link has pointed out in his description of his text-generator *POETRY MACHINE 1.0* that, there, a different game between man and machine takes place; so that

> when there are no viewers present, the system quickly and smoothly generates downpours of letters. . . . But as soon as visitors come close to it, the text-generator begins to stall, hesitates and sometimes even completely stops. The system leaves the field of action to the visitor, even invites him to hit the keyboard himself. As soon as he enters a word, his text appears on the screen the same way as that of the machine. Poetry Machine carries on with the visitor's text and begins to create associations from that text. The stream of texts created in turns by the machine and its users never dies down.[21]

To restate my earlier claim, we might therefore conclude that in order to experience aesthetic *difference*, in other words: in order to experience *poetry*, we have to realize the clash between two or more schematized perceptions—whether they be created by machine or human. That is, the conflict between the perceiver's and the symbolic system's view has to be experienced in order to create poetic effects.

A possible blueprint of another relationship can be experienced in Camille Utterback's installation *Text Rain*. Here, if we leave the pure body-motion, the unconscious performance or dance with the falling words by suspecting or realizing that these could be bound together to a sense, now moving our hands, arms, the whole body to catch more than one in a line—then we start reading the poem behind with our body—or could/should we say: we start communicating with the AI?

In a similar way the victim of the "writing machine" in Kafka's *Penal Colony*, deciphering the words "written" in his skin is "reading with his wounds" while we, as readers of this story, are still and all only using our eyes. But in Utterback's installation our whole body is in action. While the soldier only passively suffers the reading process (and while we suffer with him), in *Text Rain* we can—or have to—use our hands, arms, and legs. We can play with the falling words, we can dance—or we can try and catch them, try and make sense out of them, read them; we can try and collect our own text, gathering meaning. Whereas in Kafka's *Penal Colony* a never ending imaginary quest for possible meanings is activated in our mind, in Utterback's *Text Rain*—even though here as well there is no end of reading—we do not merely suffer. Reading and writing also disengage the reader from the (skin-, paper-, monitor-) surfaces and extend into a space of light and matter that is performed and "inscribed" by the bodies present.[22] Irrespective of all our efforts, we can never experience the completed poem—unless we leave the installation in order to read the "database" underlying it.

In digital environments the paradox "*inhabiting*" literature mentioned above is changing: from a situation, where body and medium (say, book or screen) are fixed and under control, but the mind is confused to an oscillating interplay between medium, body, and mind, between sense and senses, with a nonexistent center of control, awareness, intentionality. The installation confronts us with a conundrum: are we reading a poem—or is the poem reading us?

Notes

1. Elisabeth Walther-Bense reminds us that "in his *Theorie der Texte* Max Bense has differentiated natural and artificial poetry: 'With natural poetry I here mean that type of poetry which . . . has as a precondition a personal poetic consciousness.' By artificial poetry he meant a type of poetry in which there is no personal poetic consciousness. Artificial poetry today is termed Computer-Poetry, digital or cybernetic poetry." Trans. by Brigitte Pichon from Elisabeth Walther-Bense, "Die Welt der Literatur—Welt-Literatur," http://www.goethe.de/wis/bib/prj/hmb/das/de3289544.htm (accessed November 26, 2008).

2. Noah Wardrip-Fruin, "Christopher Strachey: The first digital artist?," *Grand Text Auto*, August 1, 2005, http://grandtextauto.org/2005/08/01/christopher-strachey-first-digital-artist (accessed November 26, 2008).

3. Ibid.

4. Chris Crawford, *On Game Design* (Berkeley, CA: New Riders, 2003), 89ff.

5. Noah Wardrip-Fruin, "Reading Digital Literature," in *Reading Moving Letters: Digital Literature in Research and Teaching*, ed. Roberto Simanowski, Jörgen Schäfer and Peter Gendolla (Bielefeld: Transcript, 2009, forthcoming).

6. Ibid.

7. Ibid.

8. It seems to me that the secondary literature on the subject, be it that of Espen Aarseth, Marie-Laure Ryan, Scott Rettberg or of Friedrich Block or Christiane Heibach with their taxonomies and tables of categories that in themselves certainly are of value, has been published much too early. Before anybody really knows whether the projects or processes in question are really art or literature and not instruction manuals for games, advertisement, a new religion, or a soliloquy of an unknown intelligence, they are already packed into boxes and sub-boxes that only have to be mixed up again with the next generation soft- or hardware and their next misuse by a creative artist.

9. Cf. Georg Lukács, The Theory of the Novel: A Historico-Philosophical Essay on the Forms of Great Epic Literature (London: Merlin Press, 1971), 101ff.

10. Cf. Hans-Jörg Neuschäfer, Der Sinn der Parodie im Don Quijote (Heidelberg 1963).

11. Cf. Stanisław Lem, A Perfect Vacuum (Evanston, IL: Northwestern University Press, 1999).

12. Joseph von Eichendorff, "Mondnacht," in Werke, ed. Wolfgang Frühwald, vol. 1 (Frankfurt am Main: Deutscher Klassiker-Verlag, 1987), 322–323.

13. Trans. by Brigitte Pichon.

14. Paul Celan, "Todesfuge," in Werke: Historisch-kritische Ausgabe, vol. I.2/3: Der Sand aus den Urnen. Mohn und Gedächtnis, ed. Andreas Lohr (Frankfurt am Main: Suhrkamp, 2003), 101. You can hear the poem read by the author on lyrikline: http://www.lyrikline.org/index.php?id=162&L=1&author=pc00&show=Poems&poemId=66&cHash=d16b55bd19.

15. Paul Celan, "Death Fugue," in Selected Poems of Paul Celan, trans. Michael Hamburger (London: Anvil Press Poetry, 1988), 61.

16. Cf. Raymond Queneau, Cent mille milliards de poèmes (Paris: Gallimard, 1961). English language ed.: One hundred million million poems (Paris: Kickshaws, 1983).

17. Timm Ulrichs, "Am Anfang war das Wort am," repr. in Michael Wolfson, Beuys / Ulrichs – ICH-Kunst, DU-Kunst, WIR-Kunst: Joseph Beuys und Timm Ulrichs im Kunstmuseum Celle mit Sammlung Robert Simon (Celle: Kunstmuseum Celle, 2007), 94 (fig. 108).

18. Cf. Italo Calvino, "Cybernetics and Ghosts," in The Literature Machine: Essays, trans. Patrick Creagh (London: Pan/Secker & Warburg, 1987), 3–27.

19. David Link, "Christopher Strachey's Love Letters and Manchester University Computer, files and executables," http://www.alpha60.de/research/muc (accessed on November 26, 2008).

20. Martin Auer's Poetry Machine for example: http://www.martinauer.net/poetryma/_startpm.htm

21. Trans. by Brigitte Pichon from David Link, "Poetry Machine (version 1.0)," http://www.alpha60.de/poetrymachine (accessed on November 26, 2008).

22. "But how still the man grows at the sixth hour! Enlightenment dawns on the dullest. It begins around the eyes. From there it spreads out. A spectacle that might tempt one to lay oneself down under the harrow beside him. Nothing further happens, the man simply begins to decipher the script, he purses his lips as if he were listening. You've seen that it isn't easy to decipher the script with one's eyes; but our man deciphers it with his wounds." Franz Kafka, "In the Penal Colony," in The Transformation and Other Stories, trans. Malcolm Pasley (New York: Penguin, 1992), 136f.

Bibliography

Auer, Martin. The Poetry Machine, http://www.martinauer.net/poetryma/_startpm.htm (accessed on November 26, 2008).

Calvino, Italo. "Cybernetics and Ghosts." In The Literature Machine: Essays. Trans. Patrick Creagh, London: Pan/Secker & Warburg, 1987, 3–27.

Celan, Paul. Selected Poems of Paul Celan. Translated by Michael Hamburger. London: Anvil Press Poetry, 1988.

—. Werke: Historisch-kritische Ausgabe, vol. I.2/3: Der Sand aus den Urnen. Mohn und Gedächtnis. Edited by Andreas Lohr. Frankfurt am Main: Suhrkamp, 2003.

Crawford, Chris. On Game Design. Berkeley, CA: New Riders, 2003.

Eichendorff, Joseph von. Werke. Edited by Wolfgang Frühwald, vol. 1. Frankfurt am Main: Deutscher Klassiker-Verlag, 1987.

Kafka, Franz. "In the Penal Colony," in The Transformation and Other Stories, Translated by Malcolm Pasley, New York: Penguin, 1992, 127–153.

Lem, Stanisław. A Perfect Vacuum. Evanston, IL: Northwestern University Press, 1999.

Link, David. "Poetry Machine (version 1.0)." http://www.alpha60.de/poetrymachine (accessed on November 26, 2008).

—. "Christopher Strachey's Love Letters and Manchester University Computer, files and executables." http://www.alpha60.de/research/muc (accessed on November 26, 2008).

Lukács, Georg. *The Theory of the Novel: A Historico-Philosophical Essay on the Forms of Great Epic Literature*. Translated by Anna Bostock. London: Merlin Press, 1971.

Neuschäfer, Hans-Jörg. *Der Sinn der Parodie im Don Quijote*. Heidelberg: Winter 1963.

Queneau, Raymond. *Cent mille milliards de poèmes*. Paris: Gallimard, 1961. English language edn: *One hundred million million poems*. Paris: Kickshaws, 1983.

Utterback, Camille, and Romy Achituv. *Text Rain*, http://www.camilleutterback.com/textrain. html (accessed on November 26, 2008).

Walther-Bense, Elisabeth. "Die Welt der Literatur—Welt-Literatur," http://www.goethe.de/ wis/bib/prj/hmb/das/de3289544.htm (accessed on November 26, 2008).

Wardrip-Fruin, Noah. "Christopher Strachey: The first digital artist?" *Grand Text Auto*, August 1, 2005, http://grandtextauto.org/2005/08/01/christopher-strachey-first-digital-artist (accessed on November 26, 2008).

—. "Reading Digital Literature," in *Reading Moving Letters: Digital Literature in Research and Teaching—A Handbook*. Edited by Roberto Simanowski, Jörgen Schäfer, and Peter Gendolla. Bielefeld: Transcript, 2009 (2010).

Wolfson, Michael. *Beuys / Ulrichs – ICH-Kunst, DU-Kunst, WIR-Kunst: Joseph Beuys und Timm Ulrichs im Kunstmuseum Celle mit Sammlung Robert Simon*. Celle: Kunstmuseum Celle, 2007.

Post-Chapter Dialogue, Gendolla and Ricardo

FJR: Your analysis begins at the assertion that digital literature has two aesthetic dimensions, one for the content of its fictive world, and another for the "dynamics of processualization," a reference to how the mechanism itself operates, thus referring to the work's *method of unfolding* in its electronic environment as a medium for the construction of its fictive or aesthetic world. From that point of departure you next ask what it is about the *second* of these dimensions that is aesthetic or poetic (when analytic consensus has generally emphasized the first as the poetic object and the second as a computational/diagrammatic object). What is, you ask, the connection between the quality of "literariness" and the work's own machinery? With the machinery as empirical object, I am brought to reflect and ask about the qualities of "literariness" as an essential dimension of the work. It is not a bounded entity, is it?

PG: "Literariness" is always only open, and reflexive since the fictitious realizations of literature at their core generate "something" that does not exist directly, materially, physically—and that really cannot "exist" at all; it is an almost paradoxical, self-destructive and at the same time—constructive figure. Literariness means a specific, specifically aesthetic difference vis-à-vis *all* historical, normative, functional meanings and uses of language. It means perception, not as a passive registering of symbolic-material schemata and their functional practice; but rather as an active "pause," a "breather" or temporary halt in the sense of temporarily repudiating the (unreasonable) demand to behave in any "normative" way. Aesthetic distance or difference designates a situation, a moment and a process *between* neuronal-physiological (spiritual and physical) activity and mediated-material programs. It is an individual aesthetic negotiation and a "taking apart" (= literal in German: "auseinander setzen" = to move apart from each other) of the symbolic-material artifacts that the species "human" is continually inventing. And it is exactly at this point where the differences between digital media (to which, in reality, aspects or moments of the human agency could also be delegated) and print media could be discussed.

FJR: How do you explore this? In one strategic direction, you take accepted ideas about the literariness of digital literature—for example, that we should read both dimensions of digital literature (text and interaction) and maintain that "*both* the plane of narrative that comprises subject, story, and characters, as well as the forms of its appearance, presentation, and arrangement have to be reflected upon in a very specific way." Here is where the story intrigues me, because you then move through a dizzying survey of print literature and do *exactly the same thing, but with print works*: you take their mode of interaction with the reader, hold it up for analysis, and argue that, like digital literature, the print tradition has a rich history of reaching the reader by playing with *both* the plane of narrative and with its arrangement, its forms. This is a fundamental philosophical connection that I think would have been missed without the procession of print works that you gather, and the method of these works is patterned as a kind of *trompe l'oeil*, of stepping outside the

interaction of normal reception and into an explicit awareness of the relationship between reader, work, and genre. One premise of this argument could thus be that digital literature and print literature are at an ontological level not incommensurably different and that assumptions of rupture or revolt from the traditional, historical, and conventional forms are, for some reason perhaps related to the status of new media, somewhat magnified. Is this reading of your rhetorical trajectory approximately correct?

PG: Yes, though specifically in the following sense: the two elements of aesthetic activity are preserved; that is, the presentation of a character, a situation, a story or the like, *as well as* their distancing or their rejection; both are preserved by letting readers perceive their culturally standardized creation, the ways in which they are constructed, including the set ways of putting them into action. It is precisely this which I also would expect of digital literature—with the addition, however, that this reflexive, distancing part has now to be expanded into the digitally encoded symbolic processes, procedures, and programs. Take the example of an already quite successful project: Wardrip-Fruin's *Screen*. Here the problem of remembering, of holding on to vital experiences is not only narrated but is acted out in literally physical interactions with the possibilities of the digital medium to "hold onto" memories. To be more exact: After the memory text is first projected and spoken, it slowly disintegrates, detaches itself from the walls and approaches the "reader"— and moves through her if she is only reading with her eyes. If she is "reading" it with the sensor stick in her hand and with the respective physical movements, she can briefly hold onto the words of the text and push them back, thereby collecting them—in German the etymological core of "lesen," to *read*, is "auflesen" in the sense of to *collect*, to *gather*, to *pick up*. We could rephrase this and say: in the spiritual–physical interaction with programmed chains of symbols we are holding on to a part of a text that deals with the problem of holding on to something. This is what I mean by aesthetic distance or difference: a momentary (and then possibly lasting) perception (*aisthesis*), a "notion" of "something" and a simultaneous distancing, "rejecting" of dictated, programmed meanings and the demand connected to this to act in a specific way.

FJR: In a specific passage of the essay,[1] I was intrigued by the "impossibility to make machines as machines do symbolic work." This called for an expansive exploration of symbolic work, which seems like a field onto itself in this sense.

PG: Yes, this is formulated a bit too simply since the computers are already doing symbolic work. Here is a better version: As it becomes clear in print literature that heroic (Don Quixote) or love (Emma Bovary) expectations (symbolic schemata or conventions, etc.) become counterproductive because they are applied much too directly and practically by the anti-protagonists, now the programmed man–machine-interactions should become "counterproductive" or "meaningless"; they should become clear, dissociable and therefore "playable."

Note

1. "Or, better yet—thinking of the futility of all the efforts of the sad knight from La Mancha or the futile love-projections of Emma Bovary—our attention should be turned to the impossibility to make machines *as machines* do symbolic work."

CHAPTER TEN

Screen Writing: A Practice-based, EuroRelative Introduction to Digital Literature and Poetics

John Cayley

I write from London, using media, so-called "new" or "digital" media, literally "electronic" media.[1] In an important sense, I am no longer unusual in this. Most of the writers represented here will have drafted and redrafted their work using electronic media: word processors running on programmable, general-purpose computational machines.[2] However, when I write (to include "now" as I write these words), I tend to do so in such a manner that produces in me a fundamental questioning of the process itself, as both cultural and artistic practice. What is it that I am doing? What is it that I desire to do when I write? Typically, even as they arise, most writers leave such questions to one side, at least to some extent. How could we proceed otherwise? How could we even begin to write if we discovered ourselves to be always entirely surrounded by the abyss of uncertain practice? We would be paralyzed by confusion and fear. Nonetheless, in my own case, the characteristics and contexts of what is now a conscious choice of media make it impossible to ignore the ever-present paraphernalia and prostheses of writing. Nor now would I ever desire to leave them out of account. In common with other writers, I desire to produce meaning and generate affect in my readers, but by contrast with many who tend to take their media as given or for granted, I want to do this using techniques and procedures that are marked by their mediation and in which programmable technology plays a significant and proper part.

To other writers who may not have a special interest in the subject, and before directly addressing the practice of writing in electronic media, it may be helpful to provide a little more context based on my own personal experience and development. I can try to give some indication of why I turned to programmable machines in order to change the way I write. I also want to try and show how my particular location and history influenced the way in which my practice became part of a cultural formation—so-called electronic writing—and how the manner of this appropriation inflects and distorts some of the more familiar relations of influence and association: a writer's shared history and location in Europe and the world.

I was trained as a specialist in Chinese classical literature. This training ran parallel with a long-standing engagement with poetry and poetics in English. At times, I have translated classical Chinese poetry into English. As a student, influenced by my professor and in the course of linguistic research, I marked up texts and attempted to use

computational procedures to analyze classical Chinese prose style. The period during which this work was begun, the late 1970s, corresponded with the first dissemination of affordable personal computers. Coincidentally, correspondence with a literary friend sparked in me the discovery of a potential for varieties of literary composition that are modulated and, to an extent, generated by the kind of regular algorithmic processes—programs—which are carried out typically and tirelessly by computational machines. I became fascinated by the relationship between composition (especially literary composition) and rigorous procedure. Initially, for the most part, these interests developed in ignorance of similar engagements that were and are carried out in writing associated, for example, with the theory and practice of Fluxus or the OuLiPo.[3] Retrospectively, I became aware of a number of writing traditions and counter-traditions that had been engaged with algorithmic procedure well before I incorporated such practices into my own work.

This brief trajectory brings out a number of points that are vital for our discussion. My literary education is entirely unremarkable as personal artistic history. There is traditional textual scholarship, there is poetry and poetics, and there is a relatively conservative literary practice, translation, that is often downplayed as subservient or technical in the Western world of letters. If there is anything novel in my story, it is, of course, linked with the advent of personal computing, the coincidence of a particular historical moment, when a developing writer could acquire a relatively powerful programmable machine capable of processing text. The point I would like to emphasize is that, despite the fact that it may seem to do so, this latter technological coincidence did not and does not overdetermine my literary practice. Generally, in the field of new media as cultural production, readers tend to be dazzled by novelty and so blinded to continuities of artistic poiesis. Moreover, as we well know (it is all but a cliché), this usually means that too much infatuated attention is paid to the media and technology themselves while there is a notable lack of critical sensibility applied to either the content or to the *compositional* form (as distinct from the form of delivery media) that is realized in particular new media works.[4]

The continuation of my own story reinforces these points. I went on to *make* literary works in programmable media, intermittently, from the mid-1980s through to 1994–95. During this period the work was all but invisible and remained unconnected with similar practice elsewhere. I mean that it was both invisible to a literary culture which resisted new mediation (this still concerns me) and also invisible to the art world which was soon actively to embrace new media and net art (about which I care slightly less). If anything, the work I produced during this time was perceived as ludic, incidental, trivial by established literary practitioners, including "innovative," "experimental" poetic practitioners. Only in the mid-1990s, during the short space of time when the internet suddenly became accessible to first-world culture in general, only then did work such as mine and my colleagues-to-be become visible. When I scratched around for a name to describe what I had been doing and continue to do, I rejected or badly needed to qualify those terms that had begun to circulate—hypertext, cybertext, hyperpoetry, cyberpoetry, elit(erature), epoetry, etc.—as either meaningless or misdirected. I still refer to what I do as "writing in networked and programmable media" and I baulk at shortening this to electronic or digital writing.[5] Here, the point I want to make is that

in the 1990s, as a matter of fact, I did not write in or for *networked* media, I continued to write in *programmable* media.[6] Nonetheless, my work was only appreciated in the context of cultural effects that were, basically, generated by the exponentially growing internet, and so the two focal aspects of computationally-mediated work—precisely the networking and programmability of compositional media—were already inextricably linked. Along with everybody else, I was bound to the interwheels of fire.

Why tell these stories, as if to personalize what should be—always assuming they *are* of cultural significance—a practice that can speak for itself and in its own terms? Because, after so many years, writing that is composed in and for networked and/or programmable media is still relatively unfamiliar and downplayed in the mainstream. It is little understood and appreciated, less so even than the new media work in, for example, the fields of visual, performance, and installation art. My story aims to suggest how, despite this, a located writer with particular cultural and linguistic skills and inclinations might decide to compose using tools and techniques that were, in a certain sense, "new," but the use of which implied no major discontinuities of practice or cultural allegiance. I would argue that my decisions entailed no greater discontinuities than those we encounter when, for example, particular writers or groups of writers achieve a critically significant shift of "style" or "school," of rhetorical technique and purpose. Typically, a major shift may be associated with an avant-garde, but this is not necessarily the case. Was the Movement in English poetry, or the New Wave in French cinema and fiction, an avant-garde? In the case of new media, the shift of rhetoric, of technique and purpose is, arguably, historic and paradigm-shifting. Because these changes are major changes in media history, in artistic practice they may themselves appear to herald an avant-garde. New media artists may be caught up in movements that have nothing to do with the underlying cultural significance of the work that they are making. Moreover, because these changes of technique and purpose are aligned with parallel shifts in economics, politics, and culture generally, new media artists are all but inevitably caught up in *hype*.

Hype. Despite their association with a particular moment in cultural history, the "new" of new media, the "hyper" and "cyber," the "digital" and "electronic," all these prefixes and the characterizations they encourage have the effect of removing history and locatedness. They substitute a fixation with the dehistoricized "new" and an over-emphasis on delivery media-as-technology that overwhelms the determinations of formal and compositional technique. At times the result for culture is a shallow haunting, the comic-book specter of a hyper- or cyber-avant garde, a virtual visceral banal "jacking-in" to a supercharged networked which amounts, in the final analysis, to a naive and unprogressive deracination, a discontinuity and delocation that itself requires deconstruction.

Apart from any call to critique the hyper- and cyber-naïf, there are constructive and generative reasons to trouble time and location, because once the hype has been cleared away, networked and programmable media do enable the instantiation of forms of literal art which represent serious challenges to both these fundamental dimensions of cultural practice. I will get to this, concluding with what I hope will be a pertinent demonstration. But before re-undermining history and location in artistic practice, I do want to make this brief discussion "EuroRelative," as pretended. Again, I can do this

using the continuing story of how my own work found a place in what is now undoubtedly the recognized field of digital or electronic literature.

As an Anglophone Canadian permanently resident in England, when, after 1994, my work in programmable media became, as I say, visible, it was at first attracted to the gravity of "hypertext," specifically hypertext fiction. Hypertext as a writing technology and practice predates the World Wide Web.[7] Although hypertext theorists would largely claim that the Web is (or at least, was) an impoverished realization of hypertextual technologies, the Web version of passages-with-links textuality has swallowed up and overwhelmed any higher ideals in the real-world popularization that is now a part of everyday textual life for millions of people. In the latter half of the 1990s, this conclusion was not, however, inevitable. Hypertext fiction was a literary and theoretical ideal that seemed to offer great promise for both writers and academics in the English-speaking world, by which we mean the techno-globalized cultural-imperial United States.[8] To all intents and purposes, in this monoglot utopia, hypertext fiction *was* electronic literature, it *was* writing in networked and programmable media as I would, paradoxically, have said.

As a result, in the course my own and others' attempts to find and engage with colleagues who were actually practicing literature using these new, that is, networked and programmable media, I was *cast* (I am thinking of this term as much in its programming, especially object-orientated programming, sense as in that sense of role-play) as a hypertext writer, while the network implicitly shifted the "location" of my practice westward, transatlantically toward the Californian mondo utopia that is every(net) where. I did not change what I did or where I did it. Instead where and how my contribution to culture was appropriated and determined by an emergent hyperhistory and by a hypergeography that was internet-configured. I was not alone in this predicament. One of the main distinctions in my practice was and is the fact that it is engaged with poetics, as opposed to narrative or other large-scale prose structures for which hypertext technologies may be crucial. Strangely, another of the Anglophone pioneers of electronic literature, Jim Rosenberg, was also a poet. It was difficult to cast his work as passages-with-links hypertext, yet he too was and is active on the hypertext scene.[9]

What was happening in Europe? Both Rosenberg and myself were, later, and within the constraints of our linguistic capabilities, to find other and arguably greater commonalities of theory and practice with the less well-known creative and critical activities of the writers gravitating around what was the world's first digital periodical publication devoted to digital literature, *alire*.[10] Moreover, the French-led and located formation represented by *alire* is explicitly understood in relation to ongoing literary history in France, where the OuLiPo in particular still demonstrates serious, recognized and occasionally mainstream literary practice that employs techniques and, latterly, media which are, in a real sense, continuous and sometimes identical with so-called "new" media. In other words, the OuLiPo produced and produces work in programmable media, and although the way they do this and their reasons for doing it differ significantly from both the *alire* writers and, for example, writers like myself, they do provide a located context and history for our practices.

In 1997, Espen Aarseth's *Cybertext: Perspectives on Ergodic Literature* was published. If the best-known practitioners of self-identified hypertext fiction were located

in anglophone USA, some of the field's most acute and appreciative critics worked in Europe, especially Scandinavia, where literature was seen as an important aspect of emergent, so-called digital culture.[11] Aarseth questioned the overdetermination of electronic literature by hypertext and hypertext theory, offering up a restructured analysis of the field in which cybertext became an overarching term used to describe "ergodic literature," that is, literary art which requires the reader's "non-trivial" effort to engage its media and so realize its rhetorical potential. Hypertext amounted, in this scheme, to a variety of cybertext. Because Aarseth's "textonomy" was sensitive to a broad range of distinguishing characteristics of compositional form in all manner of writing for networked and programmable media, writers such as myself welcomed a theory that was able to appreciate the formal and compositional distinctiveness of our work. It no longer had to be seen as "hypertext with special characteristics."

The northern European critical engagement with electronic literature continues to develop, branching out into the related territories of mediated online textual interaction and gaming.[12] Germany has also had its own, more "cybertextual" engagement with writing in networked and programmable literature. This is perhaps best represented by the online periodical *dichtung-digital* and the two p0es1s conferences, the latter of which involved a major exhibition of digitally mediated literary work at a national level gallery in Berlin. Here, in the center of Europe, we see electronic literature being appreciated less in terms of hypertext and hypertext narrative or fiction, and more in terms of a wide-ranging poetics and rhetorics, drawing influence from visual and sound poetry, visual and installation art and also—important in this context—code and coding as, arguably, itself, artistic practice.[13]

How to propose, in summary, a EuroRelativization of electronic literature from what I have said? In a world of letters already resistant to new media and therefore relatively uninvolved (compared to established practice in the visual arts, for example), the final incursion of networked media into, shall we say, "word processing" during the 1990s gave rise to a hyped miscasting and misdirection of literary practice in networked and programmable media. These hyperliterary historical misshifts centered in the superheated technological and cultural engine of the US-centric English-speaking imperium. Much cultural activity migrated to the hyperempire. In Europe the parallel (not, please note, subsequent) development was relatively located and relatively historicized through what are chiefly instruments of cultural resistance. These formations resist because they demand articulation in terms of *compositional* form. I am (at least provisionally) identifying these resistances under the heading of poetry and poetics, other languages, specific prior artistic practices (including historical avant-gardes) and culturally specific technological requirements (what the computing world actually labels "localization"). In Europe location and history are complex and elaborated. Complexity inevitably and importantly demands enriched and articulated practice and critique. As a *re*placed European, explicitly trained to place even these histories in a global context relative to East Asia, my own practice gravitates to the EuroRelative. And I would encourage writers from other places to keep hold of history and location when they enter the arena of the intertextual hypernet. A EuroRelative positioning has more promising prospects for ingress and access, and is likely to allow contributions from a perceived "outside" to be understood and appreciated rather than simply appropriated or miscast.

In the letters and literature of new media, the irony we encounter is that any program of deracination and dislocation purveyed by the hyperhistory of hypertextuality proves to have been instantiated in a rhetoric that is in fact only mildly subversive of the established, instituted temporal and spatial structures of language. Passages-and-links (for which read texts-and-references of all kinds) have long been familiar to us. Their ordering and reordering is something that we deal with whenever, literally, we read or write. It is in more poetic engagements with language that its temporal and spatial form becomes constitutive and determinative of the composed text. In familiar, print-mediated literature, our established literary cultures recognize these poetics in the special attention we pay to the time and space of the poem—the way in which its words and lines are arranged and then silent-implicitly or oral-actually realized in temporal rhythms that are borne by these same arrangements. As a matter both of inclination and of recent literary historical fact, it is in the European or EuroRelative engagements with electronically mediated writing that we more often find a challenging poetic address to language as time and space.

Something that programmable systems allow us to do is to embody this address to poetics as material process. This makes it possible for us now to experience literary phenomena that are still difficult to talk about critically. This work is poetic in the sense I have described: it arranges words in time and space. By contrast with the print-published poem, programmable compositional and delivery media allow this arrangement and its recital to take place in performance, in real passing time and space rather than in the imaginary space-time of the silently reading mind. Potentially (and always assuming that the significance and affect they offer is of adequate moment) such mediated poems are poetic in a real, material sense, while paradoxically, it is harder for us to say what it is that they are as cultural objects (are they "poems"?) because, for example, they pass before our eyes and disappear, like music or film, without the seemingly fixed, print-located traces of poems that are familiar to us.

In order to demonstrate these qualities of, as I claim, a EuroRelative poetic writing in programmable media, I will close by presenting a demonstration from the series of pieces I call *translation*.[14] These and related pieces are, in one sense, examples of literal art in programmable media that demonstrate an "ambient" time-based poetics, a poetics in which temporal phenomena of language cannot be bracketed or deferred because the work is precisely an instance of continual change in language over time, a constant algorithmic writing and rewriting. These processes *are* the work. The writing is not the record of an inscription or prior composition. It is a program running. It is the sum of all the phenomena which occur when a program—a "prior writing" in anticipation of performance—is set in train.

In terms of content, *translation* investigates iterative, procedural "movement" from one language to another. Passages from the texts which underlie the piece may be in one of three states—surfacing, floating, or sinking. But they may also be in one of three language states, German, French, or English. If a passage "drowns" in one language it may "surface" in another. The main source text for translation is extracted from Walter Benjamin's early essay, "On Language as Such and on the Language of Man."[15] Other texts from Marcel Proust may also, less frequently, surface in the original French, or one or other of the standard German and English translations from *In Search of Lost*

Figure 1. John Cayley,
translation,
2002.
Digitally mediated poetic text.
Image courtesy of the artist

Time. The shifts between languages are not preformed at the level of semantics, but at the level of the letter. They are, nonetheless, linguistic and poetic, generating transitional textual forms that pretend (in the strong sense) significance and affect.

Quite apart from whatever meanings *translation* offers which could be re-rendered as paraphrase, using relatively simple procedures, this piece aims to challenge our conceptions of time and location in language and poetic practice. But it does not do this by pointing toward or pretending to inhabit an everwhen and nowhere. *translation*, together with all writing, suggests that time is an integral aspect of language as it is continually made and remade. Through a generative "con-fusion" of located linguistic practices, it shows that languages can be iteratively related through their granular, literal, liminal structures. This located, historical, active interrelation of languages is an intimate aspect of poetry and poetics, and it happens daily, hourly in the markets and meeting places of Europe and the world.

Notes

1. The use of the terms "new" and "digital" can be problematic and their interrelationships are often discussed in the literature. See, for example, Lev Manovich, *The Language of New Media* (Cambridge, MA: MIT Press, 2001); Peter Lunenfeld, ed., *The Digital Dialectic: New Essays on New Media* (Cambridge, MA: MIT Press, 1999);

John Cayley, "Literal Art: Neither Lines nor Pixels but Letters," in Noah Wardrip-Fruin and Pat Harrigan, eds, *First Person: New Media as Story, Performance, and Game* (Cambridge, MA: MIT Press, 2004), 208–217.

2. The effects of these applications on practices of writing are still little understood and sometimes, I suspect, disregarded, as if the software is "neutral" or "simply a tool." For an interesting critique of Microsoft Word, see Matthew Fuller, "It Looks Like You're Writing a Letter: Microsoft Word," *Behind the Blip: Essays on the Culture of Software* (New York: Autonomedia, 2003).

3. In the field of poetry and poetics, Emmett Williams, Jackson Mac Low, and John Cage are important references explicitly associated with Fluxus. From the OuLiPo, Raymond Queneau is well known in this context for his *Cent Mille Milliard de Poèmes*, and many members of the OuLiPo wrote highly formal poetry under procedural constraint. However, the OuLiPo seems to have been as much concerned with the mastery [sic] of process as with its poetics *per se.*

4. The web-based journal *dichtung-digital* provides an important forum which works to correct such tendencies. See http://www.dichtung-digtal.com.

5. Sometimes I call what I do "literal art" but that is another story. See Cayley, "Literal Art," op cit.

6. In writing, programmable media are media that may be configured and/or altered by both authors and readers, in such a way that the significance and potential affect of the work is changed. Programmable media need not be networked. Networked media are distributed using programmable machines on networks, now globalized for us through the internet. Given that they are, typically, delivered on programmable systems, networked media are likely to be (at least potentially) programmable, but this is not necessarily the case in practice and the contrary is still (perhaps increasingly) the norm. A piece of music or the pdf version of a poem downloaded from the internet is not programmable in the sense intended here.

7. On the history and development of new media, especially from the perspective of text and literature, see Noah Wardrip-Fruin and Nick Monfort, eds, *The New Media Reader* (Cambridge, MA: MIT Press, 2003). On digital poetics, see Loss Pequeño Glazier, *Digital Poetics: The Making of E-Poetries* (Tuscaloosa, AL: University of Alabama Press, 2002). There are essays by a number of important practitioners in Loss Pequeño Glazier and John Cayley, eds, *Ergodic Poetry: A Special Section of the Cybertext Yearbook 2002–2003* (Jyväskylä: University of Jyväskylä, 2003). Chris Funkhouser of the New Jersey Institute of Technology has just completed a book about the early history of digitally mediated poetry—Funkhouser, Christopher T., *Prehistoric Digital Poetry: An Archaeology of Forms, 1959–1995* (Tuscaloosa, AL: University of Alabama Press, 2007).

8. This promise was clearly spelt out in books such as Jay David Bolter, *Writing Space: The Computer, Hypertext, and the History of Writing* (Hillsdale, NJ: Erlbaum Associates, 1991), also published on disk as a Storyspace hypertext; and George P Landow, *Hypertext: The Convergence of Contemporary Critical Theory and Technology* (Baltimore, MD and London: Johns Hopkins University Press, 1992), which has been revised and updated as George P Landow, *Hypertext 2.0: The Convergence of Contemporary Critical Theory and Technology* (Baltimore, MD and London: Johns Hopkins University Press, 1997).

9. This is, of course, an oversimplification. Rosenberg is a very serious hypertext researcher who has been involved with the technical aspects of hypertext implementations from the inception of the field. Nonetheless, he is also a poet and his work in programmable media does not conform to any standard hypertext model. I have written on these issues in relation to Rosenberg's work in John Cayley, "Time Code Language: New Media Poetics and Programmed Signification," in Adalaide Morris and Thomas Swiss, eds, *New Media Poetics: Contexts, Technotexts, and Theories* (Cambridge, MA: MIT Press, 2006), 307–333.

10. For the story of *alire*, the first issue of which came out on January 16, 1989, visit http://motsvoir.free.fr, and follow the *alire* links.

11. In the 1990s, Aarseth and others made the University of Bergen a center for research on digital culture. A Finnish contingent, notably Raine Koskimaa of the University of Jyväskylä and the novelist and independent scholar Markku Eskelinen, were and are often involved. Aarseth is now at the IT University of Copenhagen along with a group of other researchers. Their interests have shifted somewhat to explore the relationship of culture, including literary culture, with such phenomena as digitally mediated gaming and playable media generally. Instrumental and playable textuality will clearly be important areas for literary development, in my opinion.

12. Espen Aarseth is now at the IT University in Copenhagen, in the Department of Digital Aesthetics and Communications, along with a group of other researchers, including Lisbeth Klastrup, Jesper Juul, Susana Parjes Tosca, and Gonzalo Frasca, with shared interests in the field, engaging, in part, with literary concerns.

13. The site for *dichtung-digital* is given in a note above. Friedrich Bloc was the primary organizer of the two p0es1s conferences, for which see: http://www.p0es1s.net. An important theorist of code as writing and writing as code is Florian Cramer, some of whose work is accessible via: http://userpage.fu-berlin.de/~cantsin/homepage/. Through Germany also, it seems to me, there are strong links to the Brazilian tradition of visual poetry and its digitally mediated descendent practices.

14. *translation* is accessible on the Web at http://programmatology.shadoof. net/?translation.html. *translation* was developed from an earlier but still quite recent piece called *overboard*, http://programmatology.shadoof.net/?overboard. html. An extended explanation of the workings of *overboard* can be found on the dichtung-digital site, John Cayley, "Overboard: An Example of Ambient Time-Based Poetics in Digital Art," *dichtung-digital*, 32, 2004, http://www.dichtung-digital.org/2004/2-Cayley.htm. The generative music for the *translation* pieces was developed in collaboration with Giles Perring who did the composition, sound design, performance and recording of the sung alphabets.

15. Walter Benjamin, "On Language as Such and on the Language of Man," in *One-Way Street and Other Writings*, trans. Edmund Jephcott and Kingsley Shorter (London: Verso, 1997).

Post-Chapter Dialogue, Cayley and Ricardo

FJR: In this narrative, the curtain rises on a world which, while recognizable to digital media artists and audiences, is nonetheless rendered from a highly personal vantage. As described here, your coming to electronic writing was a dénouement of sorts, an engagement that resulted from a search for a problem solution rather than as the outcome of experiment or diversion alone. While digital media work generally presents itself as an opportunity for expressive play, there is in your account an additional undertone of necessity about that move, perhaps suggesting that your creative trajectory was, if not entirely determined, nevertheless resolute. And if the turn to new expressive directions made digital media a necessary choice, one might ask what is the nature of that reason? The intimation is in what the medium does at the point of reception. The elevation of *procedure* from the *a priori* process of writing, up into the subsequence of the end product, in real-time marks the moment at which artists using new media found themselves not only over new terrain, but with an ineluctable sense of having arrived there as if over a precipice, with no turning back. And by having your work embrace the problems of procedure as an aesthetic dimension itself, there is thus complex richness in your practice and approach, evident from the moment of refusal to reduce the fullness of writing in networked and programmable media with the terms "electronic or digital writing." This latter term's reduction isn't only linguistic to you; it disavows the breadth and inclusiveness of media and methods that motivated your sympathy for creating new media works in the first place. It seems then that the trajectory of your work turns on should be called a poetics of procedure. I wonder if you could illustrate how the power of that direction is different for you from more conventional expressive affordances and traditions, something made more precise in your claim that European or EuroRelative engagements with electronically mediated writing pose a deeper poetic address to language as time and space and that programmable systems deploy this form of poetics as material process.

JC: I agree that I pretend a "necessity" for my personal "digital turn" and I continue both to seek out and read critically the crucial aspect of mediated writing practice to which you refer: expressive process (in Noah Wardrip-Fruin's emerging formulation). What seems to be at stake is the possibility that writing as representation in programmable systems does express a "deeper," "necessary" engagement with poetics, with the art of language and its "strange materiality." Thus, in terms of my personal development, I published my "last" book of poems, translations, and adaptations in 1996. The brief "bios" which often accompany my essay contributions—such as the one in the present volume—reiterate the ambiguity and pretence of "last." I pretend that since 1996 I only ever "publish" the results of my literary practice in or as digital media. I continue to stand behind my pretence. Nonetheless, I am increasingly aware that what may actually be at stake is something to do with the properties and methods of linguistic practices more generally, with the relationship of these practices to the world, and

with the peculiarities of linguistic mediation that our world allows: the way we present language to the world, the way language presents itself to us in the world, the way language represents the world to us, and strangeness of media-constituted "worlds" that language can embody for us. The distinct symbolic practice represented by programming (i.e., programming as distinct from writing) and its relationship to the objects that its processing makes manifest in the world (including the world of media) do, it seems to me, establish an analogous structure of representation to that which generates language objects in the world. One difference is, however, that the objects of programming are, historically if not by definition, multimediated. They are not, unlike the objects of writing, specified or constrained in terms of their media embodiments (constrained to print and located speech fundamentally, still). We expect outputs of programming, especially artistic programming, to be novel and extraordinary without any diminution of their symbolic significance or affect. Remarking this analogy and this difference, I derive an obligation, a necessity, and a vast, indeterminate potential to recast—culturally, critically—the making (poeisis) of literary objects and these objects themselves. It is not that processing or programming becomes necessary for writing, or that writing with processing has some "media specificity" that we must necessarily come to value. It is that writing has always already had the potentiality to manifest itself in the world in unimaginably various, manifold, multiply mediated embodiments, and that some parts of this potentiality has been made accessible to us by what we call new or digital media.

FJR: I agree with how your account traces not one evolutionary history in digital literature, but two—one in the Americas and another in Europe—and perhaps there are others. It appears that your work, very distinctly created in the openness of the European spirit, became caught in the aegis of an American optic that converged around a canon of hypertext. Openness matters tremendously at the distinction between poetics versus literature, which is structurally much more dependent on a system of protracted interconnections in the unfolding of fictive realm. Poetic openness is associated with the critical perspective that northern European critical engagement with electronic literature provided, as you importantly trace here. Espen Aarseth, wanting to pave an academic portal to serious game study, titled his book *Cybertexts* and not *Hypertexts*. To effect this move, a critique of hypertext had to be mounted that resolved to the post-literary openness that the game. Progressively, many still favor pure formalist analysis, which I think ironically sometimes risks being reductive, icy, and lacking the sweeping rigor that Northrop Frye's formalist criticism bestowed to print literature. For this reason, your work is it seems to me, is very far from that, and I think many authors and artists would resist diagrammatic x-rays of their work. The difference between American and European approaches in new media analysis seems increasingly to relate to this question of which methodology to use, a phenomenological/aesthetic or a computational/schematic one.

JC: I placed myself as "Eurocentric" as a matter of fact (sort of—is England Europe?), and in order, as you suggest, to reveal traditions of practice that have been, arguably, downplayed, not only in digitally mediated literature and poetics. Openness is, to my mind, strongly recommended by the vast and indeterminate range of potential formal

affordances implicit in programmable media. Moreover, rather than focusing on two anglophone strands of digital literary practice and history, we might multiply both by the differences of linguistic practice represented embodied in what we tend to identify as distinct natural languages, and then by engagements with related cultural practices— like gaming. The field, its strands and tentacles, expands like an eleven-dimensional universe. Nonetheless a focus on form and formalism rhymes with an engagement with poetics that I do see as significant and I agree that, for example, the implicit attention to (conceptual, figurative, narrative) "content" that might have been a feature of US-centric hypertextual essays in fiction does provide a contrast with a formalist, poetical approach to writing in digital media. The latter is perhaps more easily seduced by "new" form, by the prospect of poetics everywhere and author/readers writing anywhichwhere. I want aesthetic gaming and any other cultural practice going—digitally mediated or not—to challenge writing practices, even those that I would never myself consider attempting. And I also want to use programmable media in order to embody a number of engaged, radical formalisms—*poethically* as Joan Retallack might say—so as to make aesthetic, literary objects in the process—for the sake of poeisis. My computation (amongst other things), I trust, embodies aesthetics.

FJR: A distinction that may have seemed conceptually inconsequential until now appears in the contrast that you detect between programmable media and networked media. Since the former affords programmability to both authors and readers, the emphasis is on changing the work in variations of *serial* form, as through a palimpsest-like accretion, or Talmudic over-annotation, with each subsequent hand altering the work from moment to moment. This hints at an evolutionary approach, a kind of maturity through successive geological strata in the base of creative engagement, or as interventions, in the way that the frames of a film temporally reveal the development of scene, character, and plot. Opposing this, networked media make the work revolve around a quite different shape of change. The work here through under a process that might more accurately be called dispersion rather than progression. In concurrent distribution, the work becomes subject to the same effects evidenced in the distributive law of algebra, which declares that $w(b+c) = (wb) + (wc)$. This premise implies that a creative work w, simultaneously engaged by users (or readers, viewers, participants) b and c essentially becomes two independent works through the experience that b has of it and through the modifications that b performs to it, all of which are private to b's individual context, even though reader c is potentially also interpreting, and altering the work toward separate personal directions. The difference then indicates that programmable media induce historically unfolding work whereas networked media essentially promote aesthetic experience whose trajectory is neither direct nor singularly identifiable at any given historical moment. Both directions reflect the contingent mutability of the object that is postmodernity's challenge to the classical ideal of a work, but each follows distinct contours of interpretive experience.

JC: This is a necessary strategic distinction. Media are programmable and they are networked. Programmable media were developed before they were networked and their development was a precondition of the existence of networked media (as distinct from broadcast[ing] media, of course). Their popularization in the mid-1990s was a

perhaps inevitable coincidence and it continues to be difficult to unravel the conse-
quences of their subsequent co-dependency. On the one hand, as a practicing artist/
theorist of a certain vintage, I would prefer to bracket the cultural effects of the inter-
net and concentrate on the effects of programmable media; and to regard the effects
of networking as (quite properly) a consequence of programmable media. But I have
the sense that, despite the fact that the cultural moment of the network is a basically a
function of some new psychosociology of cultural practice rather than emergent from
the properties and methods of networked media *per se* (which should rather be seen as
a subset of properties and methods ascribed to programmable media), what happens,
aesthetically, artistically, culturally on the internet will dominate and prevail. If any-
thing can shift the balance of power in cultural mediation, it is the internet and its neti-
zens. Thus, although I, personally, might lament the demise of singular experience and
I might indulge maudlin speculation on how this will have an impact on, for example,
our understanding and experience of "the literary," I acknowledge the fact that cultural
production is less and less "singular"—precisely because of the internet—and that this
is one of the great questions for our time (I speak within a tradition of artistic and crit-
ical practice here): How can there be something beautiful that has been made when we
cannot know or properly acknowledge the multitude that has made it?

Index